MARY CASSATT

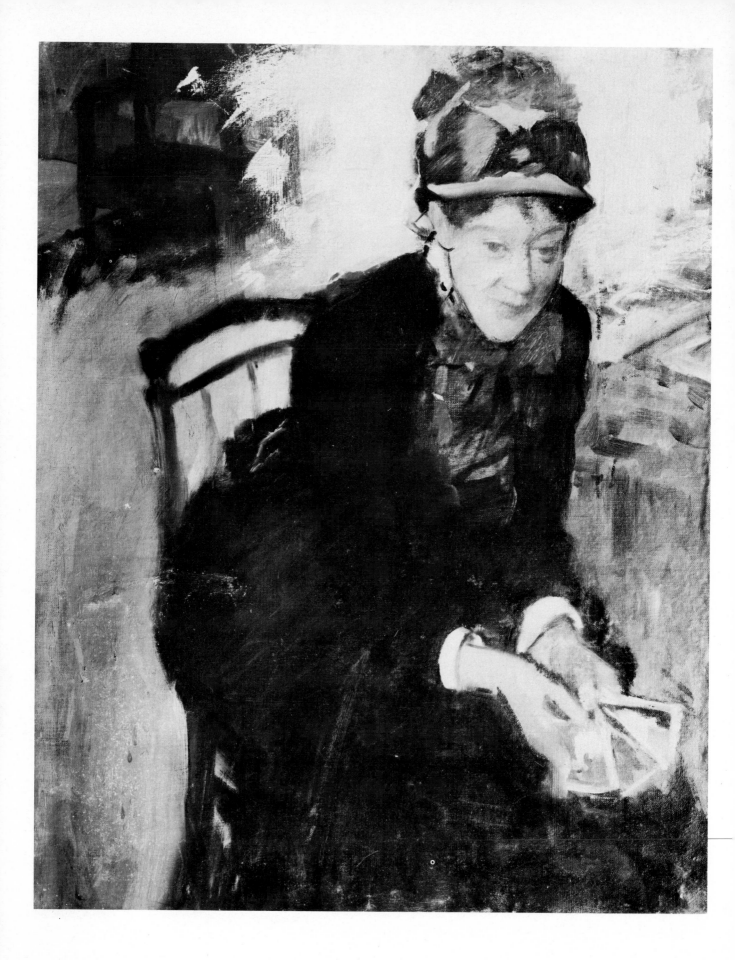

MARY CASSATT

GRISELDA POLLOCK

HARPER & ROW, PUBLISHERS

NEW YORK

Cambridge London
Hagerstown Mexico City
Philadelphia São Paulo
San Francisco Sydney

1817

(frontispiece)
Edgar DEGAS
Portrait of Mary Cassatt
PARIS, Collection of Andre Meyer. c. 1880. Oil on canvas 71·2 × 56·9 cm.

Cassatt's self-portraits (Plate 12) are far more reticent than the strong and interesting portrayals of her by her close friends. Degas did a number of portrait studies of his colleague, the most famous of which, the aquatint *Au Louvre* of c. 1879 (Paris, Musée du Louvre), shows Cassatt and her sister as elegant and attentive visitors to the Louvre, where the artist is only seen from the back. This unfinished but more characteristic oil sketch did not, however, please Cassatt and when it appeared many years later in a dealer's hands, she tried to suppress the identity of the sitter. Yet it is a valuable document since it provides a bold and unusual image of Cassatt at the time of her close involvement with the Impressionist group and with Edgar Degas in particular. She is shown dressed as befitted a woman of her class and age, but her appearance is also thoughtful, determined and self-contained just as she herself was so consistently to portray women. In her hands, placed prominently in the foreground of the canvas, she holds some coloured cards, one of the new influences like Japanese and popular prints which she and Degas found so rich in suggestions for novel compositional and stylistic devices. Despite its unfinished state, the characterization, the setting, the forceful positioning of the figure and the stylish dress bespeak the points of contradiction from which a study of Cassatt must depart; the middle-class lady who became a professional painter, the American painter of high Philadelphia society who joined the French avant-garde and interrogated throughout her career traditional modes of representing women.

ACKNOWLEDGEMENTS

This book is the product of the Women's Movement. I owe a great debt in particular to the women in the Women's Art History Collective with whom I first began to study the history of women artists and discover the art women have produced throughout history. There are also certain individuals who have helped me considerably whom I would like to thank, Ruth Pavey for her interest and invaluable criticism and suggestions during the writing, Susan Owen for reading and making important comments on the manuscript and sharing with me her considerable knowledge of American women writers, Roszika Parker for the many discussions of feminism and art history which have inspired and informed this book. For initial encouragement of the project and the great labour of editing, clarifying and condensing an overlong text, my editor Robert Oresko earns my gratitude, as does Elizabeth Marr for her arduous task of collecting the illustrations.

**For Andra and Gordon
In Memory of Kathleen**

FIRST U.S. EDITION

ISBN 0 — 06 —013348 —1
LIBRARY OF CONGRESS CATALOG CARD NUMBER: 79-1914

Mary Cassatt

I

It was Stéphane Mallarmé, the poet,—one of the best critics I know, who took me to see the impressionist pictures at the gallery of Boussod et Valadon & Cie., on the Boulevard Montmartre, and at both the gallery and house of M. Durand Ruel. M. Mallarmé wrote me a list of living impressionist masters, roughly in order of their importance. It reads thus: Claude Monet, Renoir, Degas, Sisley, Pissarro, Mme Berthe Manet [Morisot] and Raffaëlli. Having handed me this list, he took it back again, and added the name of an American lady, Miss Mary Cassatt, who was of too much consequence, so he said, to be ignored in selecting his chosen few.

Louise Chandler Moulton, *Lazy Tours in Spain and Elsewhere*, 1896, p. 171

YOU MAY WELL have never heard of Mary Cassatt (1844–1926), an American woman who worked as a professional painter with the Impressionists in Paris in the late nineteenth century. There are two possible but somewhat crude explanations for this. Firstly it might be assumed that she was not a good painter, but even a cursory glance through illustrations of her work provides ample evidence of her ability and this book is written from the firm conviction that she was both an excellent and a significant artist, whose *oeuvre* adds a new dimension to the study of the rich and varied sources out of which Impressionism developed. The second is that women are generally excluded from our cultural heritage, overlooked by art historians and omitted from exhibitions in museums and galleries simply because they are women. Cassatt's contemporaries were well aware of her existence and the quality of her work, as the above quotation indicates. This book's main and more subtle concern is twofold, both to explore the specific historical reasons for Mary Cassatt's considerable achievement as a painter and graphic artist because of, as well as despite, being a woman and secondly to explain her subsequent neglect by art historians outside the United States, where she has never been assigned to complete oblivion.

The quotation from Louise Chandler Moulton hints at a third, more subtle explanation for her obscurity, the fact that she was an '*American* lady'. She was the only American painter of her generation who whole-heartedly embraced the style and practice of the Impressionists, or Independents as she preferred to call them, and for obvious reasons has therefore been acknowledged to a greater extent by posterity in America. However, this aspect is not without problems, as Margaret Breuning, an American author writing in 1944, pointed out. 'Mary Cassatt, who has only recently received recognition as one of our foremost artists, presents the anomaly of being thoroughly American, although spending the greater part of her life in Paris, and acquiring her distinctive style under French influence.' Her nationality places her in the context of American nineteenth-century art, which is little studied outside the United States, while her style evolved within a European movement whose historians treat her only as a fellow traveller. For instance, John Rewald in the fourth edition of his authoritative *The History of Impressionism* (1973) mentions Cassatt in passing as a follower of Degas but does not include her in his chronological tables of the main artists of the group, though he does include Berthe Morisot, the other woman who exhibited consistently with them. Thus Cassatt suffers a double disability; generally as a woman painter her significance is underplayed, and particularly as an American in Paris she represents an anomaly to art historians working within strict national categories.

However, many American artists and writers of this period did in fact come to work in Europe and they received due acknowledgement at the time. For instance in 1893, in the preface to Cassatt's second one-woman show at Durand-Ruel, André Mellerio wrote fulsomely, 'In all sincerity, it must be said, Miss Cassatt is perhaps, with Whistler, the only artist of an elevated, personal and thoroughly distinguished talent that America possesses at the moment.' Although this comment reflects considerable ignorance on the Frenchman's part of native American art of the period, it does raise a significant point by mentioning the painter, James Abbott McNeill Whistler (1834–1903), another American who came and worked in Europe in the second half of the nineteenth century and was an acquaintance of Cassatt. It was in fact customary for American artists to come to study in Paris, Rome, Munich and Madrid, and many leading artists who later made their reputations exclusively in the United States, such as Winslow Homer (1836–1910) and Thomas Eakins (1844–1916), had spent their student years in European studios or museums. But a significant number of Americans chose to remain abroad and this group includes not only painters like Whistler, John Singer Sargent (1856–1925) and Mary Cassatt herself,

but also the writers Henry James and, on a less permanent basis, Edith Wharton. That most of these male artists have not suffered to the same extent from having been expatriated suggests that Cassatt's female gender is at least as important a factor in her neglect as her anomalous position as an American amongst French Impressionists.

Ironically, Cassatt, like her compatriot Edith Wharton, came to work in Europe specifically because she felt that it was a more favourable climate for women's creative activity than her native country. Writing to a Miss Hallowell in 1893 about the Woman's Building at the World's Columbian Exposition in Chicago organized by Mrs. Potter Palmer, to which Cassatt sent a large mural on the theme of *Modern Woman* (see Plates 40 and 41), she exclaimed in frustration with American attitudes to the women's project:

After all give me France. Women do not have to fight for recognition here if they do serious work. I suppose it is Mrs. Potter Palmer's French blood which gives her organising powers and determination that women should be *someone* and not *something*.

Not surprisingly in the light of such a statement, Mary Cassatt, who became more and more involved in radical politics during her lifetime, was a staunch supporter of women's rights and participated enthusiastically in an exhibition for the benefit of the suffragettes in New York in 1915, about which she wrote to its organizer Mrs. Havemeyer on 30 May 1914, 'You know how I feel about *the*, to me, question of the day, and if such an exhibition is to take place, I wish it to be for the cause of Woman Suffrage.'

In the recent revival of the women's movement, scholars with feminist sympathies have turned to Mary Cassatt with particular interest and enthusiasm. Many books and articles have been added to the already respectable bibliography on the artist and in 1970 her work was given a comprehensive retrospective exhibition at the National Gallery of Art, Washington, organized by the eminent Cassatt scholars, Adelyn

Breeskin and John Bullard. However, despite all this, Cassatt is still an isolated individual outside the mainstream of cultural history and continues to be confined to a special category of exceptional women, whereas, in truth, she is exceptional only because of the treatment she has received. Three facts, that she was a woman, an American and an Impressionist, which have contributed in different ways to her disappearance from the history of Impressionism, are all equally significant and in their particular conjunction in Cassatt's career determined the distinctive individual art an American woman produced within the Independent or Impressionist movement in Paris in the late nineteenth century. However as a woman she has been, within the *history of art* as a discipline, neglected and often, even by her admirers like Frederick Sweet, patronized; as an American she is outside or, at best, on the fringes of mainstream European art history and as an Impressionist she can only be on the periphery of American culture. To correct this picture of disadvantage and place her in the history of art, which must modify some of the assumptions made about Impressionism as a result of her place within it, one cannot ignore the positive influences of all three factors.

The questions that must be posed are why did Cassatt become a professional artist and not a lady amateur; why did an American woman come to Europe; why did she join the Independent avant-garde in France in the 1870s and, most importantly, what in fact are the real themes of Cassatt's *oeuvre*?

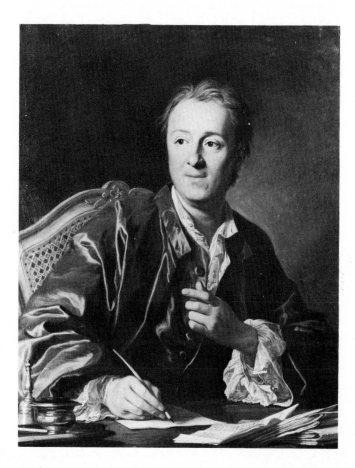

fig. 1 Louis-Michel VAN LOO
Portrait of Denis Diderot
Paris, Musée du Louvre. 1767. Oil on canvas
81 × 65 cm.

This is one of the finest examples of the eighteenth-century portrait of 'le philosophe' and Denis Diderot, writer, critic and *encyclopédiste*, fully represented the type. Here he is shown in his study, casually dressed, seated at his desk amidst his papers and books from which he looks up to gaze intelligently and alertly at the spectator. However when Jean-Etienne Liotard produced a portrait of a female intellectual, Mme. d'Epinay, a contemporary of Voltaire and Rousseau, she was represented as a middle-class matron, without any pictorial references to her erudition.

II

With almost no exceptions . . . she only painted one subject: children, and the rôle she gave in the majority of her canvases to the mother of the baby was ordinarily a secondary rôle in order to define the emotional intention and to emphasise by means of dark or light touches of costume or by means of the justness of her movement the general, overall harmony.

Achille Segard, *Un Peintre des Enfants et des Mères—Mary Cassatt*, 1913, p. 127

In summing up Miss Cassatt's complete works, there are . . . more portraits and figure studies of women than of mothers and children. It is only because of her unique approach to the maternity theme that she is known primarily as a painter of mothers and children.

Adelyn Breeskin, *Mary Cassatt: A Catalogue Raisonné of Oils, Pastels, Watercolours and Drawings*, 1970, p. 15

After all a woman's vocation in life is to bear children.

Mary Cassatt, 1926, quoted in John Bullard, *Mary Cassatt, Oils and Pastels*, 1972, p. 11

Mary is at work again, intent on fame and money she says . . . After all a woman who is not married is lucky if she has a decided love for work of any kind and the more absorbing the better.

Mrs. Cassatt, the artist's mother, to Alexander Cassatt, the artist's brother, 23 July 1891

MARY CASSATT WAS both a woman painter and a painter of women. What this means and how she came to concentrate on portrayals of women is not easily explained. A glance at the first two extracts quoted above suffices to show the differences of opinion between even her most diligent and sympathetic biographers. The last two quotations place the problem in its precise historical context, for they are typical expressions of late-nineteenth-century ideas about women which Cassatt herself seems to have accepted, while contradicting them by her activity as a professional, dedicated and independent artist.

Mary Cassatt was born on 22 May 1844 in Allegheny near Pittsburg, Pennsylvania, the second daughter and fourth surviving child of the solid upper-middle-class family of Mr. and Mrs. Robert Simpson Cassatt. Her father was a stockbroker, with a respectable position, comfortable income and a passion for moving from house to house, town to country, continent to continent and inevitably up the social scale. Her mother also came from a long-established Pennsylvanian family and had had an exceptionally fine education. She spoke French fluently and was extraordinarily well-read. The portrait of her by Cassatt, *Reading 'Le Figaro'* of 1883 (Plate 23), is an unusual if not unique image for a mother, for Mrs. Cassatt is shown seriously engaged in an intellectual pursuit that invites comparison not with the traditional iconography of women or mothers, but rather with portraits of intellectuals, for instance of eighteenth-century philosophers (fig. 1). In other ways, this portrait can be compared to Cézanne's portrait of his father reading *L'Evénement* (fig. 2), although the difference of parental sex underlines the novelty of Cassatt's imagery. In her memoirs Louisine Havemeyer, a lifelong friend of Cassatt, paid tribute to Mrs. Cassatt when she wrote:

Anyone who had the privilege of knowing Mary Cassatt's mother would know at once that it was from her and her alone that [Mary] inherited her ability. In my day, she was not young [but] she was still powerfully intelligent, executive and masterful and yet with that sense of duty and tender sympathy that she had transmitted to her daughter . . .

Cassatt therefore had close at hand a model of intelligence and accomplishment in her mother which seems to pervade her presentations of women, who are often shown reading. The painting, *Mrs. Duffee Seated on a Striped Sofa* of 1876 (Plate V), is one of the earliest of these and shows her debt to the Old Masters she studied so intensively in her youth. Fragonard comes to mind with the eighteenth-century connotations of elegance of dress and casualness of pose. Cassatt's images of women reading soon lost their obvious dependence on Old Master sources and in 1877 she painted *The Reader* (New York, collection of Electra B. McDowell), in which the book itself gains prominence, being placed firmly in the hands of the absorbed young woman, creating a kind of barrier between the spectator and the sitter, admonishing the viewer to maintain a respectful distance, silence and quietude appropriate to the subject of the work. The theme reappears in portraits of the artist's sister, *Lydia Reading the Morning Paper* of 1878 (Omaha, Joslyn Art Museum) and *Lydia Reading in a Garden* of 1880 (Chicago, Art Institute of Chicago) in which the figure in profile, self-absorbed in mental activity, is turned completely away from the viewer, while the newspaper she reads proclaims a distinct flavour of the modernity so precious to the Impressionists. The radical implications of self-absorption and sustained activity in portrayals of middle-class women cannot be sufficiently emphasized, for it was the lack of undisturbed time that so impeded the majority of women from attaining any degree of professional competence. Florence Nightingale, an older contemporary of Mary Cassatt, railed against women's oppressive lot in her unpublished essay, 'Cassandra' where she discussed the 'odd times'

that middle-class women could work undisturbed:

Women dream of a great sphere of steady not sketchy benevolence
... For how do people exercise their moral activity now? We visit,
we teach, we talk 'among the poor'. How different would be the
heart for work, how different would be the success if we learnt
our work as a serious study and followed it up as a profession.
If a man were to follow up his profession or occupation at odd
times, how would he do it? ... Women themselves acknowledge
that they are inferior in every occupation to men. Is it surprising?
They do everything at 'odd times'.

Cassatt's reading women contain a very personal
element verging on the autobiographical. She was
herself very well-read and well-informed, a fact that
her father proudly reported to Alexander Cassatt in a
letter of 13 December 1878:

I suppose you saw that the Boston paper gave Mame a silver
medal. I believe she was the only woman among the silver medals.
Her circle amongst artists and literary people is certainly extending
and she enjoys a reputation among them not only as an artist but
also for literary taste and knowledge, which moreover she deserves
for she is uncommonly well-read especially in French literature.

However reading and its creative counterpart writing
were in the nineteenth century slightly more accessible
to a middle-class woman than the professional practice
of the visual arts. Virginia Woolf describes Jane Austen
writing in her drawing room, hiding her manuscripts
under the blotter when the inevitable visitors claimed
her attention. One cannot conceive such possibilities
for the painter. A more telling variation on the subject
of women reading which has a distinctly autobiogra-
phical note is *Young Girl with a Portfolio of Pictures* of
c. 1876 (Plate 6), in which the girl's absorbed attention
is focused on a study of art. Traditional iconography,
this time of the print lover in, for instance, Daumier's
The Collector of Prints (fig. 3), was once again inverted
by the substitution of a female figure, whose youth,
moreover, calls to mind Baudelaire's and Champ-
fleury's cult of the naïvety of childhood, which was
portrayed in Courbet's great allegorical work *The
Studio* of 1850 (Paris, Musée du Louvre) by a young
child studiously drawing. However Cassatt's image sug-
gests no such sense of the naïve and untutored eye, but
rather the young girl's serious and intent study, unusual
for its earnestness in one whose age, dress and apparent
class might hint at more frivolous pursuits. The
fashionable costume of the girl, slightly suggested with
its lace-frilled sleeves and bodice and ruffled skirt, is
strangely at odds with the dominant air of unself-
conscious preoccupation with which she gazes at the
pictures. There is also a subtle comment on the art of
painting itself. The viewer gazes at a framed image of a
girl gazing at bordered prints. The girl, the unmarried
sister, the married woman and the mother, the models
for the paintings discussed so far, are presented without
any concern to emphasize the social rôles so important
in nineteenth-century society. Instead these early
paintings are unified by the recurring images of self-
contained and mental activities in which women were

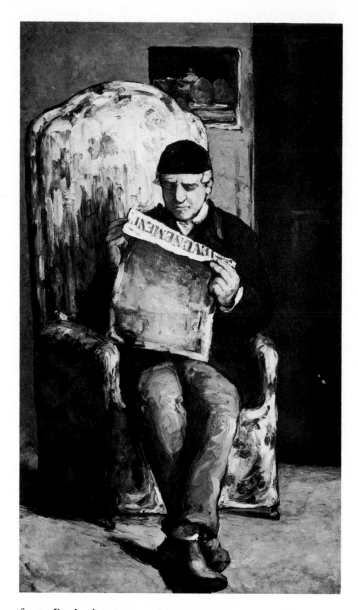

fig. 2 Paul CÉZANNE
*Portrait of Louis-Auguste Cézanne Reading
'L'Evénement'*
Washington, National Gallery of Art
(collection of Mr. and Mrs. Paul Mellon).
1866. Oil on canvas 198·5 × 111·3 cm.

During the 1860s Cézanne painted a number
of portraits of his father reading the news-
paper. However in this work Cézanne
specified the name of the newspaper for a
particular reason: it contained an article on
the very artistic activities in Paris of which his
father disapproved. Cézanne's painting is
therefore not a simple statement about his
father's reading habits, but knowledge of this
private intention is not necessary for an
understanding of the painting which
represents a not uncommon view of a man
reading in his study.

engaged, reading books, newspapers and studying
prints. These features constitute the fundamental
theme of Cassatt's *oeuvre*. Women in her paintings
rarely look out of the picture or meet the gaze of the
viewer; they are absorbed in their own activities. This
is even more remarkable in those subjects that reflect

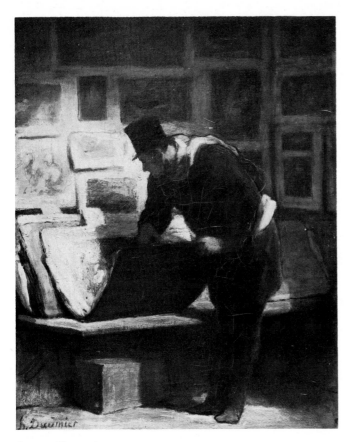

fig. 3 Honoré DAUMIER
The Collector of Prints
Paris, Museé du Petit Palais. 1857–60.
Oil on canvas 40 × 32 cm.

This is but one of many versions in oil,
watercolour or lithography of a favourite
theme of Daumier's, the lover of prints. It has
been suggested that one notable *amateur,* the
poet Baudelaire, inspired the series which
commemorates the growing interest in popular
and graphic art in the period. Cassatt's image
(Plate 6), however, has a more personal and
intimate quality.

the more commonplace occupations of the bourgeoise
such as crocheting (Plate IX), embroidering (Plate 19),
knitting (Plates 14 and 15) and taking tea and visiting
(Plate X), which form the major part of Cassatt's work
in her early maturity, from the mid-1870s to the mid-
1880s.

One other activity of the middle-class woman's life
which took her outside the home was theatre-going,
a motif that often attracted Cassatt as it had her
new friends in the Impressionist circle. Impressionist
iconography was deeply influenced by the call for
painters of modern life made by writers throughout the
nineteenth century, but most famously by the poet
Charles Baudelaire who published a seminal essay in
1863 entitled 'The Painter of Modern Life'. The novelty
of the life of a large city, with its fashionable and arti-
ficial high society jostling depths of degradation and
ugliness, called on painters to record for posterity its
particular character and demanded new styles to cap-
ture the essence of modernity. Manet, Degas and Renoir
turned to public entertainments for inspiration, where
the glitter of fashion shone under the artificial lights of
the theatre.

From 1872 onwards Cassatt regularly exhibited in
the Salon portraits of fashionable women or figure
studies, whose distinctive Spanish flavour and bold
brushwork (Plates I and II) suggest a debt to the art of
Edouard Manet. At the Salon of 1874 she showed a
Portrait of Mme. Cortier (Plate 5) which elicited from
Edgar Degas an admiring comment, 'C'est vrai.
Voilà quelqu'un qui sent comme moi' ('It is real
[true, genuine]. There is someone who feels as I
do'). In 1877 Degas was introduced to Cassatt by
Joseph Tourney, who had met her in 1873 in Antwerp
where they were both studying the art of Rubens. At
this meeting Degas invited Cassatt to join the inde-
pendent exhibiting society which had been founded in
1874 and whose members had become popularly
known as the Impressionists. In 1913 Cassatt told her
biographer of her response:

It was at that moment that Degas persuaded me to send no more
to the Salon and to exhibit with his friends in the group of Impres-
sionists. I accepted with joy. At last I could work with complete
independence without concerning myself with the eventual
judgement of a jury. I already knew who were my true masters.
I admired Manet, Courbet and Degas. I hated conventional art.
I began to live. (quoted by Segard, 1913, pp. 7–8)

She first exhibited in 1879 with this group which was
renamed 'Un Groupe des Artistes Indépendants,
Réalistes et Impressionistes' (A Group of Independent,
Realist and Impressionist Artists) showing two works,
The Cup of Tea of 1879 (New York, Metropolitan
Museum of Art) and *Lydia in a Loge, Wearing a Pearl
Necklace* of 1879 (Plate 8). The latter's bright and
luminous colour and fluent brushwork with its quint-
essentially modern subject placed her immediately well
within the Impressionist group and compositionally
recalls *The Loge* (fig. 4), which Pierre-Auguste Renoir
(1841–1919) had sent to the First Impressionist Exhibi-
tion. *Lydia in a Loge,* one of her first paintings set in a
theatre, is, however, unsatisfactory in many ways
despite the seductive sureness of her brushwork and
dazzling treatment of the pale transparent flesh tones.
Renoir's painting is successful because there is an under-
lying identity between the subject, the spectacle in the
theatre which the woman is watching, and the image,
the spectacle the woman herself offers to the appre-
ciative viewer outside the painting. In Cassatt's painting
there are contradictions, for instance between the lack
of engagement of the woman with spectator, through
the shading of her face and the direction of her gaze,
and the sensuous treatment of pink silk and pearly skin
to which we are drawn by the liveliness of the brush-
work. A pastel portrait of *Lydia Leaning on her Arms,
Seated in a Loge* of c. 1879 (Plate 9), possibly related
to the oil, is, however, a far more coherent image
with fewer distractions and inconsistencies. The mirror
here reflects only the back of the figure, complementing
the frontal view and creating a sense of the figure's

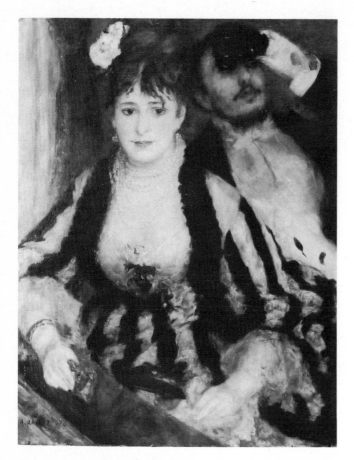

fig. 4 Pierre-Auguste RENOIR
The Loge
London, Courtauld Institute Galleries. 1874.
Oil on canvas 78·7 × 62·5 cm.

The woman herself is the true centre of this
painting. Her figure fills a large part of the
canvas and her dress and overall appearance
received most detailed work. But it is Woman
as object of vision that Renoir created and
everything in the painting reinforces certain
notions of feminine appeal. The obvious beauty
of this painting serves to underscore the
traditional notion of Woman and its 'natural-
ness' reveals the difficulties facing a woman
artist who attempts to change the un-
questioned canons of artistic representation of
Woman.

wholeness. There is an overall material consistency in
the web of pastel strokes, unifying all the textures and
features, while the immaterial and psychological
activity of the attentive woman is conveyed by the pose,
Lydia leaning forward on her arms and clasping her
hands, which underlines the direction of her gaze out of
the picture and away from the viewer. The display of a
woman as spectacle gives way and instead private
mental activity dictates the meaning and unity of the
painting, as in the series of pictures of women readers.

The strongest and wittiest of Cassatt's series of loge
scenes, in which her original contribution to this motif
is most apparent, is *Woman in Black at the Opera* of 1880
(Plate VIII) The black figure in the foreground serves as
a *repoussoir* into the auditorium where the smaller
figures, also dressed in black, punctuate the surface and
link back to the young woman with her opera-glasses.

But as one follows the direction of her gaze through
them to look across the surface of the painting, one
notices a man leaning prominently out of his box to
train his opera-glasses on her. The idea of woman as
spectacle and viewer as spectator, which is implicit
in Renoir's *The Loge* and which I suggest Cassatt's
series begins to question, is made explicit in this work
by inscribing a male viewer into the painting itself,
while the woman is sublimely unaware of the fact that
she is the object of his gaze, for her own consciousness is
powerfully asserted in pictorial terms by her colouristic
dominance and her structurally decisive pose at a
right angle both to the male spectator within and to the
viewer outside the painting.

In 1882, Cassatt returned to the theatre motif with a
painting *Two Young Ladies in a Loge* (Plate XIII), for
which several preparatory studies exist (Plate 21).
The models were Geneviève, the young daughter of the
poet Stéphane Mallarmé, and a Miss Mary Ellison
whose portrait Cassatt had painted c. 1880 (Plate XI).
The stiff and formal poses of two girls on the brink of
womanhood and society, one carefully clasping an
unwrapped bouquet, the other sheltering behind a
large and opened fan, both tensely aware of the desire
to appear adult and lady-like despite any excitement
inherent in the novelty of theatre-going, reveals
Cassatt's profound capacity to comprehend and portray
the character, nuance and feeling of different stages
of women's lives. For an equally perceptive portrayal
of old age one need only look at her later portrait of
her mother c. 1889 (Plate 26). Renoir also painted an
adolescent girl in his charming *The First Outing* of 1875–
76 (fig. 5), delighting in the lively excitement of the
young girl. Her snub-nosed profile and open lips are
engaging and pretty. Cassatt's version is solid, hard-
edged and rigorously free from any prettiness. Her
draughtsmanship is evident in the preparatory drawing
with its economical and pure line, clean contours and
subtly modelled features that underpin her most
painterly canvases. The delicacy of feature and
beautiful forms of the drawing are coarsened in the
oil from which all sentimentality or superficial charm
has been excised. Pure sensual appeal is sacrificed to
solidity of form, through which the elusive quality of
psychological states is realized. All the trappings of the
age, class and sex of these two fashionable young women
are portrayed with contemporary realism and factual
accuracy, but they do not determine the nature of the
image. Instead they throw into relief the unusual
seriousness and the subjective consciousness of etiquette
and social convention that Cassatt alone of the
Impressionists perceived and portrayed in young
womanhood. Cassatt did not, therefore, ignore the
traditional attributes of femininity, of costume and
fashion located in the drawing room, the secluded
garden or the loge of a public theatre, but rather trans-
formed them, by marrying to the iconography of

fig. 5 Pierre-Auguste RENOIR
The First Outing
London, National Gallery. 1875–76. Oil on
canvas 63·7 × 49·4 cm.

While the subject invites comparison with
Two Young Ladies in a Loge (Plate XIII), the
composition offers parallels with *Woman in
Black at the Opera* (Plate VIII). The differences
between Cassatt and Renoir can be observed
most notably in technique. Renoir's superb
manipulation of colour and skilful use of
glazes give a lightness and feminine prettiness
which accord with his conception of Woman.
Cassatt instead used the bold colours and
strong contours of Manet and by employing a
style so opposed to Renoir's prettiness she
challenged the notion of Woman offered by
Renoir's theme and treatment.

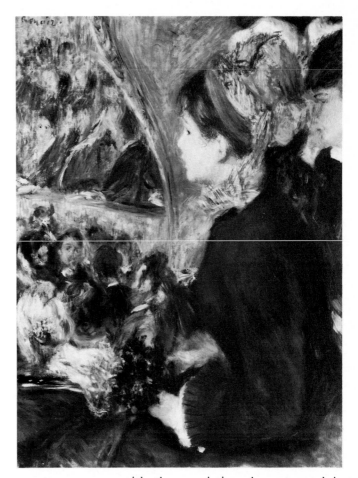

woman, both historical and in contemporary art, with
its play on external accessories and sensual charms, the
intellectual or rather inner world of thoughtful re-
flection and subjective identity, traditionally reserved
for representations of men.

III

IN CASSATT'S WORK there are no more than a mere
handful of portraits or figure studies of men. Apart
from six portraits and sketches of her father and ten of
her closest brother Alexander, there are only three
realized male portraits, an oil, *Portrait of Marcellin
Desboutins* of 1879 (United States of America, private
collection), and two pastels, *Portrait of Moyse Dreyfus*
of 1879 (Paris, Musée du Petit Palais) and *Portrait of
M.O. de S.* of c. 1909 (Paris, private collection), as well
as a few odd sketches. One simple explanation for this
vast disproportion is that social convention made
it unsuitable for a woman to be alone in a studio
with a male model except, of course, when the man
in question was a close family relative, which ex-
plains the greater number of portraits of her father
and brother. Furthermore, most woman artists were
denied access, on account of propriety and decency, to
the male nude except in plaster casts and thus had
little sound knowledge of the male figure. Cassatt's
contemporary and fellow Pennsylvanian, Thomas
Eakins, was dismissed from the staff of the Pennsylvania
Academy of the Fine Arts, where Cassatt herself had
studied between 1861 and 1865, for removing the loin
cloth from a male model during a mixed anatomy
lecture. Yet the fact that the portraits of Desboutins
and Dreyfus were both painted in 1879, when Cassatt
worked in her own studio outside the family home,
suggests that these conventions could in fact be over-
come.

It has been argued that the small number of male
subjects in her works resulted from her inability to
portray a man with the conviction she conveyed in
images of her own sex. To some extent the pictures
themselves support such an assertion, for they are often
incomplete and wooden, but the relative insignificance
of her male *portraits* is due more, perhaps, to the fact
that she was not primarily a portraitist but a figure
painter. In her figure studies which include men no lack
of force can be observed. For instance the 1873 *Toreador*
(Plate 4) is such an image, with strong colour con-
trasts of red tie and cape and the blue and silver
embroidered jacket, while for unrelieved boldness,
physical strength and truth-to-type the image of the
boatman in *The Boating Party* of 1893–94 (Plate
XXVIII) is unmatched, with the clear contours and
vigorously painted face in *profil perdu*.

The lack of representation of men in Cassatt's
oeuvre can be viewed from yet another perspective. Her
sex and her class placed firm restrictions on her
knowledge of the world of men. Despite some friend-
ships with artists like Edgar Degas and familiarity
with her retired father or visiting brothers, she lived
apart from any close or daily contact with the worlds
that men of her class occupied in the public spheres of
business, the professions or government and she was
absolutely cut off from the lower haunts of men of all
classes in the streets of Paris and in its cafés and brothels.
An illuminating parallel with Cassatt's situation as an
artist is the novelist George Eliot whose position
Virginia Woolf analyzed in her essay on women and
fiction, *A Room of One's Own* (1928):

George Eliot escaped [the cramped life of a clergyman's daughter's sitting room] after much tribulation, but only to a secluded villa [the Priory] in St John's Wood. And there settled down in the shadow of the world's disapproval . . . One must submit to social convention and be 'cut off from what is called the world'. At the same time, on the other side of Europe, there was a young man living freely with this gypsy or that great lady; going to wars; picking up unhindered and uncensored all that varied experience of human life which served him so splendidly later when he came to write his books. Had Tolstoy lived at the Priory in seclusion with a married lady 'cut off from what is called the world' however edifying the moral lesson, he could scarcely, I thought, have written *War and Peace*.

But despite these very real and too often unrecognized limitations on a woman's experience of the world in which men passed so freely, there is a positive side to this particular coin, for Cassatt knew the world of women, the drawing room and child-bearing as few men in that period could have done, a dimension perceptively recognized in 1881 by the contemporary critic J.-K. Huysmans who stated:

For the first time thanks to Miss Cassatt, I have seen the likenesses of ravishing children, quiet bourgeois scenes painted with a delicate and charming tenderness. Furthermore one must repeat, only a woman can paint infancy. There is a special feeling that a man cannot achieve . . . only a woman can pose a child, dress it, adjust pins without pricking themselves . . . This is family life painted with distinction and with love . . . She achieves something none of our painters could express—the happy contentment, the quiet friendliness of an interior. (quoted by Hale, 1975, pp. 103-04)

Behind Huysmans's effusion lurks a sentimental tendency and the seeds of the disease of the 'special category' for womanly subjects and for woman artists that has distorted their work and reputation. But it does contain a grain of truth. Cassatt knew the 'bourgeois interior' and rarely presumed to paint what her class or sex determined that she should not know, a fidelity to the experience of class and sex not shared by the majority of male artists.

IV

IF THE ADULT male is conspicuously absent from Cassatt's *oeuvre* small boys and male infants are clearly not, for the male occurs as often as the female in Cassatt's representations of childhood. However, it would seem that Cassatt did not really emphasize sexual differentiation in the very young. The very young child seems to function in Cassatt's work not only as a miniature version of adult masculine or feminine rôles but can also be read as a symbol or an analogy for the art of painting itself.

Cassatt's treatment of the child and mother elicited this comment from an early biographer, Edith Valerio (1930):

Mary Cassatt was not married, she was never a mother, and yet, there are few women painters, and scarcely any men who have interpreted maternity, and early childhood in a language so

authentic, so right, so accurate and so moving. She understood and expressed those beauties whose meanings are obscured from most mothers. The gestures, the movements which characterize earliest childhood, this slow discovery of self, of these faculties that are still untested by the world around it Mary Cassatt rendered with unequalled charm.

That charm has often obscured the more rigorous and truthful observations Cassatt made of the process of personal development as the immature, dependent and physically undeveloped baby progresses towards becoming a separate and self-conscious individual. Max Raphael in an essay 'The Struggle to Understand Art' makes a statement on the nature of art which suggests that creative activity concerns a similar process of becoming. He writes, 'It is the nature of the creative mind to dissolve seemingly solid things and to transform the world as it is into a world process of *becoming* and *creating*' (author's italics). Cassatt was, as Valerio pointed out, neither wife nor mother, despite her own assertion late in life that these rôles were women's vocation. She was a painter, creating cultural artefacts instead of performing the procreative act, yet as one of the main themes of her creative work she turned to the image of mother and child, the epitome of the vocation she had forsworn, which is also the moment of new lives and new identities, states of becoming and creating which her evolution as an artist in her paintings and her activities paralleled in the cultural rather than natural or biological sphere and in doing so she radically transformed the theme of maternity.

This image, so deeply rooted in Western culture in its traditional form of Madonna and Child, evolved slowly in Cassatt's *oeuvre* and indeed she may never have consciously perceived the full implications of what she produced. However, her participation in the Independent movement after 1879, with its programmatic search for thoroughly modern subjects and a novel style of painting to convey modern sensibility, provided the necessary impulse for such a departure from tradition. Both Segard and Breeskin emphasize (p. 7) the central importance of mother-and-child paintings, which have become her most famous motif. That may further account for her neglect, for one asks cynically how could a painter of apparently so familiar a subject, so traditional a theme, who repeatedly reworked the motif in the second half of her career, bear comparison with the radical innovations of Degas, Manet or Toulouse-Lautrec, who brought absolutely new subjects into the history of painting. However, Cassatt's mothers and children illustrate superbly the two-sided coin of women's art. Although she was restricted by social conventions to models from the life of bourgeois women and children around her, she nonetheless used the everyday happenings of family life to forge her most significant achievement, a new image of women.

One of Cassatt's earliest recorded paintings is a

pastel of c. 1868, *Two Children at a Window* (Plate 1), which shows a brother and sister locked in a supportive embrace, gazing out of a window into a luminous beyond. The symmetry and interlocking arms of the children cause the boy and girl to fuse into a single mass silhouetted against the light, which disguises the importance of their different sexes. But as the foreground space opens out, the masculine and feminine separate. On the right, behind the little girl, a doll lies in a small cot, while on the boy's side of the room there is a large, adult-sized desk and chair, as disproportionately large as the cot and doll are miniature. Yet the children turn their backs on the symbols of their likely future rôles and look to something outside the homely room.

Cassatt herself looked beyond the domestic rôle which was a probable destiny for any woman of the period and especially for a Pennsylvanian lady of good family and reasonable fortune. Instead, at sixteen, she decided to study art seriously. Painting was, however, one of the acceptable and indeed desirable 'accomplishments' of a middle-class woman as innumerable novels, texts on women's education and the vast number of amateur women painters amply document. A Mrs. Ellis, a prolific writer on the subject of women's rôles and duties sounded a warning, however, in her popular *Family Monitor and Domestic Guide* (New York, 1844) against pursuing any 'accomplishment' further than social necessity demanded:

It must not be supposed that the writer is one who would advocate, as essential to woman, any extraordinary degree of intellectual attainment, especially if confined to one particular branch of study . . . To be able to do a great many things tolerably well, is of infinitely more value to a woman than to be able to excel in any one. By the former, she may render herself generally useful; by the latter she may dazzle for an hour . . .

Cassatt did not heed such advice to develop her interests only to a limited and altruistic degree and enrolled, apparently against her father's wishes, in the Pennsylvania Academy of the Fine Arts, Philadelphia, where she remained from 1861 until 1865, when she set off for Europe to follow her male and female colleagues to Paris to study the techniques of the Old Masters, who were so poorly represented in the United States. Even then Cassatt had a firm conviction of her seriousness, which she light-heartedly explained, while on a sketching tour in France, to her more conventional sister-in-law in a letter of 1 August 1869:

I am here with my friend Miss Gordon from Philadelphia and we are roughing it most artistically . . . [Aix-les-Bains] was too gay for two poor painters, at least for one, for although my friend calls herself a painter, she is only an amateur, and you know how we professionals despise amateurs.

The outbreak of hostilities between France and Prussia in 1870 obliged her to return briefly to Philadelphia, but as soon as that war and the subsequent civil war in France of 1871–72 were over, she sailed for Europe and went to Italy; to Parma, where she concentrated her attention on two masters of the theme of Madonna and Child, Correggio (c. 1489–1534) and Parmigianino (1503–1540). The style of Correggio, a native of Parma, anticipated the Baroque and is said to have influenced eighteenth-century French art, which can be cited as a source for French Impressionism. From Correggio, Cassatt learnt to admire both solid draughtsmanship of true line and the luminous and suggestive colour which the Italian artist had combined in moving but sophisticated compositions of the Madonna and Child. In Parmigianino's Madonnas and children she studied complex compositions of elongated figures in elegant poses. Of this period in Parma Cassatt told Mrs. Havemeyer:

I felt I needed Correggio and I went to Parma. A friend went with me. She did not remain but I stayed there for two years, lonely as it was. I had my work and a few friends I had made. I was so tired when my work was done that I had little desire for pleasures.

She did not, in fact, stay two years, but her comments illustrate the way in which she planned her education, following its dictates across Europe. Her study of Correggio and Parmigianino was complemented by a sojourn in Spain in 1873. In Seville and Madrid she looked at the work of Velázquez and in Madrid she also studied Rubens, seeing more of his pictures during a trip to Antwerp. Rubens's lush Madonnas and chubby children provided yet another confirmation of her interest in this type of composition, while Velázquez's treatment of children in, for instance, *Las Meninas* (Madrid, Museo del Prado), explores a quite different aspect which Cassatt later developed, that of the juxtaposition of childishness and adult artifice.

After an initial interest in children in her paintings of the late 1860s and early 1870s, Cassatt turned, as has already been shown, to figure paintings of mature women in scenes from modern life. A visit to Paris in 1880 by her brother Alexander with his young family provided an opportunity to study and paint children from life and possibly reawakened in her memories of what she had learnt from the Old Masters in her travels through Europe earlier in the decade, but which she had put aside to study and work with contemporary masters, such as Courbet, Manet and Degas. One of her first renderings of the mother-and-child motif was executed in 1880, *Mother about to Wash her Sleepy Child* (Plate XII), in which some of the many threads of her career come together, childhood and womanhood and the stylistic influence both of the Old Masters and of the new avant-garde.

The child sprawls loose-limbed on the mother's broad lap but is held firmly in place. The direction of its body forms an opposing diagonal to the pose of the almost massive mother, who is contained by the solid frontal rectangle of the chair which her right arm breaks into, while the frame in turn cuts across her arm preventing any simple symmetrical reading of the painting. The opposing postures of the figures'

bodies are counterbalanced by the closeness of their heads and the interlocking gaze of mother and child, which, significantly, breaks with the usual self-containment and self-absorption of Cassatt's female figures. The mother's gaze, which is so often turned away from the spectator in Cassatt's pictures, is here directed towards her offspring, whose overwhelming sleepiness is subtly conveyed by the vagueness with which the paint was applied to its face. The breadth of handling, the large areas of white touched with blue, yellow and pink, so beloved by the Impressionists as a demonstration of their theories of reflected and mutually modifying colours, the Rubenesque carmine outlines of the figures still apparent beneath the layers of paint and the directional brushwork more often associated with her contemporaries here achieve a stylistic synthesis. Furthermore the dynamic but monumental composition can be compared to Cézanne's portraits of Mme. Cézanne; for instance *Mme. Cézanne with a Fan* of 1879–82 (Zürich, collection of Emile Bührle). Cassatt admired Cézanne very early and bought his paintings, but he is rarely mentioned in relation to her work. Yet the comparison is illuminating. In her images of mothers and children, Cassatt used solid, balanced structures and insistent physicality of paint to capture what is most elusive, the most momentary glance, gesture or movement. This synthesis of the immediate and the instantaneous with the permanent and the monumental, which Cézanne sought to achieve in painting the infinite variations of nature's constantly changing appearance, can be found in this early rendering of a child's daily bath.

In a painting of 1889, *Emmie and her Child* (Plate XXI), Cassatt initiated her great phase of treatments of the maternal theme, a subject which she had only infrequently reworked in the intervening decade. Close dependence and security are conveyed by the binding gestures of the hands. Here mother and child do not look at each other, but are linked by the physical bond created by the child's hand on the mother's face while she firmly grasps its small limb. The unfinished state of the canvas provides an opportunity to study Cassatt's working method. Over a warm beige ground broad areas of colour were laid, moving from dark to light, a technique associated with Old Master processes. The dress, which in its completed parts is white with a red pattern, was painted over a layer of unexpected blue, a colour which gives resonance to all colours affected by it, while touches of red with its characteristic warmth and liveliness suggest a thorough study of Rubens's procedures in particular. But in the contrast of the unfinished and the completed parts of the child's legs the transition from a chaos of colour and arbitrary brushstrokes to fully modelled and realized form can be observed, a transition which unconsciously inscribes into the painting the process of life, both in terms of physical development and of the more psychological passage from the unformed immaturity of the infant to a distinct, separate and conscious individual. The physical closeness of the child itself to its mother is contrasted with the look of private reverie as it caresses its mother's face. That gesture recurs in a pastel of 1891, *Baby's First Caress* (Plate XXII). Cassatt caught a rarely-portrayed moment, a child's first intuitions of separateness from its mother as it reaches out to examine her as an object distinct from itself. With penetrating insight and sure mastery of her medium and composition she simply and convincingly painted a crucial moment in a child's development, in its becoming a separate person while still profoundly dependent both emotionally and physically; a state that is represented pictorially by the languid and lolling pose of the infant in the lap of the mother, whose large adult hand tenderly holds his pale, soft-skinned foot.

The nude and clearly male baby with its mother, its plump healthiness and her charming sweetness, focus attention on the question of these images as a secular and contemporary form of Madonna and Child. Degas's reaction to the oil painting *The Oval Mirror* (Plate 49) was reported by Cassatt to Mrs. Havemeyer:

When he saw my *Boy Before a Mirror* he said to Durand-Ruel 'Where is she? I must see her at once. It is the greatest painting of the century.' When I saw him he went over all the details of the picture with me and expressed great admiration for it, and then, as if regretting what he had said, he relentlessly added, 'It has all your qualities and all your faults—it is the Infant Jesus with his English nurse.'

Indeed, the structure of the painting comes closest to the religious compositions of Parmigianino. Achille Segard went so far as to suggest the alternative title *The Adoration* for the exquisite pastel *After the Bath* (Plate XXXI), but in the complex articulation of the three figures across the frieze-like composition it is the structure of a Parmigianino mother-and-child painting that is suggested rather than the underlying ideology.

Any profound association with Christian tradition is negated by the important fact that Cassatt as often painted mothers and daughters, a subject which has no prototype in religious iconography but looks back to the eighteenth century when the distinctly secular and bourgeois celebration of family life and domestic happiness was elaborated as a subject both by figure painters like Greuze in *The Beloved Mother* of 1795 (Paris, De Laborde collection) and by portraitists, a fine and relevant example of which is Elisabeth Vigée-Lebrun's *Portrait of The Artist and her Daughter* of 1789 (fig. 6). Some of Cassatt's pastels of mothers and daughters, such as *Marie Looking up at her Mother* (Plate 43) and *Pensive Marie Kissed by her Mother* (Plate 44), both of 1897, do have a touch of that sweetness and intimate charm characteristic of the eighteenth century and of Vigée-Lebrun in particular, but one should not underestimate the undeniable, if at times uncomfortable, appeal of such pastels, which in many ways faithfully convey

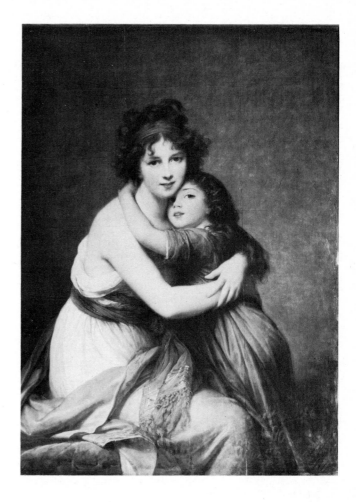

conventional notions of the sweetness of the ideal little girl. Cassatt has unjustifiably been accused of senti-mentality and prettiness in pastels such as these two of 1897, yet *Marie Looking up at her Mother* shares a com-positional structure of interlocking figures and opposing diagonals with the more monumental *Mother about to Wash her Sleepy Child* (Plate XII) and *Pensive Marie Kissed by her Mother* is as subtle a portrait of a child as *Baby's First Caress* (Plate XXII).

In two oil paintings of the 1890s, Cassatt, with refreshing directness and authenticity, showed a less conventional idea of little girls. Both *The Bath* (XXVII) and *Breakfast in Bed* (Plate 42) have the vigour of her fully mature style, which had developed from her bold use of flat colour and design in coloured aquatints of 1891 (Plates 31–39, XXV, XXVI). In the former painting, an awkward, plain little girl with her infantile plump body and childish, straight limbs is bathed by a business-like mother and the structure of interrelating forms conveys the maternal relationship rather than any superficial appeal to the viewer's sentiment. *Breakfast in Bed* (Plate 42) is perhaps even less redolent of sentimen-tal connotations. The solid, square form of the bedstead, which echoes the frame of the painting itself, is crossed by the strong diagonal of the soporific woman whose firm grasp round the upright, alert and independent figure of the child gives the whole canvas a satisfying stability. Yet the construction of the painting sets up a number of significant oppositions; squares and diagonals, verticals and horizontals, cool and warm tones, active and passive moods, which signify a shift from a simple maternal theme to a use of child-opposed-to-adult to convey a thematic contradiction of youth and maturity, which every pictorial device serves to reinforce. In a discussion of the Madonna-and-Child debate in Cassatt's work Margaret Breuning (1944) emphatically stated:

She [Cassatt] sought no symbolism, but the poignant expression of the relation between Mother and Child, the affecting contrast between the mature figure and the immaturity of childhood. The physical basis as well as the psychological basis of the relation s stressed with an objectivity that reflected her own nature.

The common notion that Cassatt reworked the religiously symbolic icon of Madonna and Child can be replaced by the idea that she used the child and its parent to express, instead, a sense of the phases of family life, an assertion already suggested by the

discussion of Cassatt's figure paintings of the early 1880s, the comparison of *Two Young Ladies in a Loge* of 1882 (Plate XIII) with the *Portrait of Mrs. Cassatt* of c. 1889 (Plate 26). This becomes clearer when consider-ing the series of paintings and drawings of girls executed in the 1870s and 1880s. In the pastel of c. 1868, *Two Children at a Window* (Plate 1), a little girl is set beside her cot and dolls, an association that is made explicit in a drawing of 1876, *Little Girl Holding a Doll* (Plate 7). A painting of her Impressionist period, *Girl in a Blue Armchair* (Plate VI), presents a completely novel and honest treatment of the ungainliness of a child, culled from observations of young children and incorporating the expressive innovations of composition to which Degas's work introduced Cassatt in the 1870s (see fig. 7). Indeed Degas actually worked on this painting as Cassatt later told the dealer Ambroise Vollard:

I did it in '78 or '79. It was the portrait of a child of a friend of M. Degas. I had done the child in the armchair and he found it good and advised me on the background and even worked on it. I sent it to the American section of the Exposition [1878], they refused it . . . I was furious, all the more so, since he had worked on it. (quoted by Sweet, 1966, p. 29)

In the painting, one is precipitated abruptly into the space because the frame cuts off the lower edges of the armchairs, but one views the room from a high view-point so that the upper limits of the frame also cut off the tops of the background sofas. Such devices indeed owe much to Degas, but here they function to create a

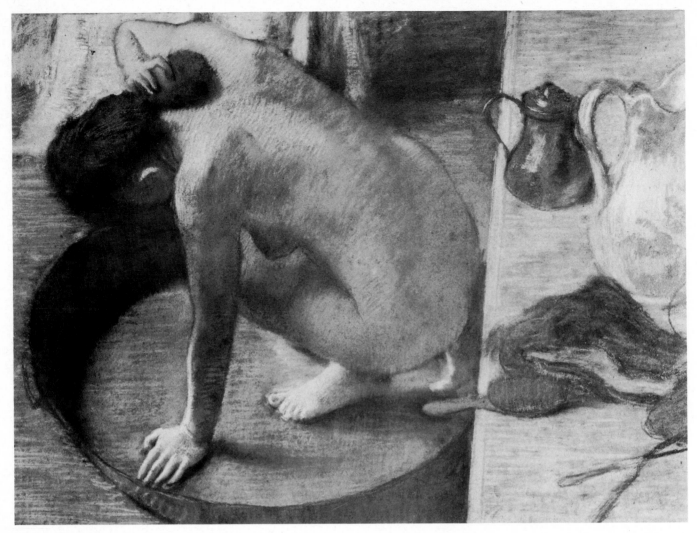

fig. 7 Edgar DEGAS
Woman Washing herself in a Tub
Paris, Musée du Louvre. 1886. Pastel on
paper 60 × 83 cm.

Degas was recognized as an apostle of
modernity by writers of the time for his choice
of subjects, laundresses, milliners, ballet
dancers and café performers. However, in the
series of women washing themselves, seen as
through a keyhole, one may read a contem-
porary transposition of the age-old voyeurism
inherent in the story of Susanna and the
Elders. Despite the brilliance of technique and
format developed in this series, Degas still saw
women as objects of vision and he admitted
later in life that perhaps he had considered
women too much as animals.

pictorial structure which conveys incompleteness,
awkwardness and disproportions of scale, notably in the
menacing fullness of the furnishings in this compacted
space, all of which correspond with the treatment of the
child herself who sprawls languidly and inelegantly on
the chair, while her smart outfit and bored expression
reflect Cassatt's grasp of her character. The picture is
not only of a child, but its perspective and scale suggest
a child's own view. Cassatt thus achieved a complete
identity between the meaning of the work and the
pictorial means themselves. A younger girl is set
beside Lydia, one of the models for the artist's paintings

of adult women of this period, in a painting of the same
period, *Woman and Child Driving* (Plate VII), which is
equally typical of Cassatt's style at this time. The three
figures, including the young groom, are all self-
contained and separate in their own preoccupations.
The child's face is especially remarkable. In the
depiction of Lydia, Cassatt emphasized the characterful
features of the mature woman, underplaying her eyes
with the shadow cast by her fashionable hat, while her
young companion's face appears soft, fleshy and un-
formed beneath the subtly modulated pale tones of the
paint, out of which her bright eyes emerge with striking
force.

However by 1896 Cassatt's closeness to Impression-
ism and its masters changed to a style of more overtly
structured compositions and clearly defined application
of flatter and more solid areas of colour. Both tend-
encies are evident in the painting *Ellen Mary Cassatt in a
White Coat* of 1896 (Plate XXX). A tiny figure perches
almost regally in a huge, square armchair whose
rectangles are repeated and varied in the bold borders
of the white coat. The model is the same as the child in
Breakfast in Bed (Plate 42), but the alert and semi-nude
form in the latter work is, in the former, virtually
encased and effaced by her smart costume from which
the only hints of the child, the steadying hands and

16

rigid feet, emerge with an unaffected simplicity which in turn contrasts with the almost adult seriousness of her face. John Bullard suggests a source for this painting in Velázquez, whom Cassatt had studied in her youth, in particular his *Portrait of the Infanta Margherita Teresa* (fig. 8). Such a comparison is appropriate since both Velázquez and Cassatt juxtaposed the immature and the childish with the overlay of restrictive clothing prescribed by class and social convention.

The reconsideration of the theme of mothers and children exposes the central theme of Cassatt's *oeuvre* as phases of womanhood. Cassatt thus produced a series in which the artist examined what might be called the seven ages of women: infancy, childhood, adolescence, young womanhood, maturity and old age, a cycle which begins again with maternity, which thus has a central place within the sequence. But it would be a mistake to see such a series as a purely abstract or philosophical exercise, for as I have tried to show the forces that condition the nature of the phases of women's lives, which Cassatt as a middle-class woman of her time knew well, are of social and psycho-social origin. As Simone de Beauvoir wrote in *The Second Sex* (1949):

One is not born, but rather *becomes* a woman. No biological, psychological or economic fate determines the figure the human female presents in society; it is civilization as a whole that produces this creature . . . which is described as feminine [author's italics].

One final painting, executed later in her career c. 1905 and entitled simply *Mother and Child* (Plate XXXII), brings together all the threads of Cassatt's programme as an artist and the stylistic means developed within the Impressionist and Post-Impressionist periods of French art in order to reveal that process. It is a picture of enormous complexity and internal oppositions, which synthesizes the elements of the vocabulary of forms and meanings Cassatt had evolved throughout her career before encroaching blindness incapacitated her painting.

In this painting the mother in her fashionable finery is opposed to the unadorned nudity of her daughter. The nude had been one of the most important forms of classical, Renaissance and post-Renaissance art, and knowledge of anatomy, on which the painting of the nude is based, was an essential prerequisite for any artist who aspired to the serious pursuit of the most elevated and respected form of High Art, the history painting. However, by the mid-nineteenth century the conviction of classical art dissipated and Charles Baudelaire, the theorist of 'modernity', had argued, in 'The Painter of Modern Life' (1863), for new treatments of the human figure which would show it nude only in places and positions in which it was so to be found in actual life as, for instance, in bed or in the bath. As a woman, Cassatt was in no position to study the nude in either a classical or a contemporary form. None

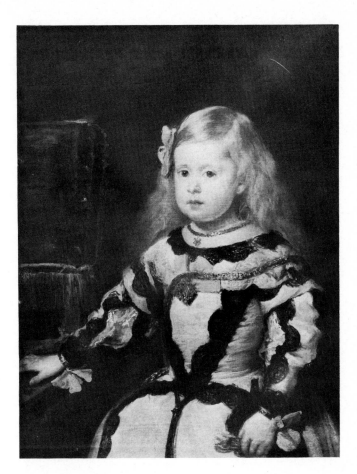

fig. 8 Diego VELÁZQUEZ
Portrait of the Infanta Margherita Teresa
Paris, Musée du Louvre. c. 1653. Oil on canvas 126·3 × 98 cm.

There is a remarkable similarity between this work and Cassatt's portrait of a child (Plate XXX), not in direct stylistic or compositional equivalences so much as in the contrast of scale and costume and the panoply of regal or class accessories with the subtle evocation of childishness. The realist convention in the hands of Velázquez, Manet or Cassatt did not depend on realistic portrayal, but rather on the use of pictorial elements to liberate obscured social meanings.

the less she seems to have found a way by turning to the infant nude, with its even more taxing problems of conveying implicit anatomical structure beneath the overlay of immature fleshiness and an undeveloped physique. In *Mother and Child* the image of the nude child after a bath, which Cassatt had so often portrayed in the 1890s, is infinitely more serious and monumental by virtue of its explicit juxtaposition with the clothed adult, which creates once again the polaritis of innocence and freedom opposed to artifice and convention.

A further layer of meaning is suggested by the mirror, a device which Cassatt, like Degas and Manet, had used so frequently to elaborate the spatial organization of a painting or to include the spectator by reflecting the space in which the viewer stands. However, in this work the mirror's shape echoes within the picture that which the frame of the painting itself presents to the viewer. This device, while referring to the reflective,

looking-glass idea of painting, actually subverts the idea of a picture as a reflection of reality by explicitly including within the painting a mirror which offers another view of the same subject on the reflection of its plane. The mirror, possibly derived from Japanese prints (fig. 11), also recalls the use the Old Masters made of the device and a particular link can be established between the nude and the mirror, on the one hand, and Velázquez, whose *Rokeby Venus* (fig. 10) springs to mind. This reference points to another iconographic tradition, that of Vanity, traditionally represented by a nude woman gazing at her own reflection in a mirror (fig. 9). In using the nude and the mirror, Cassatt again profoundly transformed yet another of the long-standing images of women in European iconography.

The mother, dressed in garments that befit her class and age, holds out a mirror to her nude daughter who looks away from the viewer, as do so many of Cassatt's women, and gazes at her own reflection in the mirror. I have previously discussed the way in which Cassatt perceived and captured in paintings those ephemeral but truly significant moments in a child's development towards a sense of its own personal identity. Jacques Lacan has elaborated the psychoanalytic theory of infantile psychological development by introducing 'the mirror phase'. At this stage the child perceives its own reflection in a mirror and inevitably can only recognize that novel image as Other than itself. A child which has hitherto experienced itself only as a part of the world around it, and specifically as a part of its mother, sees itself as separate for the first time. In the subtle and puzzled expression seen in the small mirror, this painting seems an unwitting document of this decisive phase.

However, the image that is reflected in the mirror is neither consistent in perspective nor truthful as a mirror image. Such an inaccurate effect can also be found in Japanese prints (fig. 11). The effect of this distortion is twofold. It presents the viewer more directly with the reflected image, thus breaking the hermetic quality typical of Cassatt's faces and suggesting a greater involvement of the artist herself. Secondly, it gives the mirror image the appearance of a miniature, of a close-up snapshot portrait. In this way the *smaller* mirror also acts as a commentary on the nature of painting.

Furthermore, although the mirror phase is experienced by children of both sexes it is of particular relevance to the female child, whose notion of self in our society is much more narcissistically related to how she appears, how she is seen. As John Berger has written in *Ways of Seeing* (1972), 'men act and women appear':

To be born a woman has been to be born within an allotted space, into the keeping of men. The social presence of women has developed as a result of their ingenuity in living under such tutelage within such a limited space. But this has been at the cost of a woman's self being split into two. A woman must continually

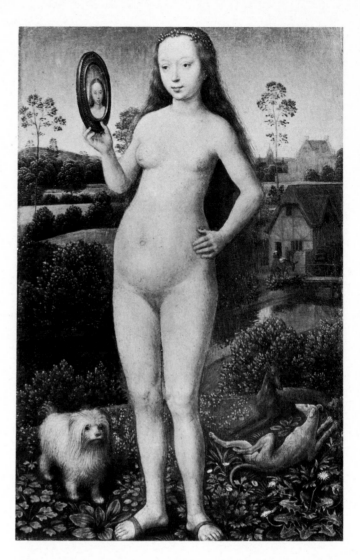

fig. 9 School of MEMLINC
Vanity
Strasbourg, Musée des Beaux-Arts. Oil on panel 22 × 14 cm.

In late medieval Christian iconography Vanity was one of The Vices. It is thought that a woman and a mirror, signifying self-absorption and concern with things earthly and transitory, represented this sin. It is interesting to consider what attitudes make possible such an association.

watch herself. She is almost continually accompanied by her own image of herself . . . And so she comes to consider the *surveyor* and the *surveyed* within herself as two constituent yet always distinct elements of her identity as a woman . . . One might simplify this by saying: *men act* and *women appear*. Men look at women. Women watch themselves being looked at. This determines not only most relations between men and women but also the relation of women to themselves. The surveyor of women in herself is male: the surveyed female. Thus she turns herself into an object—and most particularly an object of vision: a sight.

As a woman painter, Cassatt herself surveyed, observed, analyzed and studied the world in which she was confined. As a painter of women she slowly constructed a body of works depicting women in all the ages and phases of their well-bred lives, which radically questions that very notion of women as spectacle, as an *object* of vision, by the way in which she averted the gaze of her women from the viewer and

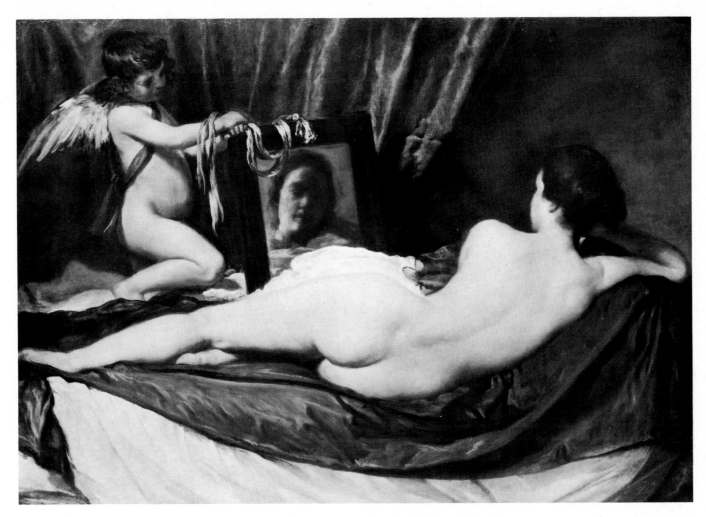

fig. 10 Diego VELÁZQUEZ
The Toilet of Venus
London, National Gallery. c. 1651. Oil on
canvas 122·5 × 177 cm.

Also known as *The Rokeby Venus*, this
painting is a fine though late example of the
association of Woman as Venus with narcissistic
contemplation. The mirror underlines the
exclusively visual character of Woman's
presence in art just as in society. In the
painting the reflected image is vague and it
is clear that it is Venus herself who is offered
to the gaze of the putative viewer.

turned their attention to their own invisible, *subjective*
world, by commenting ironically on the spectacle of
woman and the spectacle of art in her loge pictures, in
Woman in Black at the Opera (Plate VIII) for instance, or
by making women viewers only of their own children and
miniature selves as in the mother-and-child themes.
In this late great work, *Mother and Child*, the radical
implications of her work are most manifest, for she
confronted the issue with absolute fidelity to both
psychological and social reality, by juxtaposing the
immature and pre-social nude child with the future that
lies before her and by presenting her fashionably
dressed mother in the act of initiating her own daughter
into the place in society she herself occupies and which
is her daughter's future. This rich image resulted from
Cassatt's profound study of the Old Masters and of
tradition and from her familiarity with the call for
'modernity' and stylistic innovations of contemporary
art. It is clear, therefore, that her female gender and her
involvement with Impressionism are inseparable
elements in her considerable achievements as an artist.

The two main concerns of this book, to explain her

success and her subsequent neglect, are thus also
intimately related. Because she was a woman artist
she has been overlooked or looked down on. But it is
the very fact that she was a woman that accounts for
her vision and the underlying thematic unity of her
work. She is inevitably obscure to those who do not
recognize women's distinctive contribution within the
history of art as a whole, and it is Cassatt's place
within the history of Impressionism and of American
art that the final section must now consider.

19

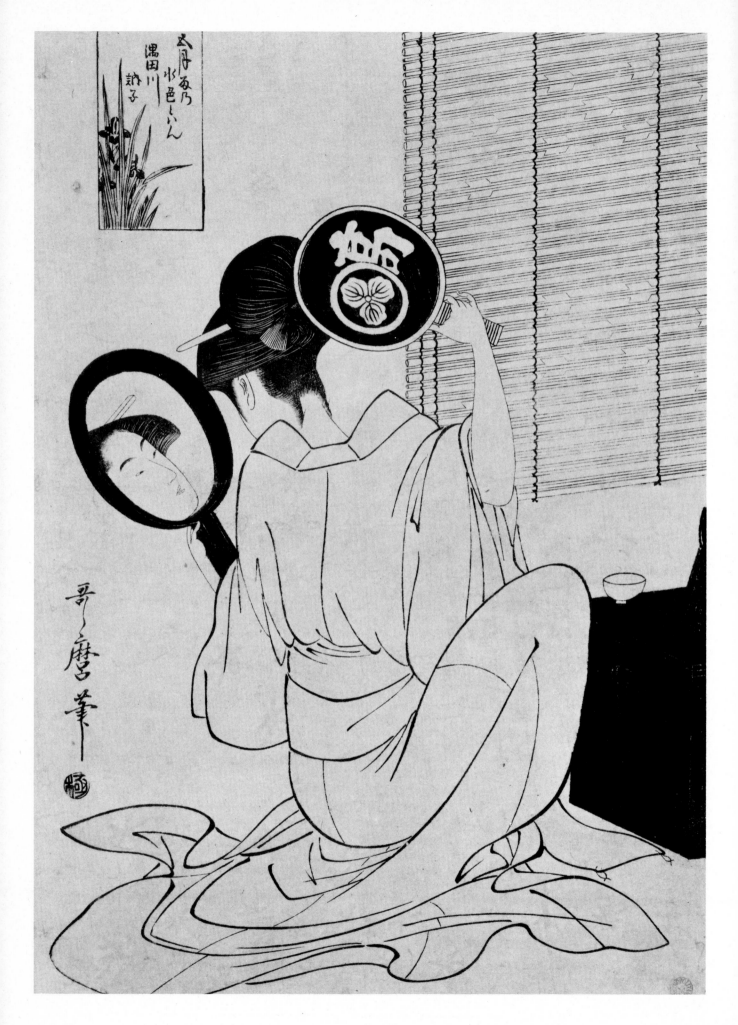

V

IT HAS BEEN necessary to examine at length and in considerable detail the work of Mary Cassatt before attempting to discuss general art historical issues, for without a clear idea of what she was painting it is impossible to answer the question why she became an Impressionist and what her participation in that group reveals about the nature of the movement.

In the nineteenth century, painting was a genteel 'accomplishment' for a middle-class woman. The restrictive prescriptions on women as wives and mothers, economic dependents and intellectual infants were so extreme in that century that they inevitably produced some protest, which appeared in the growth of political feminism and the suffrage movement amongst women both in the United States and Europe. One other form of challenge was to become professional and economically independent and one of the most immediate avenues open to women of that class was to use their 'accomplishment' as a serious career. Furthermore if a move to Europe was necessary for American artists to study original works of art, American women saw it as an escape from oppressive attitudes. In her novels about the plight of women in New York High Society, Edith Wharton (1862–1937) made scathing attacks on American men and contrasted the European woman with her less fortunate American sister. In *The Custom of the Country* (1913) she wrote:

Why does the European woman interest herself so much more in what men are doing? Because she's so important to them that they make it worth her while! She's not a parenthesis as she is here.

As further proof of the direness of American attitudes to women one needs only to quote *The Philadelphia Ledger*, reporting in a brief note Cassatt's return to America in 1898 after twenty-five years of professional work, exhibition and recognition in Europe:

fig. 11 Kitagawa UTAMARO
Woman at Her Toilet Reflected in Hand-mirrors
New York, Metropolitan Museum of Art
(Rogers fund). 1795. Colour woodcut
35 × 25 cm.
This print invites comparison with the subject
of *Woman Bathing* (Plate XXVI) and *The Coiffure*
(Plate 39).

Mary Cassatt, sister of Mr. Cassatt, President of the Pennsylvania Railroad, returned from Europe yesterday. She has been studying painting in France and owns the smallest Pekingese dog in the world.

It is not surprising that Cassatt always stressed her French descent. The artist's insistence on French connections makes sense in terms of her conviction that France had a more enlightened attitude to women's creative work. While French women's achievements in their political and legal objectives lagged far behind the rest of Europe, it is significant for Cassatt's case that much of the most effective protest was made by women in the sphere of their professional work. One can cite George Sand or Séverine, a radical woman journalist and editor of the left-wing paper *Gil Blas*, who campaigned for destitute women in strongly feminist terms but refused to become involved in the agitation for the vote until 1914, because she believed that women should achieve equality by example and accomplishment.

But while Cassatt came to Europe to escape the parochial and confined life of a Philadelphian lady, she did bring with her certain useful characteristics of that culture. Barbara Novak (1969) characterizes American art of the period as predominantly 'conceptual' and 'linear' and firmly places Cassatt's Impressionism within an American framework:

This adherence to the integrity of local colour and unfractured shape characterises most American attempts at French Impressionism in the last decades of the nineteenth century. The works of that . . . famous expatriot Mary Cassatt give ample confirmation. Even if we recognise that Cassatt's mentor . . . was the most linear and conceptual of the Impressionists, the fact remains that Cassatt made impressionism weightier and more solid, rarely allowing light and colour to disintegrate form. Indeed contemporary French critics were astute enough to realize that 'she remains exclusively of her people'. As with so many American artists of her time, the respect for form and the dominance of the conceptual mode relate her work both to the continuing American tradition and Post-impressionist attitudes of the late 1880s and the 1890s.

In addition there is a significant distinction to be drawn between the American and European view of the portrait, which in the hands of many American artists was free both from psychological dimensions

and from accessories symbolic of social status and instead became a document simply of the individual's existence. This kind of simple realism is apparent in the *Portrait of Mrs. Thomas Boylston* (fig. 12) which was painted by one of the most successful of eighteenth-century portraitists, John Singleton Copley. Copley worked with clear and linear exactitude, solid and structured composition and unaffected honesty to the particular sitter's appearance.

After her arrival in France, Cassatt acknowledged as her true masters Courbet, Manet and Degas, all of whom earn the title Realist. Courbet particularly inspired admiration, documented by Mrs. Havemeyer:

> As usual I owe it to Miss Cassatt that I was able to see the Courbets. She took me [to an exhibition in 1881], she explained Courbet to me, spoke of the great painter in her glowing, generous way, called my attention to his marvellous execution, to his colour, above all to his realism, to that poignant palpitating medium of truth through which he sought expression.

Cassatt discovered Degas in the early 1870s, probably in the windows of Durand-Ruel's gallery, to which she dragged the sixteen-year-old Louisine Elder, later Havemeyer, in 1873 in order to encourage the younger girl to purchase a Degas pastel. Manet's influence can be detected in many of the early paintings submitted by Cassatt for exhibition in the Salon and in America, notably in those which combined the French painter's bold use of broad touches of paint and strong contrasts of tone with the picturesque Spanish subjects which intimated the sources in Velázquez and Goya of Manet's novel style. *On the Balcony during the Carnival* of 1872 (Plate I) bears resemblance both to Manet's *On the Balcony* of 1869 (Paris, Musée du Louvre) and to its Spanish inspiration, Goya's *Two Majas on a Balcony* (New York, Metropolitan Museum of Art). Cassatt's interest in the realist tendencies of both modern and Old Masters corresponded well with dominant characteristics of her national school.

However by 1874 her art was tending towards greater colour and luminosity as a result of her trip to Antwerp and of her growing familiarity with eighteenth-century art (see Plate V). *The Young Bride* of c. 1875 (Plate IV) was rejected from the Salon because the colour of its background was too high, but when it was over-painted in sombre tones and resubmitted it found favour and was accepted. Thus, when Degas invited Cassatt to join the new exhibiting society, whose foundation he had supported because he felt the need for a 'Salon of Realists', she was already a painter whose style, principles and sources of inspiration provided a common ground with the artists of the group. Her cynicism towards the jury system and its repression of all save 'conventional art' was well-developed, and for this reason Cassatt saw her participation as a political act in support of independence and freedom. She and Degas were therefore Realists and Independents rather than Impressionists when the 1879

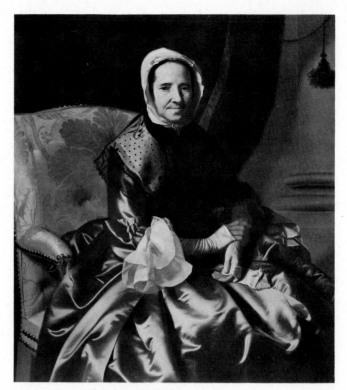

fig. 12 John Singleton COPLEY
Portrait of Mrs. Thomas Boylston
Cambridge (Massachusetts), Harvard University Portrait Collection (bequest of Ward Nicolas Boylston). 1766. Oil on canvas 128·6 × 102·3 cm.

This beautiful painting can be compared to Cassatt's portraits of her mother (Plates 23 and 26).

exhibition opened with its new title. Throughout the rest of her life, Cassatt held the principle of independence, refused almost all prizes at exhibitions and would never show when paintings were to be selected by a jury. As she told Harrison S. Morris in a letter of 1904, when refusing the award of $300 by the Pennsylvania Academy of Fine Arts for a pastel of a mother and child:

> I, however, who belong to the Founders of the Independent Exhibition must stick to my principles, which were no jury, no medals, no awards. Our first exhibition was held in 1879* and was a protest against official exhibitions and not a grouping of artists of the same art tendencies. We have since been dubbed 'Impressionists', a name which might apply to Monet but can have no meaning when attached to Degas's name . . . Liberty is the first good in the world and to escape the tyranny of a jury is worth fighting for, for surely no profession is as enslaved as ours. (quoted by Sweet, 1966, pp. 64–65)

In so far as the Independents challenged the monopoly of official art and the jury system, they also offered an opportunity for women who were consistently discriminated against by the art establishment. In the mid-nineteenth century there were a third as many women as men artists, yet none had attended the official art school of the Ecole des Beaux-Arts, only seven per cent had received a Salon medal and only one the Légion d'honneur (statistics in Nochlin, 1972). Cassatt was given this coveted honour in 1904. It is not there-

fore surprising that two of the most notable women painters of the nineteenth century, Cassatt and Berthe Morisot, joined the Independents, for the radicalism of the organization in terms of nineteenth-century art practice signalled the rupture with generations of institutional discrimination against women artists. It is well known that during the 1870s and 1880s the avant-garde had affiliations with radical politics and this aspect can be amplified by recognizing the implications for feminist politics in the organization of the avant-garde.

Yet the radicalism of the Independent movement's practice extended to its ideology, though, as is the nature of ideology, in a less conscious and program-matic manner. The confusion that surrounds the precise meaning of Impressionism, to which Cassatt referred in the letter to Mr. Morris and to which Mrs. Havemeyer's statement (p. 22) alluded, can be slightly clarified by distinguishing between the actual organi-zation of a group of artists stylistically distinct from one another and the ideology of 'modernity', or contemporaneity, that informs even the most diverse production of Degas, Monet, Sisley, Pissarro, Morisot and Cassatt.

Insufficient attention has been paid to what such nineteenth-century writers as Huysmans, Wyzewa, Roger-Marx and the Goncourt brothers called 'feminine' within the modern sensibility and to which they attached the adjective 'Impressionist'. 'Feminine', as it was used by these writers, had little to do with women, but much to do with class and was essentially about Society, *le monde*. The Goncourt brothers, who had campaigned in the 1860s in their novels for working-class subjects, turned their attention in the 1870s to the life of the *haute bourgeoisie* and in the preface of their semi-autobiographical novel *The Brothers Zemganno* (1879) made this apologia:

Man and woman of the people, closer to nature and savagery are simple creatures, uncomplicated. By contrast, the Parisian man and woman of high Society whose marked originality is made up of nuance, half tones, all those indescribable nothings . . . demand years before one can penetrate them and capture them in prose.

In 1884 they published *Chérie*, a novel about a young woman, a 'luxurious being' living in a 'world of elegance' which is conveyed impressionistically, captur-ing the nuances of that artificial world of femininity of which de Beauvoir speaks (p. 18). Cassatt had been brought up within that strange world of propriety and decorum of the drawing room, tea party and soirée which was apparently so slight and so subtle, but which was none the less rigorously ordained and rooted deeply within the social structure of nineteenth-century bourgeois society. The subjects which she knew intimately had been elevated as fit subject matter for artistic representation by such authors as the Goncourts, and so, instead of the classical and Academic con-ventional art, she could legitimately paint what was

both thoroughly modern and thoroughly personal.

Cassatt exhibited one of these bourgeois interiors *Five O'Clock Tea* (Plate X) at the fifth Impressionist exhibition of 1880. J.-K. Huysmans made the following revealing comment, contrasting Cassatt with a male painter, Gustave Gaillebotte:

Here it is still the bourgeoisie . . . it is a world also of ease, but more harmonious, more elegant . . . Miss Cassatt has nevertheless a curiosity, a special attraction for a flutter of feminine nerves passes through her painting . . . (quoted by Hale, 1975, p. 100)

It would be easy to dismiss Huysmans's 'flutter of feminine nerves' as simple male prejudice and con-descension or as a typical confusion between social notions of femininity and the biological female gender. Nevertheless, his comment, however obliquely ex-pressed, recognizes the inevitable mark on Cassatt's work of both her gender and her socialization as feminine. Precisely because there was already a space for these feminine sensibilities in Impressionism Cassatt met with partial acceptance and not bland dismissal. If one were to set up a hypothetical scale in the history of art, the suggestive and elegant art of Impressionism would probably come closer to what is generally considered 'feminine', in that it attempted to convey suggestively that which cannot be conveyed by attentive description of external forms and detailed features. Within this very general notion of Impres-sionism one can place Cassatt's portrayals of women and domestic interiors.

However, Cassatt has also been called a realist. Unlike the Goncourts with their voyeuristic fascination with a being of luxury, incomprehensible to those men of the world, Cassatt conferred on the feminine a greater degree of realism, for she subtly represented the structures of the world of women, the artifice and the process by which the child was made the feminine woman, and further she allowed the woman to be perceived beneath the superficial accessories of feminine rôles and prescribed pursuits. As Novak pointed out, her style was more structured, more solid, more substantial, more rigorous and ultimately more truthful. Finally, Mrs. Havemeyer's categorical dismissal of the term Impressionist for Cassatt makes sense in terms of neither style nor subject matter, but rather points to a more significant, almost political, divide between the various founders of Impressionism, between Degas, Cassatt and Pissarro, who remained attached to realism, and the art of Monet and Renoir.

For Degas, the real was not to be caught on the hop, in intuitive flashes, impressionistically recording the ever varying appearance of nature, but was to be pursued in a life-long discipline of study of the model, of design and of anatomy founded on a knowledge of the Old Masters and an absolute mastery of line, structure and relationships, and Cassatt's own prolonged appren-ticeship to Old Masters parallels the road to modernism taken by Degas and, indeed, Whistler. Degas believed

fig. 13 John Everett MILLAIS
Hearts Are Trumps
London, Tate Gallery. 1872. Oil on canvas
163 × 216 cm.

In the twentieth century Millais's later
works have fallen from favour but in the
nineteenth century they were particularly
admired by French critics, notably in the
Impressionist period. The French recognized
in Millais an understanding of modern bour-
geois sensibility married to a more subtle
exploration of states of mind. However where
Millais truly reflected his society, Cassatt
quietly questioned.

art to be a convention which demanded a profound
study of its history.

During 1883–85 she painted a portrait of Mrs. Riddle,
Lady at a Tea Table (Plate 22), facets of which suggest a
comparison with Degas's *Belleli Family* (fig. 14), while
the solid structure of the head, the repeating rect-
angles of the background panelling and picture frame
and the dominant colour contrasts of deep blue and
pale blue whites also refer back directly to their
common source in the portraiture of seventeenth-
century Holland. Both Degas and Cassatt believed in
the mastery of line and solid draughtmanship as the
basis for any artistic production and this extended
to the most strenuous of linear disciplines, the practice
of the graphic arts. In Parma in 1872 Cassatt had
learnt basic etching technique from one of the
Accademia's teachers, Carlo Raimondi, but it was
Degas's project for a journal, *Le Jour et La Nuit*, illus-

trated with plates by artists of the Independent group,
that stimulated her revived interest in the medium.
For the journal, Cassatt prepared a version of the
opera box series in softground and aquatint, *In the Opera
Box* (Plate 13). Although the project was abandoned,
the undertaking set Cassatt on the course of a life-long
exercise in graphic art, which became as important a
part of her output as her work in oil and pastel.
Cassatt thus won a place within one of the distinctive
movements of nineteenth-century art, the revival of
etching, which had begun in France in the late 1850s
and culminated in the foundation in Paris of the Society
of Etchers in 1862. The effects of the short-lived society
were far-reaching and the graphic arts became a
significant means of expression for many artists in
both Impressionist and Post-Impressionist periods.

The purpose of her graphic work was explained to
Segard in 1913:

. . . to impose on herself absolute precision in drawing after the
living model, she chose this means of excluding all trickery and
inexactitude. She was not satisfied to draw with a pencil. Instead
she chose to use metal, and a steel point so that the plate would
hold every trace of her mistakes or corrections. Magnificent
discipline! There is none more severe, none which is able to give
finer results.

These comments refer to the technique of drypoint
etching, but in her first essays on metal Cassatt pre-
ferred softground and aquatint, as in the plates *The
Visitor* of 1881 (Plate 16) and *Before the Fireplace* of c. 1883
(Plate 17). Subtle shading and fine pattern are qualities
particular to these processes, her use of which at this

fig. 14 Edgar DEGAS
Portrait of the Belleli Family
Paris, Musée du Louvre. 1858–59. Oil on
canvas 220 × 253 cm.

Degas's haunting portrait of his Italian
relatives uses many devices, some of which are
derived from Dutch art, to establish a sense of
the unhappy marriage and the troubled and
complex relations between the members of the
Belleli family.

date can be compared closely to the effects of the
pencil drawings that she often made for her early
etchings, for instance *Drawing for 'Knitting in the
Library'* of c. 1881 (Plate 14). In Cassatt's rigorous daily
schedule of work, which began in her studio at eight and
lasted until daylight faded, her prints were often done
at home in the evening. Lamplight interiors were thus
appropriate and *Knitting in the Glow of a Lamp* of
1881, for which Plate 15 is a preparatory drawing,
shows both her interest in the softer light and calm
atmosphere of these times of day and the appropriate-
ness of such scenes for rendition in the tonal modelling
and well defined shapes characteristic of softground
and aquatint.

An interest in the precision and discipline of pure
line evolved gradually and she turned to the most
rigorous of etching techniques, drypoint. In this
medium no acid is used to bite the design onto the
plate. The drawing is made directly with a steel or
diamond needle which leaves a slight ridge of metal
particles on the edges of the incised lines. When printed
these ridges, or burr, also take up the ink, giving a
depth to the line and a suggestive quality to the
resultant image. In *The Map* of 1890 (Plate 29), the
use of drypoint enabled Cassatt to capture the subtle
psychological atmosphere to which she aspired in her oils
and pastels with simplicity and dramatic economy of
means. By 1890 the chiaroscuro of the softground and
aquatint etchings gave way to compositions in drypoint,
in which arabesque and clarity play a more important
part.

In that same year a major exhibition of the im-
mensely popular Japanese prints of the Ukiyo-e School
of the eighteenth and nineteenth centuries was held
at the Ecole des Beaux-Arts. The Ukiyo-e School of
printmakers, which had developed as a protest against
official academic art, took the form of a popular
democratic art, celebrating the ordinary scenes of daily

25

fig. 15 Kitagawa UTAMARO
Woman Dressing a Girl for a Sanbaso Dance
New York, Metropolitan Museum of Art
(gift of Samuel Isham). c. 1790. Colour
woodcut 39 × 25 cm.

This is a lovely example of the arabesques and
decorative rhythms of Japanese woodcuts. The
contrast of the standing and crouching figures
comes very close to Cassatt's compositions, but
the Japanese master almost loses his figures in
the swirl of colourful robes, while Cassatt
controlled the pattern and left more space for
the actions and responses of the women.

life in and around the fast growing city of Yeddo
(Tokyo), and this undertaking easily parallels a
similar revolt in France in the nineteenth century
with its cult of urban modernity. Théodore Duret,
a historian of Impressionism, wrote in 1885 that the
Japanese printmakers were 'the first and most perfect of
the impressionists'. But Ernest Chesneau's early review
of the impact of the Ukiyo-e school on French art,
'Le Japon à Paris' in the *Gazette des Beaux-Arts* of 1878,
emphasized that it was a matter of affinities and not
influences when he wrote:

All found a confirmation rather than an inspiration for their
personal ways of seeing, feeling, understanding and interpreting
nature. The result was a redoubling of individual originality
instead of a cowardly submission to Japanese art.

In the common scenes of Japanese prints, teahouses,
theatres, actors' portraits and domestic routines of
female and infant *toilette*, the particular rapport with
Cassatt's subjects is apparent.

The style of the prints of Japan offered a solution to
the nineteenth-century debate between the primacy
of line and the primacy of colour by giving each an
equal force. In the woodcuts, intense, unmodulated
colour was laid on the wood block in large flat areas
whilst arabesques of line, elegant silhouettes, sharp
perspectives and acute angles of vision provided an
overall structure for these floating areas of colour in a
format that was direct, immediate and expressive.
While such lessons were the basis for experiments in oil
painting by Manet, Degas, Monet and Cassatt, their
implications were most easily incorporated into
European graphic art, as the posters of Toulouse-
Lautrec (1864–1901) beautifully demonstrate. It is
this aspect of *japonisme* to which Cassatt significantly
and originally contributed with the series of ten colour
prints of 1891, produced in response to the great
exhibition of Japanese prints of 1890.

Cassatt had known of the prints before 1890, but the
exhibition provided a new stimulus and she bought
from it many examples of work by the leading Ukiyo-e
masters. Soon after the show she set up a press and
set to work as she said 'in imitation of Japanese methods'
(Plates 31–39, XXIV, XXV and XXVI). Her success
in finding an appropriate and distinctly European way
to achieve similar effects was enthusiastically reported
by Camille Pissarro to his son, also a printmaker, in a
letter of 5 April 1891:

It is absolutely necessary, while what I saw yesterday at Miss
Cassatt's is still fresh in my mind, to tell you about the coloured
engravings she is to show at Durand-Ruel's . . . You remember
the effects you strove for at Eragny? Well, Miss Cassatt has
achieved just such effects, and admirably: the tone even, subtle,
delicate, without stains on the seams, adorable blues, fresh rose
etc . . . the result is admirable, as beautiful as Japanese work and
it is done with printer's ink.

In her study of Japanese woodcuts and Impressionist
prints, Costa Feller Ives documents the close similarities
between the subjects Cassatt depicted and those of
Japanese masters. *The Fitting* (Plate XXV) can be related
to *Woman Dressing a Girl for a Sanbaso Dance* (fig. 15) by
Utamaro (1753–1806) and the many other examples
she cites confirm Chesneau's statement of the kinship
between the two schools. However the affinities between
the subjects are superficial, for Cassatt's prints have the
human depth and compositional weight of her own
paintings, rather than the gaiety and decorativeness of
the Japanese.

The stylistic similarities are in fact the more remark-
able. Like the Japanese, Cassatt juxtaposed plain areas
of colour and richly patterned surfaces and in the *Woman
Bathing* (Plate XXVI), for instance, she only used the
slightest hint of a line on the woman's back to give

anatomical form to the otherwise unmodulated area of pale colour. In *The Fitting* and *The Omnibus* (Plates XXVI and 34) the clean outlines of the figures are silhouetted against the patterned or landscape background as linear elements in the overall design.

But the most remarkable element of Cassatt's graphic work is the technique, about which Pissarro commented. There still exists considerable doubt about how Cassatt achieved her remarkable effects, despite letters from the artist herself ostensibly explaining her procedures. In the catalogue raisonné of the graphic work (1948) Adelyn Breeskin gives the media of the prints as a combination of drypoint, softground and aquatint. Yet Cassatt only mentioned drypoint for the design and aquatint for the pattern. In 1950 an ebullient Cassatt enthusiast, Sue Fuller, published the results of her research and experiments. She proved that Cassatt used softground etching in a revolutionary way to achieve the unusual overall textured effects of the colour areas. Thus Cassatt radically expanded the potential inherent in traditional European media, such as etching, and did not, therefore, imitate Japanese methods but rather found a way to incorporate their use of line and colour into the mainstream of European graphic art. This 1890–91 series of *coloured* etchings was a milestone in graphic art and Impressionist printmaking and at the same time it was absolutely in line with her own stylistic development and treatment of the theme of women.

Three years after the exhibition of Japanese prints, the World's Columbian Exposition was held in Chicago for which a special Woman's Building, designed by Sophia Hayden, was constructed to house examples of women's creative work. The promoters stated their purpose thus:

We [Women] have eaten of the Tree of Knowledge and the Eden of Idleness is hateful to us. We claim our inheritance, and are become workers not cumberers of the earth. (quoted by Maud Howe Elliott, 1893)

As one of the most successful and avant-garde woman painters of the time, Mary Cassatt was commissioned to paint a mural for the tympanum of the Great Hall on the theme of *Modern Woman*. Her design, which included a wide decorative border set with roundels and divided into three panels, was inspired by the Eastern, Islamic and Persian models as much as by the Japanese. In a letter of 11 October 1892 she described the subject of the work to Mrs. Potter Palmer, and the metaphors she used in her strong statement of a new rôle for women paralleled those of the exhibition's organizers:

One of the New York papers . . . referring to the order given me, said my subject was to be 'The Modern Woman as Glorified by Worth [the couturier]' . . . That would hardly express my idea of course. I have tried to express the modern woman in the fashions of the day, and I have tried to represent those fashions as accurately and in as much detail as possible. I took for the subject of the centre and largest composition Young Women Plucking the Fruits of Knowledge and Science . . . An American friend asked me in rather a huffy tone the other day 'Then this is woman apart from her relations to man?' I told him it was. Men I have no doubt are painted in all their vigour on the walls of the other buildings; to us the sweetness of childhood, the charm of womanhood, if I have not conveyed some sense of that charm, in a word if I have not been absolutely feminine then I have failed . . . I will still have place on the side panels for two compositions, one which I shall begin immediately is Young Girls Pursuing Fame. This seems to me very modern . . . The other panel will represent the Arts and Music (nothing of St Cecilia).

The completed work has been lost, but other paintings that are possibly related to the mural, such as *Women Picking Fruit* of 1891 (Plates 40 and 41), illustrate Cassatt's re-working of yet another iconographic tradition, the Garden of Eden. The modern Eve plucks happily at the fruit of the Tree of Knowledge. Yet in these paintings Cassatt did not take Woman out of the Garden of Eden. This is surprising because the metaphor of the Garden of Eden had been used consistently in the nineteenth century to confine women, as, for instance, in John Ruskin's 'Queen's Gardens' in *Sesame and Lilies* of 1867, in which woman is noble, pure and wise but totally unselfseeking, dedicated to her natural vocation and always conscious of only the relative value of whatever abilities she had. In Cassatt's garden, fame and knowledge flourish side by side with maternity and feminine charm. 'Feminine' and 'charm' might seem a strange choice of words for Cassatt in the light of the feminist intentions of the Exposition and her whole-hearted support of the women's project, but they should not surprise. Many writers like Adelyn Breeskin talk of Cassatt overcoming the 'Limitations of background, precedent, sex and era', but I believe that it was as much because of, as despite, those restrictions that Cassatt's works achieved a 'place in the foremost ranks of creative endeavours of her time'. For Cassatt, motivated to independence by the limitations of polite Philadelphia society and armed with the bold progressive tendencies of her American artistic heritage, moved to Europe where her own inclinations were fed by an awareness of the artistic debates of the time. This prepared her to identify with the artistic movement whose independent organization, modern concerns and stylistic sources provided the necessary conditions to produce a body of works about women, an *oeuvre* which was both feminine in its fidelity to the social realities of the life of a middle-class woman and thoroughly feminist in the way it questioned, transformed and subverted the traditional images of Women, Madonna, Venus, Vanity and Eve, in accordance with the aspirations of the movement of women to be '*someone* and not *something*'.

Chronology

1844 Mary Cassatt was born on 22 May in Allegheny, Pennsylvania, the second daughter of Mr. and Mrs. Robert Simpson Cassatt.

1851 In the late summer the family moved to Europe, settling in Paris shortly before Louis Napoleon's *coup d'état*.

1855 The family returned to America, visiting Paris to see the Exposition Universelle.

1861 Cassatt enrolled at the Pennsylvania Academy of the Fine Arts, where she studied for four years.

1866–70 Cassatt was in Europe, studying in museums and seeing exhibitions such as the Paris Exposition Universelle of 1867, at which Courbet and Manet had pavilions, and making sketching trips around France.

1870 After the outbreak of the Franco-Prussian War, Cassatt returned to Philadelphia.

1872 Cassatt went back to Europe, settling for eight months in Parma, where she studied Correggio and Parmigianino and attended classes in graphic techniques under the direction of Carlo Raimondi. She sent her first painting, *On the Balcony during the Carnival* (Plate 4), to the Salon in Paris under the name of Mary Stevenson.

1873 Cassatt studied at the Prado in Madrid and at Seville, taking special notice of Velázquez and Rubens. She exhibited the *Torero and Young Girl* (Plate I), at the Paris Salon. She travelled to Belgium and Holland and finally to Paris where she settled.

1874 In April the first exhibition of the Société Anonyme des Artistes, Peintres, Sculpteurs et Graveurs was held. They were soon dubbed in the Press 'Impressionists'. In May Cassatt exhibited again at the Salon with *Portrait of Mme. Cortier* (Plate 6), which was noticed favourably by Degas.

1875 Of two pictures submitted to the Salon, one was rejected.

1876 In April the Second Impressionist Exhibition was held. In May Cassatt had two pictures accepted at the Salon, one of which had been rejected the year before and then toned down in colour by the artist.

1877 The Third Impressionist Exhibition took place in April. Degas visited her and invited her to join the group. Her last Salon submission was rejected. Her parents and sister Lydia came to Paris to live with her.

1879 Cassatt participated in the Fourth Impressionist Exhibition, renamed as 'Un Groupe des Artistes Independants, Réalistes et Impressionistes' with *Lydia in a Loge, Wearing a Pearl Necklace* (Plate 14) and *The Cup of Tea* (New York, Metropolitan Museum of Art). She sent two pictures to the second exhibition of a new, independent exhibition society, The Society of American Artists. She visited northern Italy with her father and began to do etchings.

1880 At the Fifth Impressionist Exhibition Cassatt exhibited a pastel *Women in a Loge with a Fan* (Fairhavent Massachusetts, private collection), which later belonged to Paul Gauguin. She spent the summer with her family at Marly-le-Roi in a villa near that of Edouard Manet.

1881 Cassatt exhibited a painting, *Lydia Crocheting in the Garden at Marly* (Plate 18) at the Sixth Impressionist Exhibition.

1882 Degas and Cassatt abstained from the Seventh Impressionist Exhibition. Cassatt lent money to the almost bankrupt dealer and Impressionist sympathizer Durand-Ruel. Her sister Lydia died in November after a long illness.

1886 Cassatt exhibited at the Eighth (and last) Impressionist Exhibition with *Girl Arranging her Hair* (Plate IV) and some of her works were included in Durand-Ruel's Impressionist exhibition in New York.

1890 In April Cassatt visited, with Morisot and Degas, the exhibition of Japanese prints at the Ecole des Beaux-Arts in Paris. She rented the Château Bachvilliers in the Oise Valley where she set up an etching press and began her series of ten colour prints (Plates 48–58, V and VI).

1891	In April her first one-woman show was held at the Durand-Ruel's gallery at the same time as that of the Société des Peintres-Graveurs Français, from which she and Pissarro had been excluded on account of their foreign birth. Her father died in December.
1892	Cassatt began work on the mural *Modern Woman* for the Woman's Building at the World's Columbian Exposition in Chicago. She brought the Château de Beaufresne at Mesnil Théribus.
1893	In November and December Cassatt had a large and comprehensive one-woman show at Durand-Ruel's gallery.
1895	In April Durand-Ruel organized a large Cassatt exhibition in New York. Her mother died at the Château de Beaufresne in October.
1898	Cassatt made her first visit to America since 1871. She returned the following March to Paris.
1901	Cassatt made an extended visit to Italy with the Havemeyers, advising them on the purchase of paintings, especially those by El Greco and Goya, many of which are now in the Metropolitan Museum of Art in New York.
1903	Cassatt's one-woman show in New York was organized by Durand-Ruel.
1904	Cassatt was made chevalier of the Légion d'honneur by the French government.
1907	Cassatt had a one-woman show at Ambroise Vollard's gallery in Paris and some of her works were shown in an exhibition of Impressionists in Manchester, England.
1910–11	She made a long trip with her family to the Near East and Egypt. Her brother Gardner died. Cassatt suffered a physical and nervous breakdown and diabetes was diagnosed. She stopped printmaking and her eyesight began to weaken.
1915	Cassatt exhibited with Degas in a benefit exhibition for women's suffrage in New York. In October she had an operation for cataracts.
1921	A final operation for cataracts was unsuccessful and Cassatt became virtually blind.
1926	Cassatt died at the Château de Beaufresne on 14 June.

Bibliography

Breeskin, A., *The Graphic Work of Mary Cassatt: A Catalogue Raisonné*. New York, 1948.

Breeskin, A., *Mary Cassatt, A Catalogue Raisonné of Paintings, Watercolours and Drawings*. Washington, 1970.

Breuning, M., *Mary Cassatt*. New York, 1944.

Bullard, J., *Mary Cassatt, Oils and Pastels*. New York, 1972.

Carson, J., *Mary Cassatt*. New York, 1966.

Chesneau, E., 'Le Japon à Paris', *Gazette des Beaux-Arts*, September 1878.

Davidoff, L., *The Best Circles: Society, Etiquette and the Season*. London, 1973.

Degas, E., *Letters* (M. Kay, trans.). New York, 1948.

Duncan, C., 'Happy Mothers and Other New Ideas in French Art', *Art Bulletin*, December 1973.

Elliott, M. Howe, *Art and Handicraft in the Woman's Building of the World's Columbian Exposition, Chicago 1893*. Paris and New York, 1893.

Fuller, S., 'Mary Cassatt's Use of Soft Ground Etching', *Magazine of Art*, February 1950.

Hale, N., *Mary Cassatt*. New York, 1975.

Havemeyer, L., 'Mary Cassatt Memorial Exhibition', *Pennsylvania Museum Bulletin*, May 1927.

Havemeyer, L., *Sixteen to Sixty: Memoirs of a Collector*. New York, 1930.

Hess, T., 'The Degas-Cassatt Story', *Art News*, November 1947.

Ives, C.F., *The Great Wave: The Influence of Japanese Woodcuts on French Prints*. New York, 1974.

Kysela, J.D., 'Mary Cassatt's Mystery Mural and the World's Fair of 1893', *Art Quarterly*, 1966.

Lacan, J., 'The Mirror Phase . . .', *Ecrits, A Selection* (A. Sheridan, trans.). London, 1977.

Leaders of American Impressionism: Mary Cassatt, Brooklyn Institute of Arts and Sciences, New York, exhibition catalogue, 1937.

Martineau, H., *Society in America*. New York, 1837.

Mary Cassatt among the Impressionists, Joslyn Art Museum, Omaha, exhibition catalogue, 1969.

Mellerio, A., 'Mary Cassatt', *L'Art et Les Artistes*, November 1910.

Nochlin, L., 'Why Have There Been No Great Women Artists?', *Art and Sexual Politics* (eds. E. Bauer and T. Hess). New York and London, 1972.

Novak, B., *American Painting of the Nineteenth Century*. New York, 1969.

Paintings, Drawings and Graphic Works by Manet, Degas, Berthe Morisot and Mary Cassatt, Baltimore Museum of Art, Baltimore, exhibition catalogue, 1962.

Rewald, J., *The History of Impressionism*. New York, 1961 and 1973.

Roger-Marx, 'Les Femmes Peintres de l'Impressionisme', *Gazette des Beaux-Arts*, December 1907.

Ruskin, J., *Sesame and Lilies*. London, 1867.

Sargent, Whistler and Mary Cassatt, Art Institute of Chicago, Chicago, exhibition catalogue, 1954.

Segard, A., *Un Peintre des Enfants et des Mères – Mary Cassatt*. Paris, 1913.

Sweet, F., *Miss Mary Cassatt: Impressionist from Pennsylvania*. Norman, Oklahoma, 1966.

Valerio, E., *Mary Cassatt*. Paris, 1930.

Vicinus, M. (ed.), *Suffer and Be Still: Women in the Victorian Age*. Bloomington, Indiana, 1973.

Woolf, V., *A Room of One's Own*. London, 1928.

Wyzewa, T. de, *Peintres de Jadis et d'Aujourd'hui*. Paris, 1903.

Yeh, S.F., 'Mary Cassatt's Images of Women', *Art Journal*, 1976.

THE COLOUR PLATES

I *On the Balcony during the Carnival*
PHILADELPHIA, Philadelphia Museum of Art (W. P. Wilstach collection). 1872. Oil on canvas
101 × 82·5 cm.

II *Torero and Young Girl*
WILLIAMSTOWN, Sterling and Francine Clark Art Institute. 1873. Oil on canvas 101 × 85 cm.

III *A Musical Party*
PARIS, Musée du Petit Palais. 1874. Oil on canvas 96·4 × 66 cm.

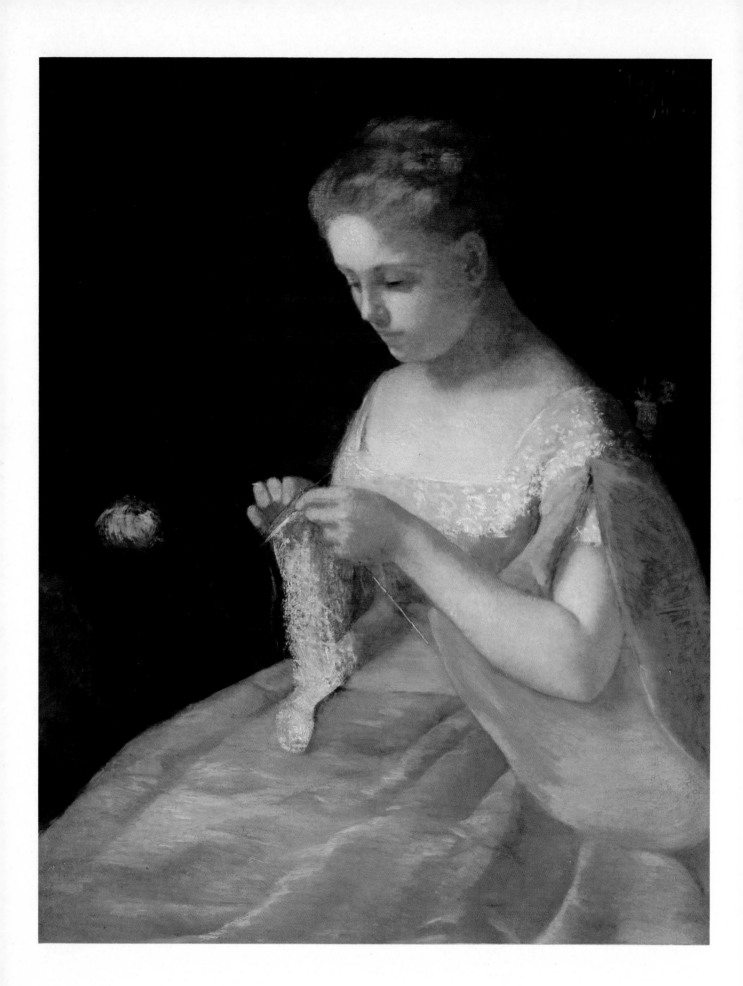

IV *The Young Bride*
MONTCLAIR, Montclair Art Museum (gift of Max Kade Foundation). c. 1875. Oil on canvas
88 × 69·3 cm.

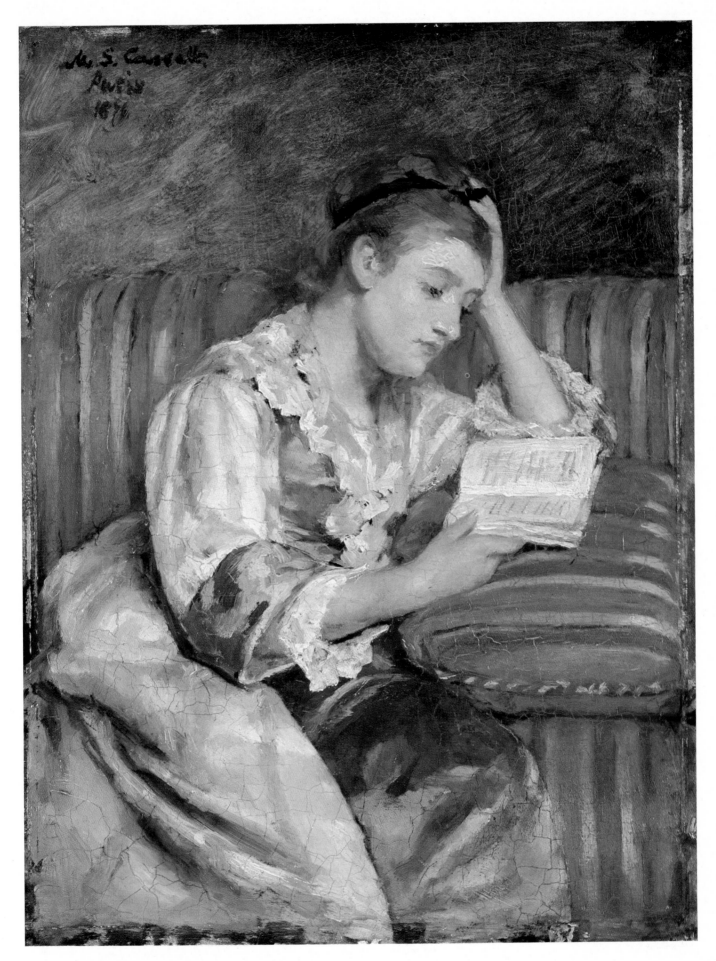

V *Mrs. Duffee Seated on a Striped Sofa*
BOSTON, Museum of Fine Arts (bequest of John T. Spaulding). 1876. Oil on wood panel 35 × 27 cm.

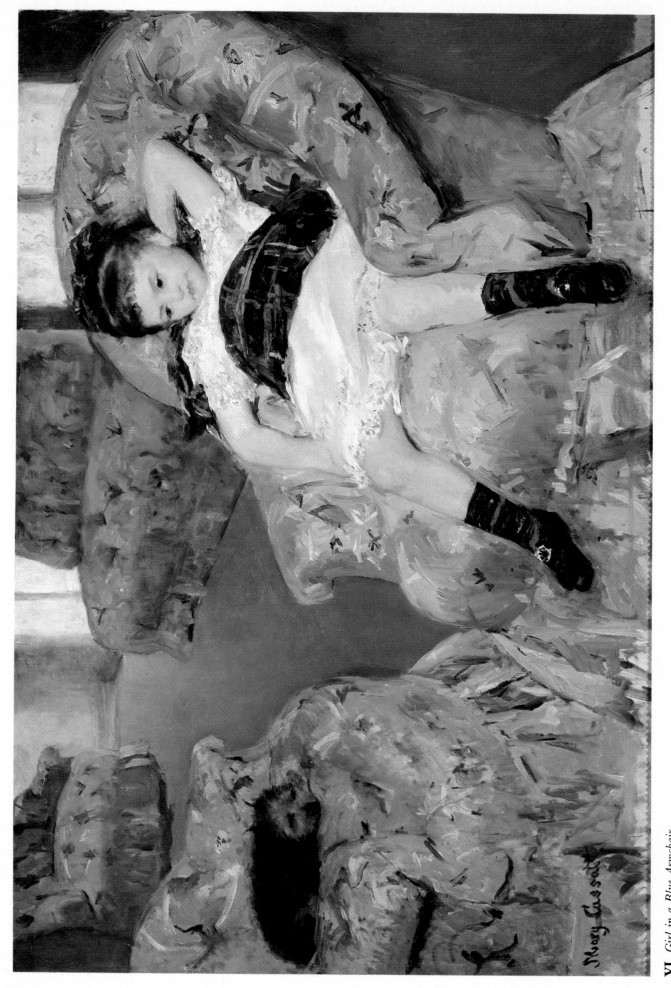

VI *Girl in a Blue Armchair*
UPPERVILLE, collection of Mr. and Mrs. Paul Mellon. 1878. Oil on canvas 89 × 130 cm.

VII *Woman and Child Driving*
PHILADELPHIA, Philadelphia Museum of Art (W. P. Wilstach collection). 1879. Oil on canvas
89·3 × 130·8 cm.

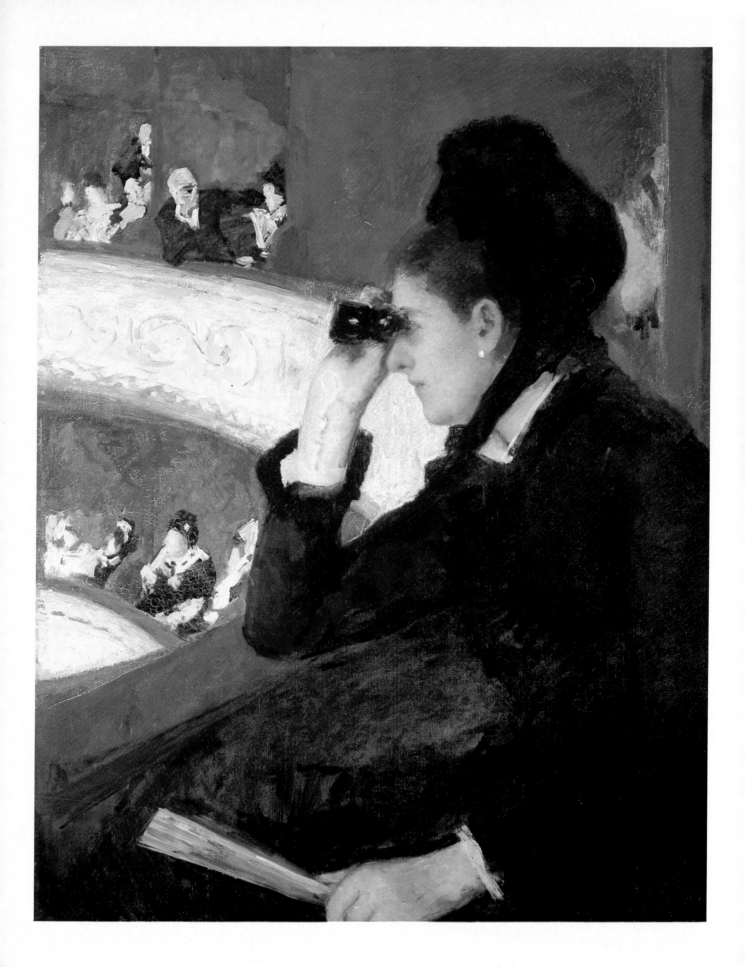

VIII *Woman in Black at the Opera*
BOSTON, Museum of Fine Arts (Charles Henry Hayden fund). 1880. Oil on canvas 81·3 × 66 cm.

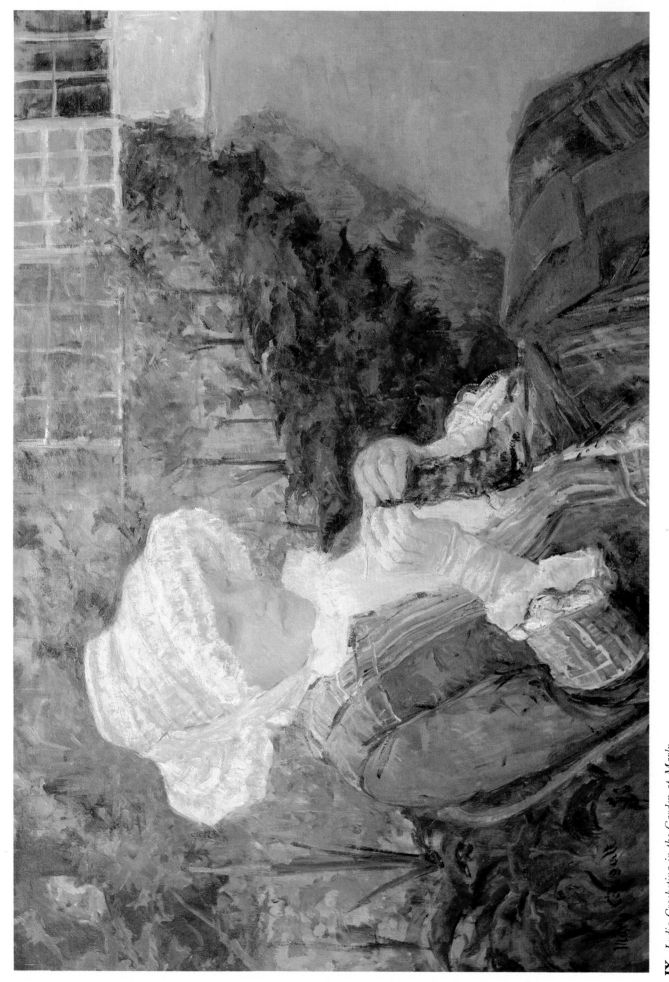

IX *Lydia Crocheting in the Garden at Marly*
NEW YORK, Metropolitan Museum of Art (owned jointly with Mrs. Gardner Cassatt). 1880. Oil on canvas 66 × 94 cm.

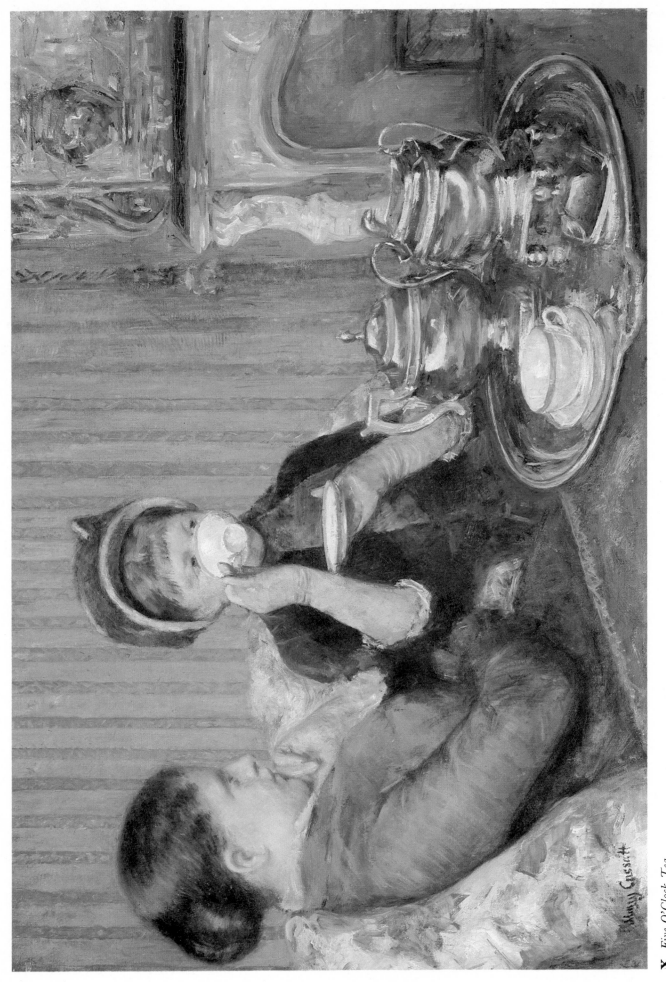

X *Five O'Clock Tea*
BOSTON, Museum of Fine Arts (Maria Hopkins fund). 1880. Oil on canvas 64·8 × 92·7 cm.

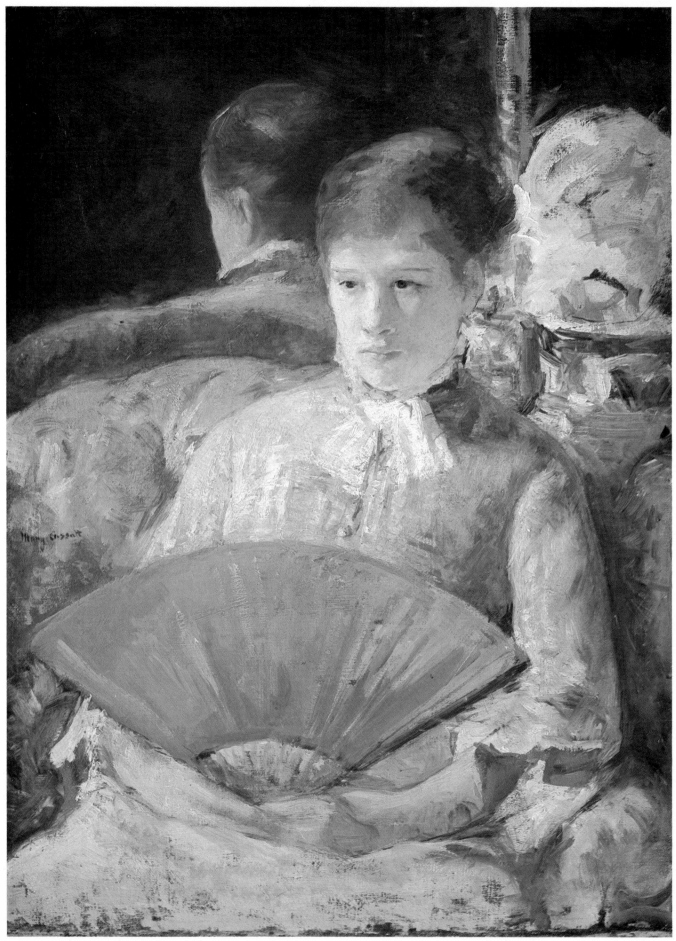

XI *Portrait of Miss Mary Ellison*
WASHINGTON, National Gallery of Art (Chester Dale collection). c. 1880. Oil on canvas 85·7 × 65·2 cm.

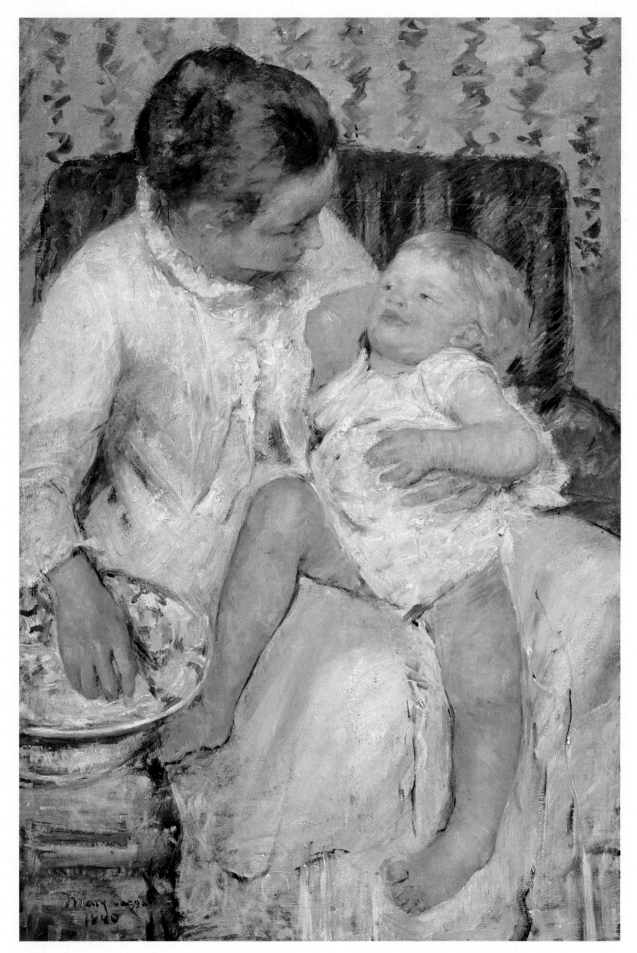

XII *Mother about to Wash her Sleepy Child*
LOS ANGELES, Los Angeles County Museum of Art (bequest of Mrs. Fred Hathaway Bixby). 1880.
Oil on canvas 100 × 65 cm.

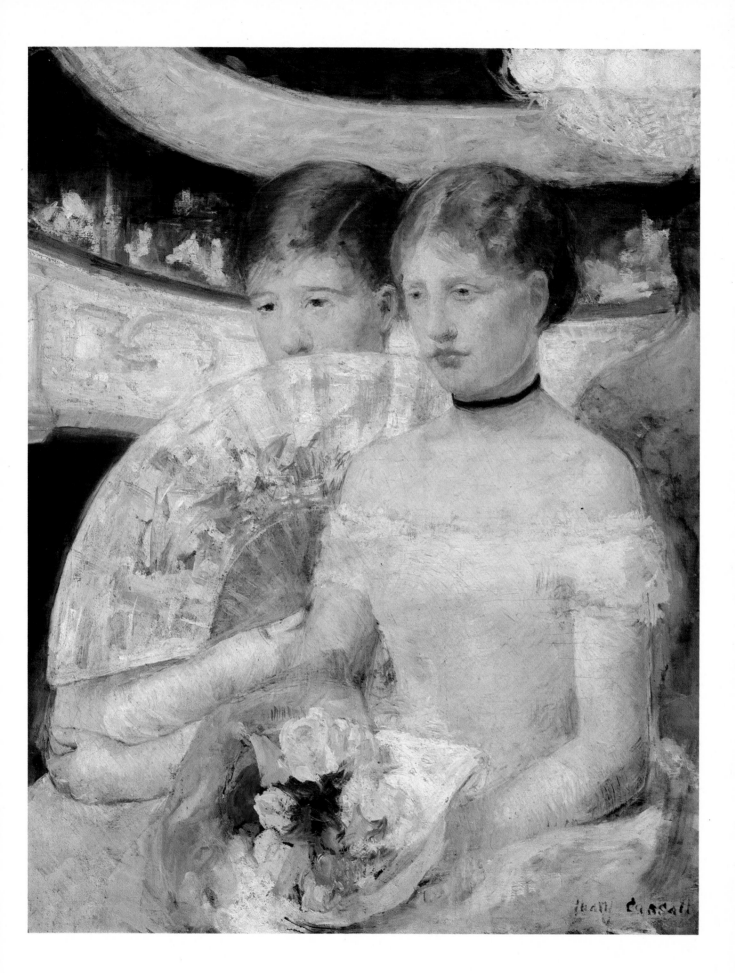

XIII *Two Young Ladies in a Loge*
WASHINGTON, National Gallery of Art (Chester Dale collection). 1882. Oil on canvas 80 × 64 cm.

XIV *Susan on a Balcony Holding a Dog*
WASHINGTON, Corcoran Gallery of Art. 1883. Oil on canvas 100·3 × 64·7 cm.

XV *Young Woman in Black*
BALTIMORE, Baltimore Museum of Art (on loan from the Peabody Institute). 1883. Oil on canvas
80·6 × 64·6 cm.

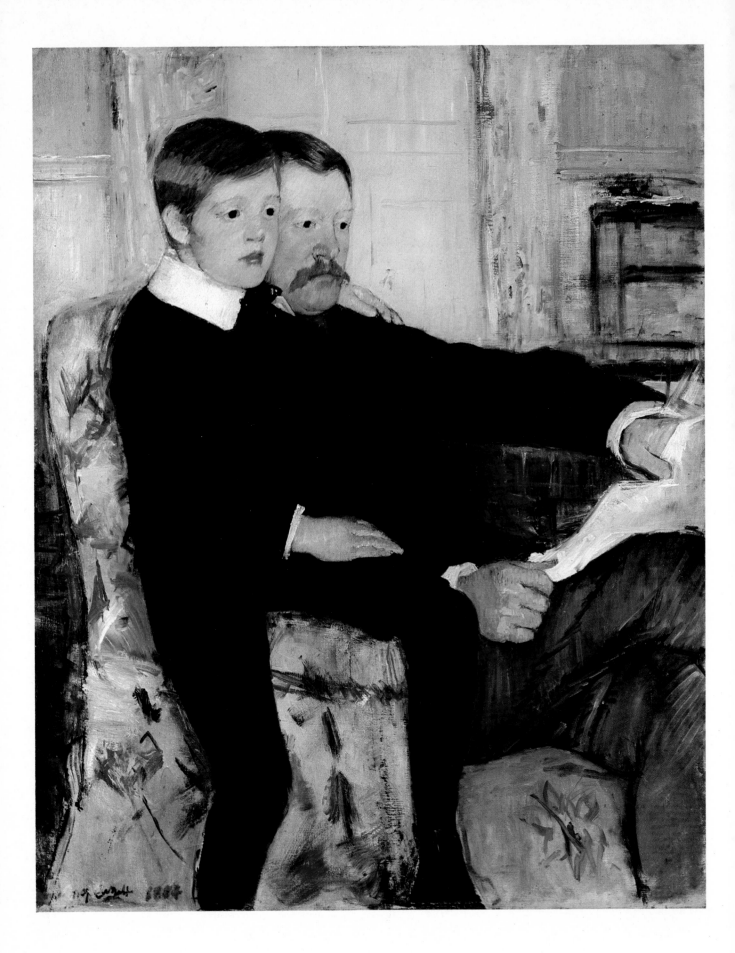

XVI *Portrait of Alexander Cassatt and his Son*
PHILADELPHIA, Philadelphia Museum of Art (W. P. Wilstach collection and gift of Mrs. William
Coxe Wright). 1884. Oil on canvas 100 × 81·2 cm.

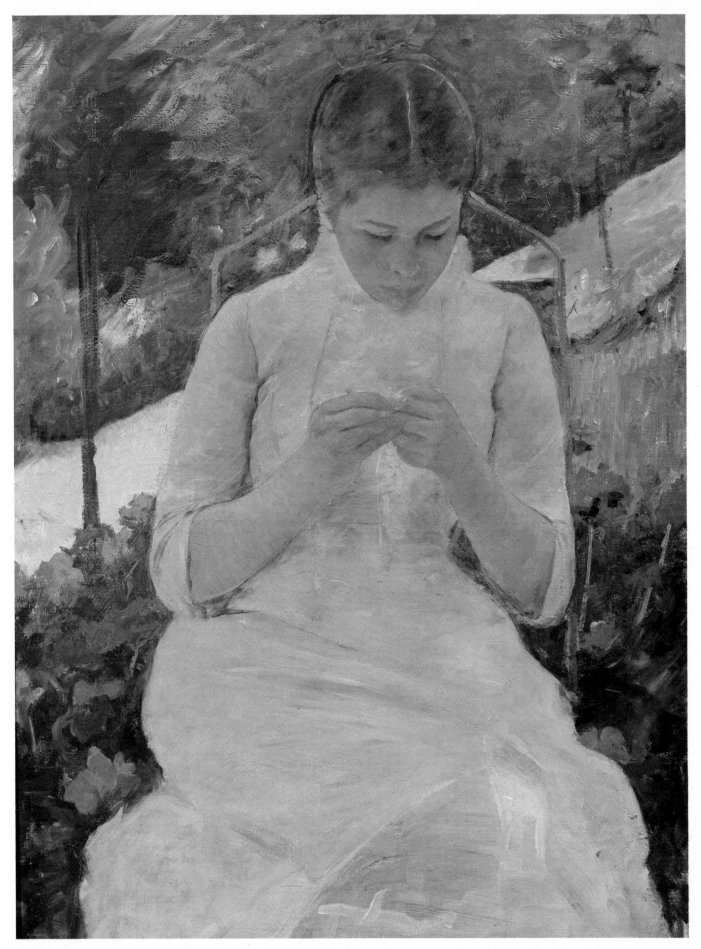

XVII *Young Woman Sowing in the Garden*
PARIS, Jeu de Paume. c. 1884–6. Oil on canvas 91·5 × 64·7 cm.

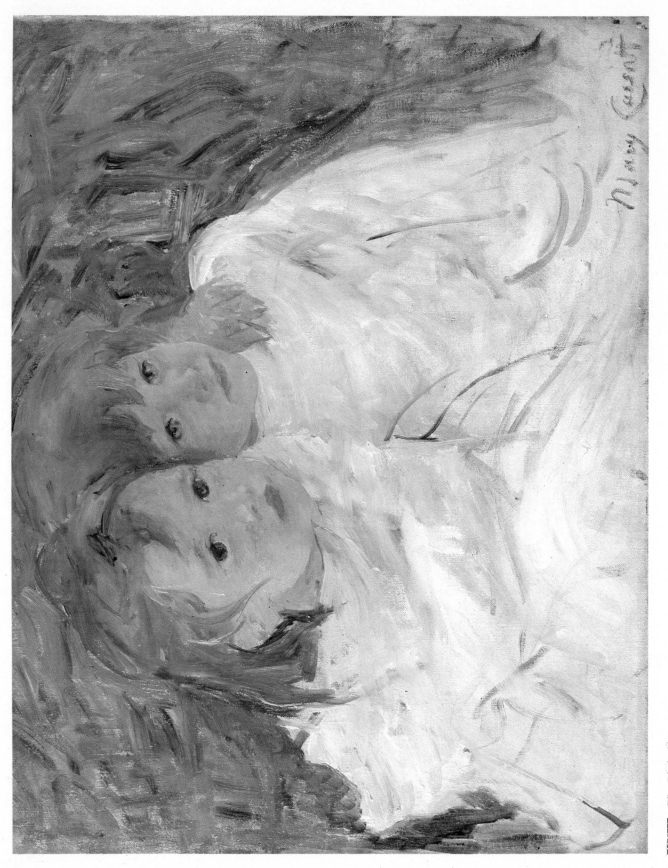

XVIII *The Little Sisters*
GLASGOW, Glasgow Art Gallery. c. 1885. Oil on canvas 48·2 × 57 cm.

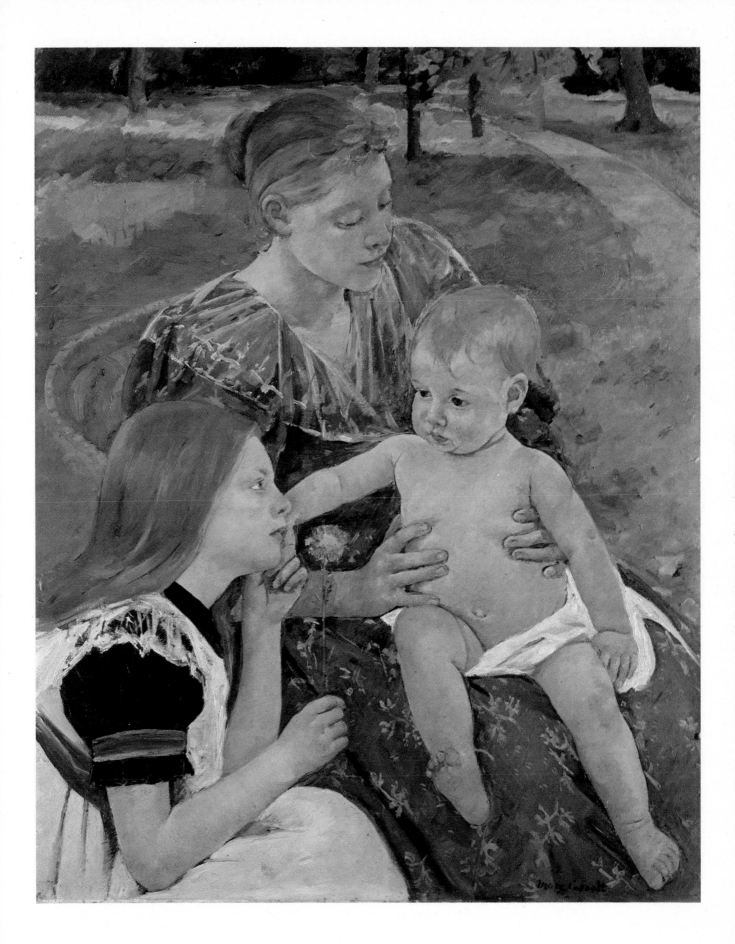

XIX *The Family*
NORFOLK (VIRGINIA), Chrysler Museum (gift of Walter P. Chrysler, Jr.). c. 1886. Oil on canvas
81·2 × 66 cm.

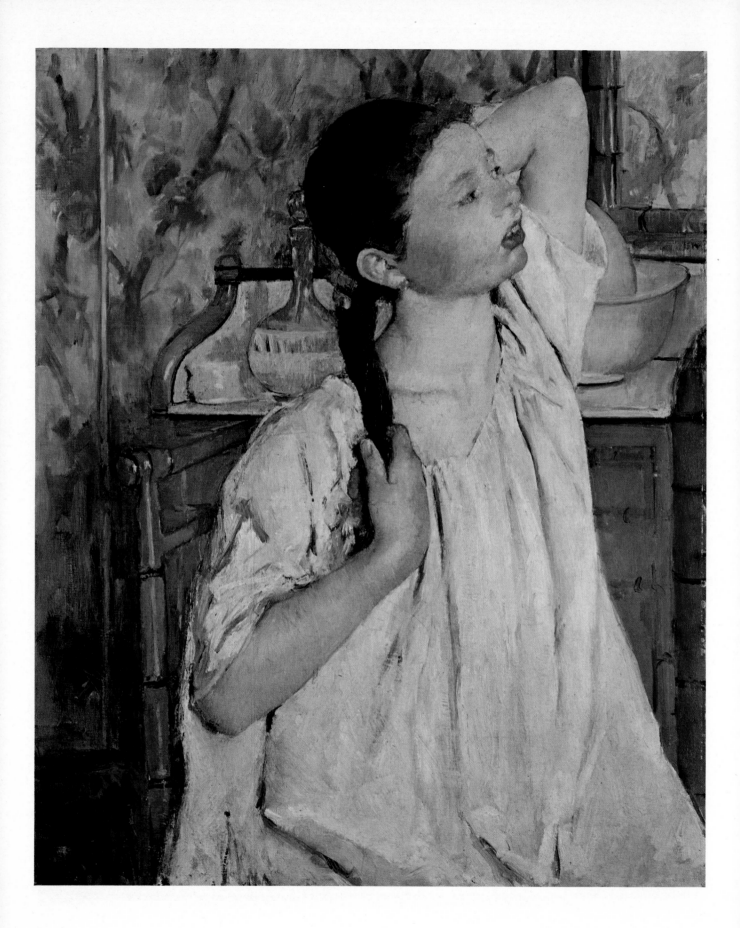

XX *Girl Arranging her Hair*
WASHINGTON, National Gallery of Art (Chester Dale collection). 1886. Oil on canvas 75 × 62·2 cm.

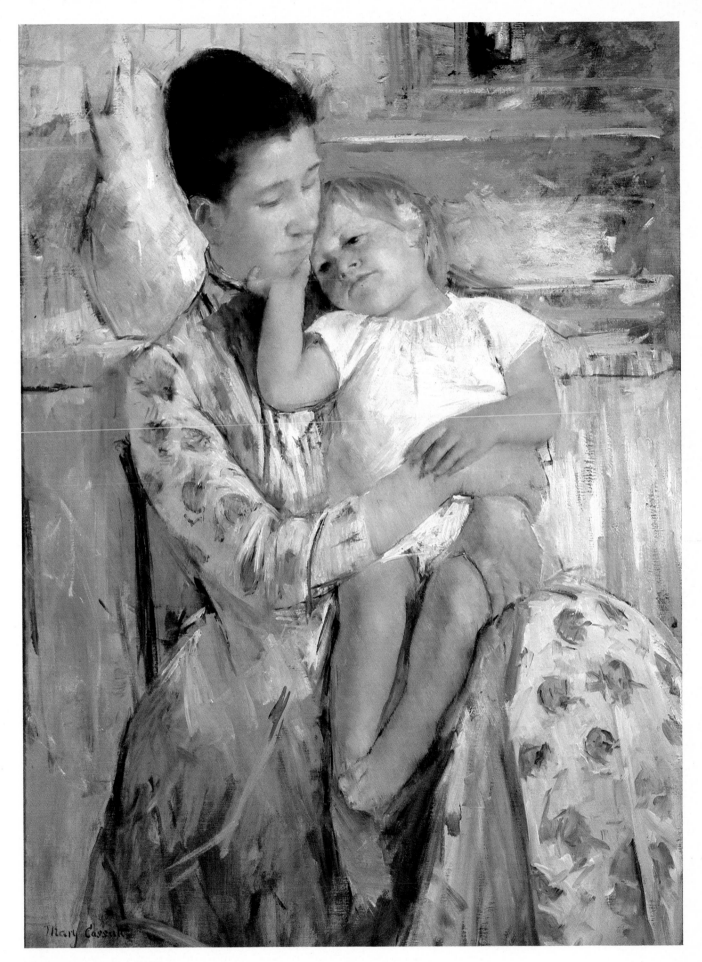

XXI *Emmie and her Child*
WICHITA, Wichita Art Museum (Roland P. Murdock collection). 1889. Oil on canvas
89·9 × 64·5 cm.

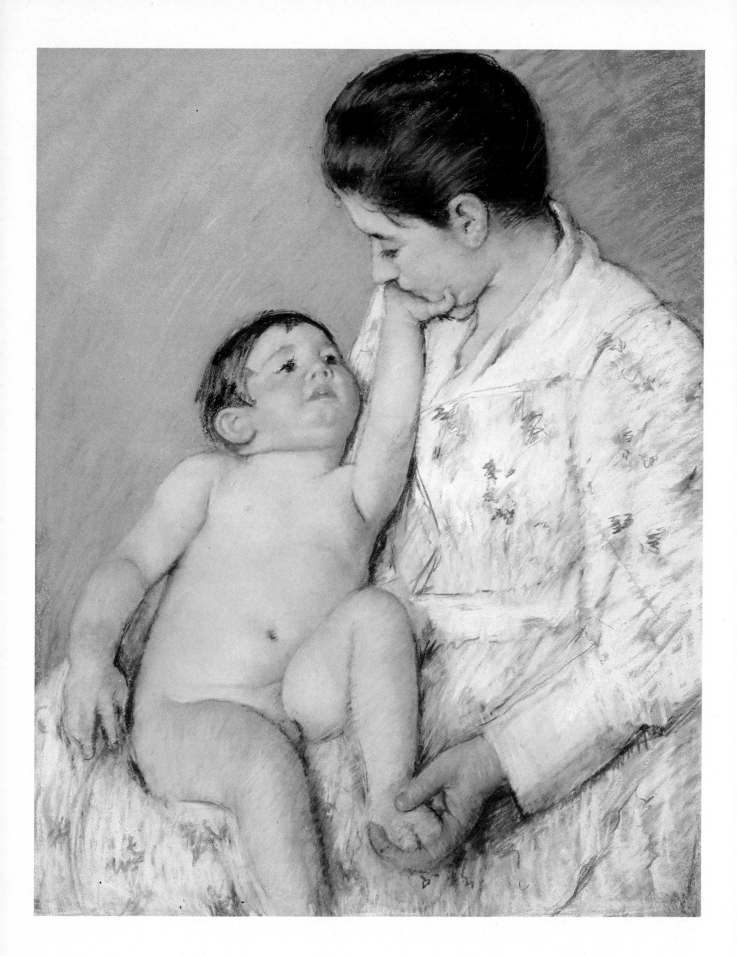

XXII *Baby's First Caress*
NEW BRITAIN, New Britain Museum of American Art (Harriet Russell Stanley fund). 1891. Pastel
on paper 76·2 × 61 cm.

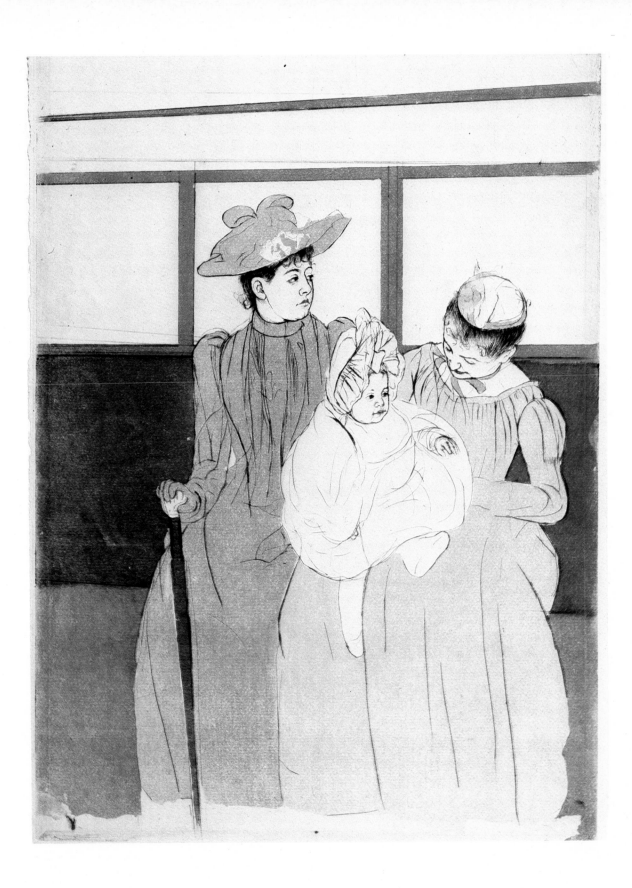

XXIII *The Omnibus*
NEW YORK, Metropolitan Museum of Art (gift of Paul J. Sachs). 1891. Colour print with drypoint, softground and aquatint, fourth state 35·6 × 26·2 cm.

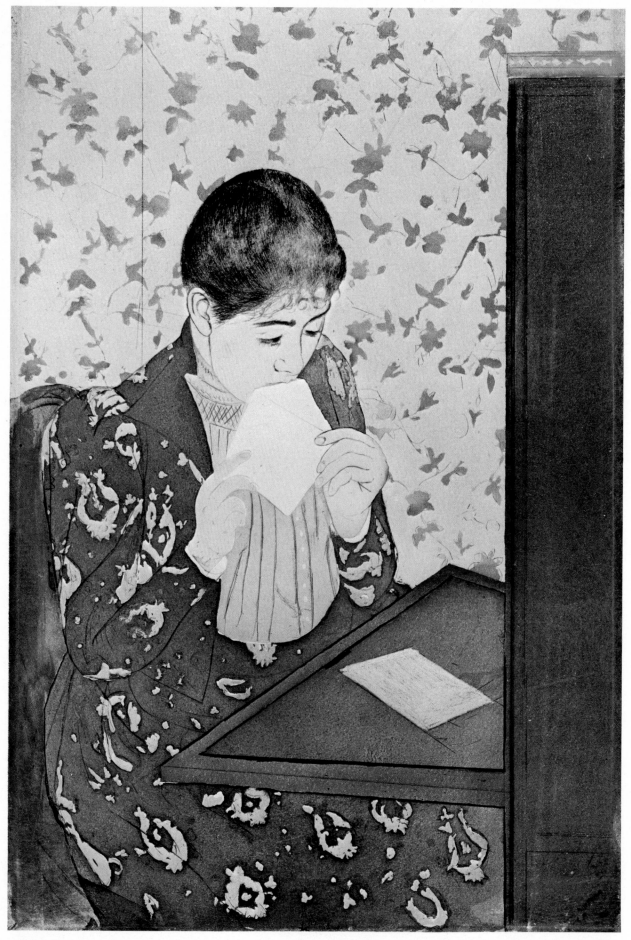

XXIV *The Letter*

NEW YORK, Metropolitan Museum of Art (gift of Paul J. Sachs). 1891. Colour print with drypoint, softground and aquatint, third state 33·7 × 22 cm.

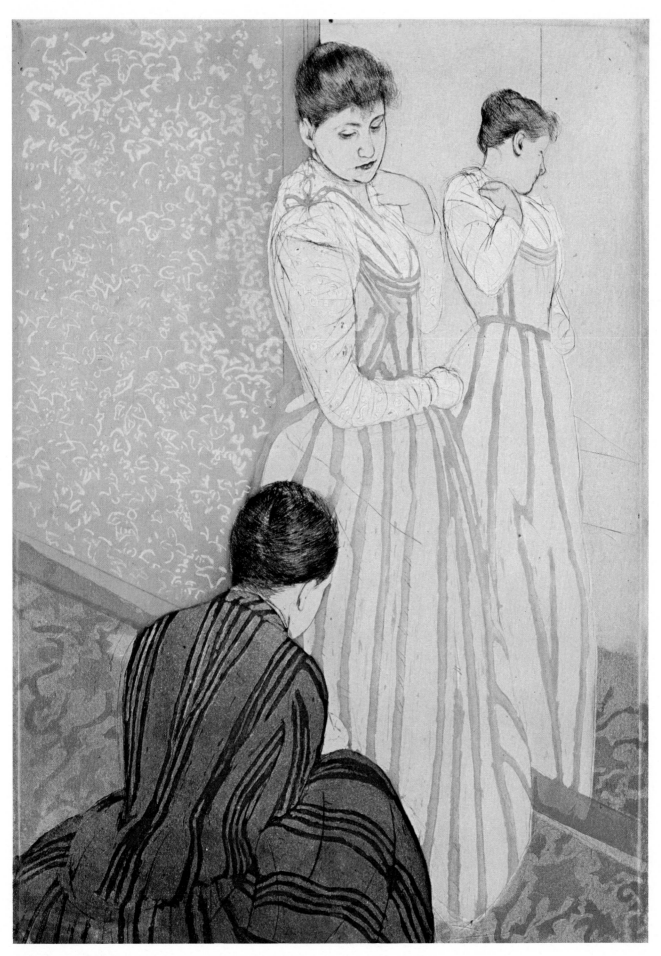

XXV *The Fitting*

NEW YORK, Metropolitan Museum of Art (gift of Paul J. Sachs). 1891. Colour print with drypoint, softground and aquatint, fifth state 36·8 × 25·3 cm.

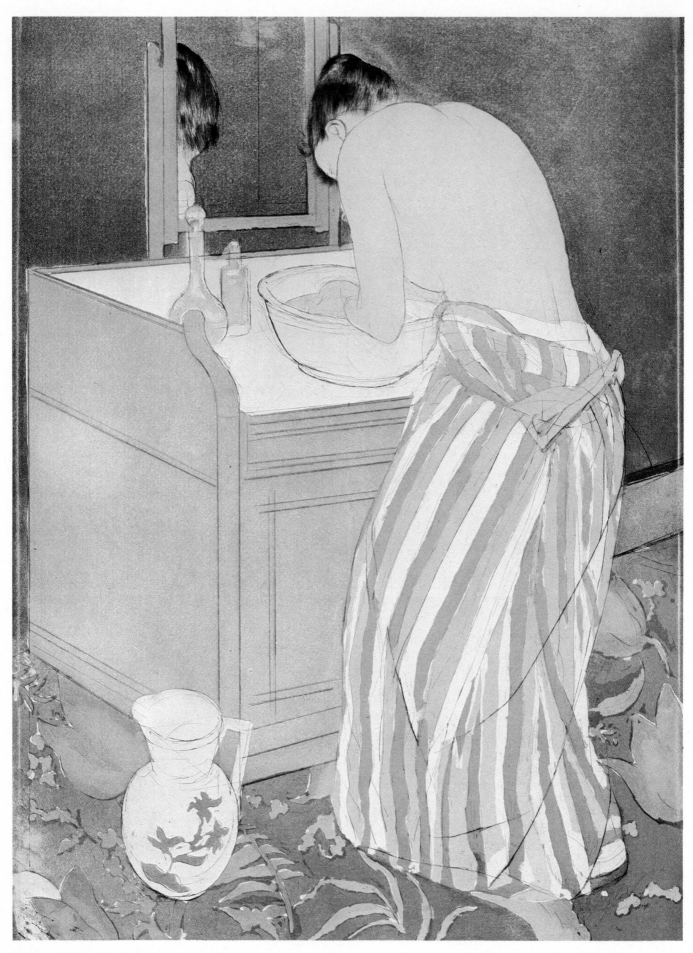

XXVI *Woman Bathing*
NEW YORK, Metropolitan Museum of Art (gift of Paul J. Sachs). 1891. Colour print with drypoint, softground and aquatint, fifth state 35·6 × 26·2 cm.

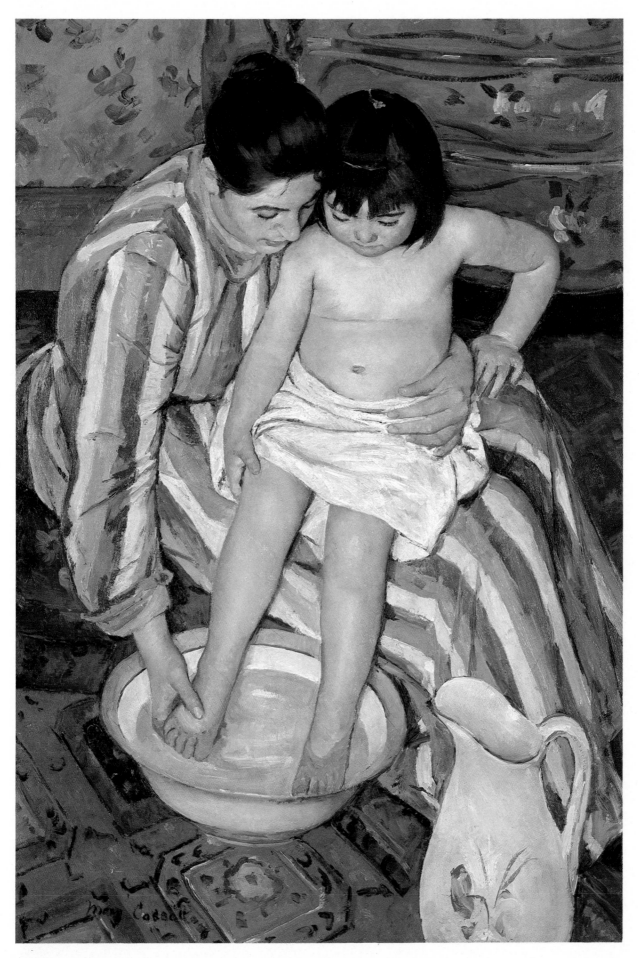

XXVII *The Bath*
CHICAGO, Art Institute of Chicago (Robert A. Waller fund). 1892. Oil on canvas 100·4 × 66 cm.

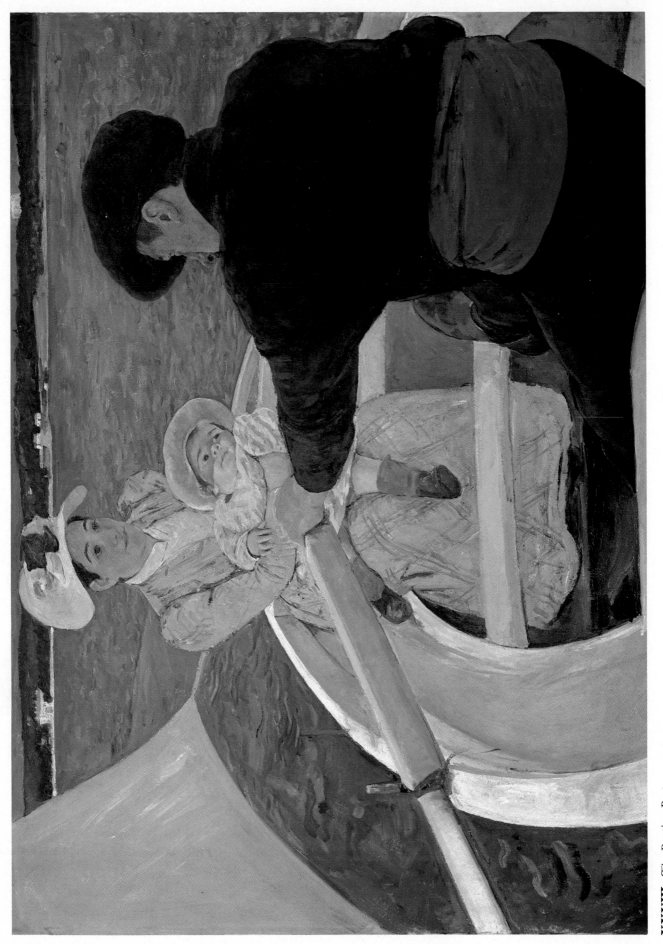

XXVIII *The Boating Party*
WASHINGTON, National Gallery of Art (Chester Dale collection). 1893–94. Oil on canvas
90·2 × 117·2 cm.

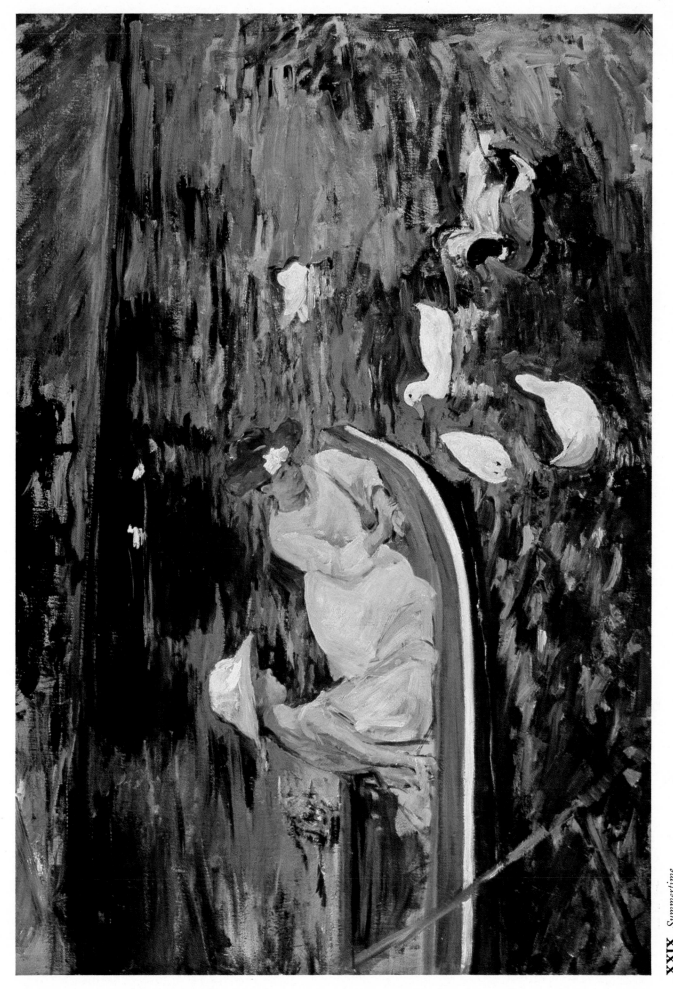

XXIX *Summertime*
LOS ANGELES, Armand Hammer Foundation. 1894. Oil on canvas 73·7 × 96·5 cm.

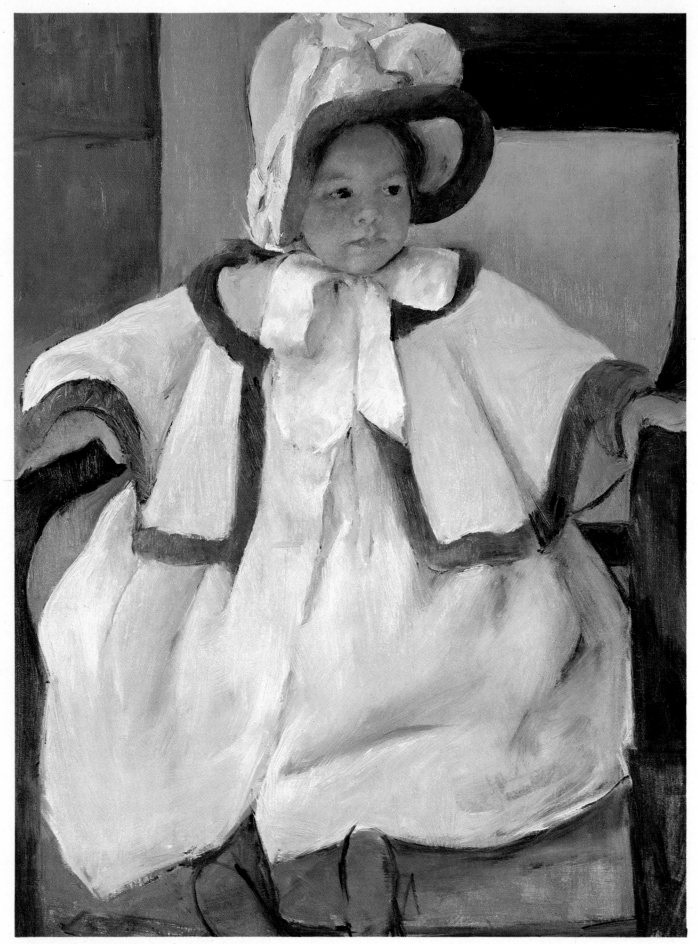

XXX *Ellen Mary Cassatt in a White Coat*
CAMBRIDGE (MASSACHUSETTS), private collection. 1896.
Oil on canvas 81·3 × 61 cm.

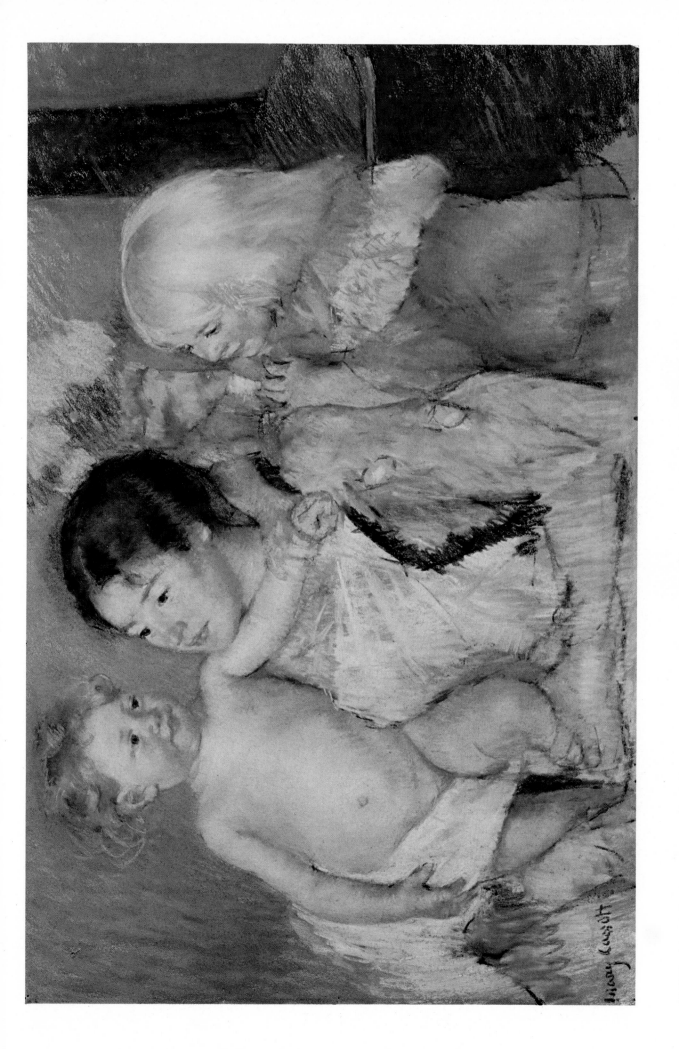

XXXI *After the Bath*

CLEVELAND (OHIO), Cleveland Museum of Art (gift of J. H. Wade). c. 1901. Pastel on paper
65·4 × 99·7 cm.

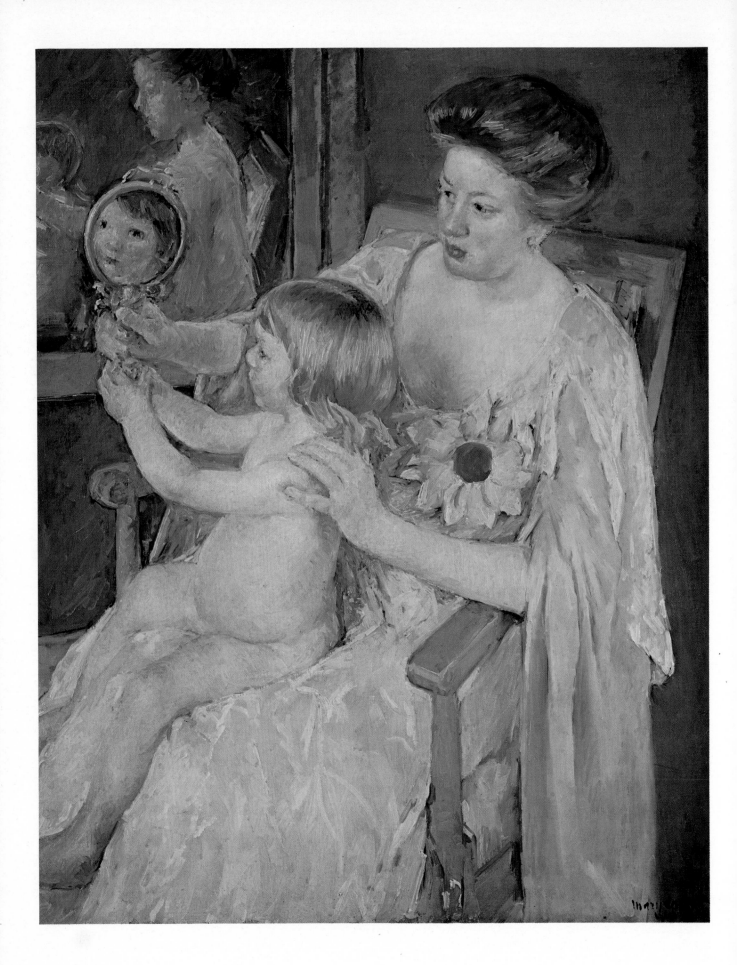

XXXII *Mother and Child*
WASHINGTON, National Gallery of Art (Chester Dale collection). c. 1905. Oil on canvas
92·1 × 73·7 cm.

I *On the Balcony during the Carnival*
PHILADELPHIA, Philadelphia Museum of Art (W. P. Wilstach collection). 1872. Oil on canvas
101 × 82·5 cm.

This was one of Cassatt's first exhibited works. It was shown at the Salon in Paris in 1872 under
the title *During the Carnival*, but for whatever reasons of modesty or family disapproval she sub-
mitted the picture under the name 'Mlle. Mary Stevenson'. Her family's reactions to her pursuit
of her career are revealed in a letter from her brother Alexander to his wife, Lois Buchanan. 'She
[Mary] is in high spirits as her picture has been accepted for the annual exhibition in Paris. This
you must understand is a great honour for a young painter and not only has it been accepted but
it has been hung on the "line" . . . Mary's art name is "Mary Stevenson" under which name I
suppose she expects to become famous, poor child.' This picture inaugurates a series of paintings of
Spanish subjects, which, while they conform to the type of picturesque costume pieces (Plate 2),
reveal affinities with an artist who exerted an important influence on Cassatt's style, Edouard
Manet. During the 1860s Manet had frequently painted Spanish subjects, for instance *Lola de
Valence* of 1862 (Paris, Musée du Louvre), many of which Cassatt could have seen in Manet's pavilion
at the Exposition Universelle in Paris in 1867. At the Salon of 1869 Manet exhibited a large
canvas of three figures on a balcony and it is tempting to establish a connection between this
work and Cassatt's. However Cassatt's painting is entirely different in conception with its complex
interrelations of figures and sense of fulsome vitality and sunny gaiety. The forms are substantial
and, instead of Manet's alienated stares and isolated individuals, Cassatt's subjects are distinctly
animated. Despite the *hispanisme* of the setting, it is still an Italian painting.

II *Torero and Young Girl*
WILLIAMSTOWN, Sterling and Francine Clark Art Institute. 1873. Oil on canvas 101 × 85 cm.

Cassatt followed up her first Salon success with a second similar subject painted the following year
in Seville. Together with *On the Balcony* (Plate I), *The Torero and Young Girl* was sent in 1874 to
the American equivalent of the Salon, the National Academy of Design in New York. At this date
Cassatt was concerned to make herself a reputation within the existing establishment in America as
much as in France. This painting reveals the impact of the studies of Velázquez which had taken
Cassatt to Spain in 1872. The smooth contours and fluid forms of *On the Balcony* gave way to a
more broken application of paint and brilliance of colour. In seeing the work of Velázquez and
Goya, the masters of Manet, Cassatt also began to evince some influence from her older con-
temporary himself, in the way she used strong contrasts of light and dark and created a truly
material effect of reality. The axis of the composition, however, still retains the traces of her
Italian Baroque and Mannerist masters.

III *A Musical Party*
PARIS, Musée du Petit Palais. 1874. Oil on canvas 96·4 × 66 cm.

Women playing musical instruments attracted Cassatt from her earliest extant works and reappear
in each period from *The Mandolin Player* of 1872 (United States of America, collection of Anthony
D. Cassatt) to the *Banjo Lesson* of 1894 (Richmond, Virginia Museum of Fine Arts). The theme was
also included in the side panels for the mural of *Modern Woman* for the World's Columbian
Exposition in Chicago in 1893. Despite the date on the canvas itself, the style and composition
suggest closer affinities with the paintings of 1872–73. However the figures are in contemporary
dress and there is a new feeling for intimacy and an interior setting that suggests Cassatt had
begun to look seriously at eighteenth-century French art or indeed the *petits maîtres* of Holland,
which she had visited late in 1873.

IV *The Young Bride*
MONTCLAIR, Montclair Art Museum (gift of Max Kade Foundation). c. 1875. Oil on canvas
88 × 69·3 cm.

On her return to Paris in 1873–74 Cassatt worked mostly on portraits and single figures. She
continued to submit her work to the Salon, but in 1875 one of her paintings was rejected for being
too highly coloured. *The Young Bride* was possibly the rejected work. It has been identified as a
portrait of Cassatt's maid at that time, Martha Ganloser, shown quietly engaged in her knitting.
Its mood, costume and occupation suggest new sources in Cassatt's development resulting from her
trip to the Low Countries where she could have seen such subjects treated by the *petits maîtres* of
Holland. It is conceivable that she had seen a painting by the then recently 'rediscovered' Vermeer,
whose *Lacemaker* had arrived in Paris in 1870 and was acquired shortly after by the Louvre.

65

V *Mrs. Duffee Seated on a Striped Sofa*
BOSTON, Museum of Fine Arts (bequest of John T. Spaulding). 1876. Oil on wood panel 35 × 27 cm.

On a sofa of striped red and yellow silk, set against a background of warm grey, is seated a figure wearing a brilliant blue dress with pink and white details on the sleeves. This colouration, the quiet interior setting and the occupation of the sitter show quite clearly the influence on Cassatt of eighteenth-century artists, notably of Jean-Honoré Fragonard. The significance of this new influence is twofold. By turning to the eighteenth century Cassatt was in line with the contemporary critical and artistic currents in France by which the group known as the Impressionists had also been touched. Eighteenth-century French painting offered a model for fluent and free brushwork and more luminous and broken colour. However beyond merely stylistic influences lay the thematic or ideological possibilities of the art of the eighteenth century, with its interest in fashion and the contemporary on the one hand and the depictions of daily life and domestic emotions on the other. In the mid-1870s Cassatt was turning away from the fanciful and picturesque and from a mannered style and was painting subjects drawn from the life around her. In order to find the appropriate means to capture her world and its immediacy she looked to those schools of the art of the past, seventeenth-century Holland and eighteenth-century France, with which her new interests shared ideological affinities. *Mrs. Dufee* incorporates these new directions and the sources on which she was to base them and as a work of transition still clearly reveals its debts.

VI *Girl in a Blue Armchair*
UPPERVILLE, collection of Mr. and Mrs. Paul Mellon. 1878. Oil on canvas 89 × 130 cm.

In 1877 Degas visited Cassatt and invited her to participate in the Impressionist and Independent group exhibition. Her explorations of the art of the past to equip herself with sound mastery of her own art and her search for a lively modern style received confirmation in the art of Holland, Italy and France and of contemporary French painters like Manet. This painting, executed within the year of meeting Degas, betrays these new allegiances in the bold composition and unconventional subject. However two features in which she came closest to Degas also retain the stamp of Cassatt's American origin and her thorough study of the art of the past; she worked with real space and, through her vigorous brushwork, conferred a solidity on all the forms.

VII *Woman and Child Driving*
PHILADELPHIA, Philadelphia Museum of Art (W. P. Wilstach collection). 1879. Oil on canvas 89·3 × 130·8 cm.

In the early 1870s Cassatt had posed figures outdoors and painted one or two landscapes, for instance *Picking Flowers in a Field* of 1875 (present whereabouts unknown), which suggest that she was familiar with the art of Claude Monet. However landscape never became an important element of Cassatt's *oeuvre* though she did, as in this fine painting, use it as a setting. Her sister Lydia, a niece of Degas called Odile Fièvre and the Cassatt family's young groom are shown driving through the Bois du Boulogne in a small carriage which had been purchased that year through the generosity of Cassatt's brother Alexander. The cropped and asymmetrical composition recalls similar works by Degas such as *Carriage at the Races* of 1870–73 (Boston, Museum of Fine Arts), which was exhibited at the First Impressionist Exhibition in 1874. The close-up concentration on the figures, on the other hand, is more reminiscent of a work by Manet, the 1873 *Gare Saint-Lazare* (Washington, National Gallery of Art), in which a woman and a young girl are placed dominantly in the foreground against railings which divide them from the busy scene of the station beyond. These comparisons suggest certain affinities, the most important of which is the fidelity to contemporary subject matter and the use of certain compositional devices to render the subject immediate and distinctly modern. Cassatt's image is, however, richer in colour and more substantial in effect and contains a greater degree of psychological insight and expressive portraiture, especially in the treatment of the child. Though more boldly treated in colour and brushwork, the presentation of Odile Fièvre belongs to the series of depictions of little girls that Cassatt painted in the first decade of her working life and anticipates the later *Ellen Mary Cassatt in a White Coat* (Plate XXX).

VIII *Woman in Black at the Opera*
BOSTON, Museum of Fine Arts (Charles Henry Hayden fund). 1880. Oil on canvas 81·3 × 66 cm.

The radical implications of this painting, in terms of the image of Woman projected, have already been fully discussed (pp. 10–11). The format is close to the pastel *Young Woman in a Loge* (Plate 10), with the figure set at right angles to the canvas, gazing into the theatre space. However the painting does not share the dazzling colour of the works of 1879 (Plates 8–10), reverting in its use of many-toned blacks and more sombre reds to the works of the early 1870s. To some critics this change has suggested a revived interest on Cassatt's part in the work of Manet. Cassatt sent *Woman in Black* to America to be shown by the new independent exhibiting group, the Society of American Artists, which she had been invited to join in 1878. She became a member in 1880 and offered this work for exhibition in 1881. Thus by 1880, in both America and France, Cassatt had decisively moved from the established institutions of the National Academy of Design and the Salon to the Independents on both sides of the Atlantic. Sweet (1966) quotes an approving American critic, William C. Brownell, discussing Cassatt in 1881. 'It is easy to see . . . that in force, few, if any, among American women artists are her rivals . . . There is an intelligent directness in her touch and her entire attitude beside which a good deal of painting now abundantly admired seems amateur experimentation. Hers is a good example of the better sort of impressionism . . . Perhaps it is especially successful . . . because Miss Cassatt served an academic apprenticeship, and "went over" to Degas . . . only after she had acquired her powers of expression.'

IX *Lydia Crocheting in the Garden at Marly*
NEW YORK, Metropolitan Museum of Art (owned jointly with Mrs. Gardner Cassatt). 1880. Oil on canvas 66 × 94 cm.

The Cassatt family often rented villas in the country areas around Paris for the summer. At Marly-le-Roi, where Cassatt painted her sister in one such villa's garden, Edouard Manet was a near neighbour and Cassatt enjoyed close friendly relations with him until his death in 1882. Another frequent visitor to Marly was the painter Berthe Morisot. *Lydia Crocheting* was in the Sixth Impressionist Exhibition in 1881, where it met with considerable success. Degas saw the painting on Cassatt's return from her summer of painting and commented in a letter to Henri Rouart of 26 October 1880, 'What she did in the country looks well in studio light. It is much stronger and nobler than what she did last year.' This painting is a very subtle portrayal of Lydia, whose invalid condition is sensitively captured in the pallor that Cassatt dared to place against the bright white of the bonnet and its bow. Lydia is dressed in blue and set before a rich variety of summer greens, while a purple-copper-toned border of plants leads the eye into the space beyond the figure to a multi-windowed greenhouse or conservatory, blocking off the back of the painting. This canvas was painted with all the skill of the Impressionist masters, for the window-panes take up in subtly modulated tones the colours and light of the surrounding greenery. The oblique angle of vision and foreground figure recall the devices employed in *Girl in a Blue Armchair* (Plate VI), but here they serve to concentrate the viewer's attention on the figure itself, its quietness and self-absorption, while the surrounding garden is rendered as intimate and secluded as an interior.

X *Five O'Clock Tea*
BOSTON, Museum of Fine Arts (Maria Hopkins fund). 1880. Oil on canvas 64·8 × 92·7 cm.

Visiting to take tea was part of the daily round of many middle-class women of the period and in this painting it is the subject of one of the interiors which prompted the admiring comments of the critic J.-K. Huysmans (p. 12), when he saw Cassatt's work at the Fifth Impressionist Exhibition. It is however tempting to interpret the compressed space of the painting as something other than the happy, harmonious quietness Huysmans observed, for the pressure of the figures against both the objects in the painting and the surface of the canvas verges on the claustrophobic. Cassatt did not convey any fleeting impression of an interior, but solidly constructed her figures with a rigorous concern for volumes and forms. The treatment of the arm of the woman on the left with its directional brushwork, reminiscent of Cézanne by whom Cassatt owned at least one work, is particularly impressive and one can sense the pressure of the flesh encased in the fine-textured, tight sleeves. The painting also heralds Cassatt's growing interest in the use of pattern, evident both in the upholstery and the wall-paper, which she was to use to such effect in the colour prints of 1891 and which younger artists of the group of Nabis, Edouard Vuillard and Pierre Bonnard, were to employ in their treatments of similar home interiors. It is conceivable that Cassatt's paintings and prints, which were exhibited in 1891 and 1893 in Paris, exerted some influence on both these painters.

XI *Portrait of Miss Mary Ellison*
WASHINGTON, National Gallery of Art (Chester Dale collection). c. 1880. Oil on canvas 85·7 × 65·2 cm.

Mary Ellison was a young American lady who attended Mme. Del Sarte's *pension*, the same school as did Louisine Elder, later Havemeyer. In 1877 her father commissioned a portrait of her by Cassatt, which is now in an American private collection. This later portrait in Washington is a very different work from the earlier portrayal of a young, spritely adolescent, looking up engagingly from her inevitable embroidery. Instead the mood here is sombre and almost mournful and the sitter seems lost in her own thoughts, a feature increasingly common in Cassatt's mature works of the early 1880s. It can be illuminatingly contrasted to portraits by Jean-Auguste-Dominique Ingres (1780–1867) who was greatly admired by Degas. Ingres also employed the device of a figure seated in a full sofa against a mirror, for instance in *Mme. Moitessier Seated* of 1856 (London, National Gallery) which Cassatt could have seen at the 1867 exhibition of Ingres's work in Paris. Unlike Ingres, however, Cassatt treated the accessories of dress and texture summarily, concentrating on the subjective consciousness of the sitter, even coarsening the features so as not to allow superficial prettiness to distract from the solid presence of the thoughtful young woman.

XII *Mother about to Wash her Sleepy Child*
LOS ANGELES, Los Angeles County Museum of Art (bequest of Mrs. Fred Hathaway Bixby). 1880. Oil on canvas 100 × 65 cm.

The compressed space and the interest in pattern to divide and vary the surface of the picture, the substantiality of the forms and the increasingly bold brushwork, all aspects previously remarked on in the discussion of paintings of this very productive year (Plates VIII, IX, X, XI and 11–13), are present again in this early treatment of the mother-and-child theme. In this picture Cassatt brought to admirable fruition both her experiments in Impressionist colour and brushwork and her study of individuals through portraits. Despite the almost averted face of the mother, Cassatt conveyed seriousness and concern for the task in hand. In the unusual pose of the child there is a complete grasp of its undeveloped anatomy and ungainliness, characteristics which could be seen in the poses of the *Girl in a Blue Armchair* (Plate VI) and *Woman and Child Driving* (Plate VII). Here, however, they serve as a contrast to the solid, monumental form of the mother, illustrating the important use of significant oppositions in the construction of Cassatt's works. Exhibited in 1880, this painting follows closely the colour theories then current in its use of complementaries of green and red and in the way the dominant green of the chair and wall-paper affect the local colour of the white dress, shadows in the folds of clothing echoing the surrounding greens.

XIII *Two Young Ladies in a Loge*
WASHINGTON, National Gallery of Art (Chester Dale collection). 1882. Oil on canvas 80 × 64 cm.

In contrast to the drawing (Plate 21), the figures in the painting are more substantial and monumental, qualities characteristic of Cassatt's American version of Impressionism. They have been moved slightly forward and fill out the space in the foreground more dominantly. Cassatt also moved the fan, which in the painting covers the lower half of the young woman's face. This daring device of hiding the face was first used in *Five O'Clock Tea* (Plate X), in which a cup held to the lips of the visitor obscures all save her lively eyes. In *Two Young Ladies in a Loge* Cassatt again set the figures in front of a mirror that shows the curving balconies which, as in *In the Opera Box* (Plate 13), contrast with the rigid verticality of the seated figures. This opposition serves to reinforce the decorous mien of the two women and their very uprightness banishes any suspicion of the sexuality so frequent in the treatments of this subject by Renoir.

XIV *Susan on a Balcony Holding a Dog*
WASHINGTON, Corcoran Gallery of Art. 1883. Oil on canvas 100·3 × 64·7 cm.

The challenge of a large area of white responding to the reflected light of sun and surroundings in a rainbow of colours was taken up repeatedly by French artists in Cassatt's circle and this picture of a woman who worked for the Cassatts is perhaps her finest essay in painting reflected light. Equally remarkable are the warm hues of the shaded face and the subtle tonalities of the fur of the little Belgian griffon she holds on her knee. This painting possibly dates earlier than the *Young Woman in Black* (Plate XV), for the paint has been applied with thick impasto in places and fine directional brushwork, for instance on the gloved hand. The view over Parisian rooftops is lightly sketched as a background. The urban scene, which so often attracted Monet and Pissarro, rarely captured Cassatt's attention and is seen here as a place beyond and outside, distant from the space of an apartment in which the viewer is hypothetically placed by the closeness of the figure in the foreground.

XV *Young Woman in Black*
BALTIMORE, Baltimore Museum of Art (on loan from the Peabody Institute). 1883. Oil on canvas 80·6 × 64·6 cm.

Behind the bold, black-dressed woman Cassatt placed part of a framed fan, which hints at her involvement with Japanese art at this date. The decoration of the surfaces of fans in imitation of Japanese imports had been explored by artists in the Impressionist circle, notably Degas, Pissarro and Gauguin. Fans were also used as decorative elements in works by Manet, for instance his *Lady with Fans* of 1873–74 (Paris, Musée du Louvre). Cassatt's use of the fan is more structural, for it is a single circular element set within and cut off by repeating rectangles within and on the frame of the painting. However the overall effect of this painting is, in fact, more decorative than many of Cassatt's works before this date. The space is very compressed. The seated figure dressed in black creates a large, sharply-defined silhouette against the lighter pinks and greens of the upholstered sofa. A pink bow at her neck enlivens this otherwise unrelieved blackness. Contour and pattern seem more important than solid form or structure and adumbrate the direction of her work until the colour prints of 1891, which fully realized this potential. But within this flattened design, the averted gaze of the woman, which everything in the painting itself serves to push forward towards the viewer, is more marked and confident.

XVI *Portrait of Alexander Cassatt and his Son*
PHILADELPHIA, Philadelphia Museum of Art (W. P. Wilstach collection and gift of Mrs. William Coxe Wright). 1884. Oil on canvas 100 × 81·2 cm.

Cassatt often took the opportunity of her brother's visits with his family to use the children as models and on occasion attempted portraits of their father. This double portrait is interesting because she not only combined father and son in the same canvas, but also united them by certain subtle effects achieved through the selected pose. In black and white reproduction, the slightly varied tones of the two figures' dark clothing fuse into one mass. The closed and stable form of the older man is contrasted to the looser and more casual pose of the younger, but their heads are directly juxtaposed in a manner that brings out the family resemblance. In the same way in which Cassatt was later to oppose maturity and immaturity, she played here on the smaller, less developed face of the boy in relation to that of the mature man. But they do not look at each other; they both gaze in the same direction, which effaces slightly the inherent oppositions and creates in effect the sense of one as a smaller version or reflection of the other.

XVII *Young Woman Sowing in the Garden*
PARIS, Jeu de Paume. c. 1884–6. Oil on canvas 91·5 × 64·7 cm.

The outdoor setting and the motif of a woman sowing recalls the work of the early 1880s done outside Paris whilst Cassatt was on Summer retreat in the country. In comparison with a similar painting from this period, *Lydia Crotcheting in the Garden at Marly* (Plate IX) it can be seen that Cassatt produces a different effect by positioning her model both centrally and frontally, framed by the chair-back and making her dominate the pictorial space of the canvas. Such an organisation of the model and space suggests the emphasis that a portrait has. However, at the same time the model's seemingly private preoccuation with the task in hand distances the spectator from such an engagement with the sitter and suggests instead that we read the painting as a Genre scene taken from the life of a middle class lady. Cassatt manages to hold the painting between these two points,

and in doing so, she once again shifts the meanings of traditional schemes of the representations of women. This painting is thus both the picture of an individual woman; she is not just a figure in a landscape, she is a specific person whose dress, facial features and manner are carefully detailed. However, this woman as portrayed is nameless; our woman sowing in the Garden engaged in a task so typical of her sex and class as to be unnoticeable as actual work. Yet in this painting Cassatt stresses the woman's self containment and completely quiet involvement in what she is doing. Her sowing is no longer naturalised as merely the natural attribute of Bourgeois femininity. The painting was done around 1884 but it was exhibited in 1886 at the eighth and last capital Impressionist Exhibition, as was another painting that approached a similar domestic motif and effected a comparable transformation of Genres, *Girl Arranging her Hair* (Plate XX).

XVIII *The Little Sisters*
GLASGOW, Glasgow Art Gallery. c. 1885. Oil on canvas 48·2 × 57 cm.

The canvas is probably unfinished despite the fact that the artist signed it and a dealer, Ambroise Vollard, acquired it. Its incompleteness as an image is however appropriate to the theme of the two young and as yet unformed persons. The most complete parts of the picture, and also the most significant, are the faces which gaze up and out of the canvas from a position within the space of the painting that stresses their vulnerability and smallness. It is one of the more delicate of Cassatt's early studies of children, upon which she based the more substantial images that follow.

XIX *The Family*
NORFOLK (VIRGINIA), Chrysler Museum (gift of Walter P. Chrysler, Jr.). c. 1886. Oil on canvas 81·2 × 66 cm.

Monumentality is fully present in this large painting of a family seated in a garden. In writing of this painting, John Bullard (1972) notes Huysmans's comparison of Cassatt's work in 1881 with that of the English Pre-Raphaelites. The profile of the girl on the left, her red hair and her subtle expression particularly recall the paintings of J. E. Millais (fig. 13). Bullard also cites the drawings of Holbein in relation to the clean profile and contours. Cassatt's association with the Pre-Raphaelites can best be understood in terms of mutual concerns, for she remained involved throughout her *oeuvre* with the subjective consciousness of her sitters, trying to find the means to capture a certain innerness or *intime* quality which French critics often remarked on in paintings of the English School. This interest is especially evident in the exchange of glances between the two children, who contemplate each other from well within themselves. A shift is apparent in Cassatt's style, from the impasto and crisscross brushwork of her earlier paintings of this decade to more controlled surfaces which are clearly defined by delicate contours.

XX *Girl Arranging her Hair*
WASHINGTON, National Gallery of Art (Chester Dale collection). 1886. Oil on canvas 75 × 62·2 cm.

Degas and Cassatt had both abstained on principle from the Seventh Impressionist Exhibition in 1882, but a last attempt to organize a show was made in 1886 and Cassatt exhibited *Girl Arranging her Hair*. Camille Pissarro reported some of the difficulties of the project to his son in a letter of 5 March 1886. 'The suggestion that the more wealthy members of the group should support it, pointed directly at Mary Cassatt. This made her intensely angry and caused her to wonder whether these artists might not be more interested in her money than in her art.' Cassatt's supposed wealth was the result of her successful sales of work, not family money, and it seems ironic that her funds, the product of her work's recognition, should have put her in the invidious position Pissarro described. This painting apparently resulted from an argument between Degas and Cassatt over the question of whether women could judge the quality or 'style' of a work of art, a question which demonstrates the extent of the prejudices against women, even within the avant-garde. However when the painting was exhibited Degas apparently remarked 'What drawing! What style!' and insisted on exchanging one of his pastels in the exhibition of women bathing for this canvas, which remained in his collection until his death. The quality of the painting was such that many who saw it in the Degas sale in 1917 at first believed it to be his work. This confusion illustrates the lack of recognition of women's skills, but, ironically, this painting had disproved for Degas his own biased attitudes.

XXI *Emmie and her Child*
WICHITA, Wichita Art Museum (Roland P. Murdock collection). 1889. Oil on canvas 89·9 × 64·5 cm.

In another unfinished canvas a quieter and more contemplative mood is depicted through the frontal placement of the figures and the pattern of interlocking gestures. *Emmie and her Child* is a marvellously satisfying picture, with its thick and confident paint brushed boldly over the objects and, its incompleteness notwithstanding, one can feel the material substance of the pitcher, the clothes and the exposed flesh of the child at the same time as one can appreciate the artist's ability to convey subtle psychological relationships by material means of paint and canvas. Despite the freely painted passages of the pitcher and the child's white shift, the influence of Cassatt's work in pastel can be observed in the delicate brushwork of the hands and limbs of the figures.

XXII *Baby's First Caress*
NEW BRITAIN, New Britain Museum of American Art (Harriet Russell Stanley fund). 1891. Pastel on paper 76·2 × 61 cm.

Cassatt used pastel more confidently and frequently in the last years of the 1880s and one can see in *Baby's First Caress* the results of her experiments. Drawing with coloured chalks incorporated both her increasing interest in line and her long established expertise in modulation of colour. On coloured paper she built up dense layers of pastel strokes; for instance on the mother's dress she moved up from the beige undercolour to the bright whiteness of the highest lights. On the child's body and the mother's face she achieved a delicate tonality of silken skin and reflected light, comparable to the effects produced by Rubens.

XXIII *The Omnibus*
NEW YORK, Metropolitan Museum of Art (gift of Paul J. Sachs). 1891. Colour print with drypoint, softground and aquatint, fourth state 35·6 × 26·2 cm.

These three illustrations document stages of the third print in Cassatt's 1890–91 series, which takes as its subject a typically modern scene of city life. The drawing (Plate 33) shows, summarily sketched, a figure of a man who was not included in the final print and also indicates the main outlines which were pressed hard for transference onto the softground of the plate. The second state of the print (Plate 34) has the main colour areas added in aquatint with shades of tan, rose, green and black ink, but it concentrates only on the scene inside the tram or bus. The fourth and final state includes the view out of the window and the shading of the interior of the vehicle. To achieve the clarity of colour that Pissarro so admired, enormous skill was needed in the printing, especially in areas where two tones intersect, for instance in the juxtaposition of the foreground figures and the view beyond.

XXIV *The Letter*
NEW YORK, Metropolitan Museum of Art (gift of Paul J. Sachs). 1891. Colour print with drypoint, softground and aquatint, third state 33·7 × 22 cm.

The influence of Japan is clearer in this, the fourth print of the series, not only in the oriental cast of the woman's features but also in the pose which Ives (1974) compares to Utamaro's *Portrait of Oiran Hinzauru* of c. 1796 (Chicago, Art Institute of Chicago). None the less a more European effect exists in the distinctly contemporary costume and setting. The quiet, reserved and distinguished quality of the woman at her writing desk recalls the eighteenth-century iconography of the love letter, as well as the depictions of women engaged in some quiet task found in the work of Vermeer. Stylistically, the print is the first to incorporate Cassatt's masterful use of both the impressionable grain of softground and the graininess of aquatint in achieving such rich and varied patterned textures.

XXV *The Fitting*
NEW YORK, Metropolitan Museum of Art (gift of Paul J. Sachs). 1891. Colour print with drypoint, softground and aquatint, fifth state 36·8 × 25·3 cm.

The patterning of the surface in this plate and the articulation of the figures, including a mirror reflection, reveal Cassatt's growing confidence and daring. The Colour Plates of *The Letter* (Plate XXIV) and *The Fitting* give some indication of the subtle tones used by Cassatt and also demonstrate further the pairing of the prints in which she alternated the use of apricot pinks and browns, associated with the eighteenth-century school of Japanese printmakers, with the blues and greens more typical of the nineteenth-century graphic artists. In both the elegant sway of the standing figure and the compact but expressive silhouette of the kneeling dressmaker Cassatt revealed her profound understanding of the Japanese prototypes, which she incorporated into a distinctively contemporary French scene. Yet her standing woman displays a certain boredom. She escapes being merely a fashionable clothes-horse, for some private thought seems to have been captured even in the slightly treated features of her face.

XXVI *Woman Bathing*
NEW YORK, Metropolitan Museum of Art (gift of Paul J. Sachs). 1891. Colour print with drypoint, softground and aquatint, fifth state 35·6 × 26·2 cm.

Blue is the dominant tone in this print with its plain walls and lavishly patterned floor. A subtle apricot is used in the stripes of the dress and on the washstand itself and the print also includes a mirror, as do both *The Fitting* (Plate XXIV) and *The Coiffure* (Plate 39), a device for which Ives (1974) adduces sources in Japanese prints (fig. 11). However Cassatt's use of the mirror is distinctive because her female figures do not look at themselves, but instead turn away to their thoughts or activities. This print of a woman's *toilette* recalls the canvas *Girl Arranging her Hair* (Plate XX), both in subject and in the rigour of the treatment. The oil has been linked directly with Degas who had exhibited a series of pastels of women, observed as if through a keyhole, washing themselves 'like

animals'. This treatment of a subject thus associated with Degas strikes one both as an opportunity to prove yet again Cassatt's competence with line and as a challenge to Degas's treatment of women in his work, for Cassatt conferred a quiet dignity on her subject, which is devoid furthermore of all voyeuristic titillation.

XXVII *The Bath*
CHICAGO, Art Institute of Chicago (Robert A. Waller fund). 1892. Oil on canvas 100·4 × 66 cm.

In one of the 1890–91 series of ten colour prints Cassatt portrayed a mother bathing her child (see Plate 48), contrasting the small and rotund naked body of the large area of the flowered dress of the kneeling mother. In *The Bath*, executed in the following year, Cassatt again used contrasts of patterned areas to enliven and construct the painted surface against which the plain towel and naked body of the child achieve pictorial prominence. However in the painting Cassatt employed a more acute angle of vision, viewing the scene from above so that the space depicted is tilted sharply upwards towards the plane of the canvas. Yet the solidity of the forms, the opposing diagonals of the figures and the contrasts of texture deny this purely decorative tendency. Degas used this tilted perspective in his earlier studies of women bathing to give the effect of peering through a keyhole or to integrate the figure with the flat surface of the paper, but he never aspired to the monumentality of the Cassatt painting. It would seem from Cassatt's unusual juxtaposition of a tilted perspective with the solidity of the figures that her intention was quite distinct from that of Degas. Indeed the effect of the angle of vision is to concentrate attention on the two figures, whose gaze reinforces the direction of the spectator's look towards the activity in which they are both engaged. By this means the image of mother and child is pruned of many of its traditional emotional associations. Thus in contrast to Cassatt's previous work, in which formal devices were manipulated to engage interest in the unexpected symbolic meanings of a mundane act, a very structured composition is deployed here in order to emphasize the actions of rather than the relations between mother and child.

XXVIII *The Boating Party*
WASHINGTON, National Gallery of Art (Chester Dale collection). 1893–94. Oil on canvas 90·2 × 117·2 cm.

The shift of intention in Cassatt's work in the 1890s is clearly illustrated by *The Boating Party*. Bullard (1972) suggests a comparison with a painting by Manet, *Boating* of 1874 (New York, Metropolitan Museum of Art), which Cassatt later persuaded the Havemeyers to buy. Indeed such an association seems inevitable for the outdoor subject of a boating party harks back to the *plein air* Impressionism of the early 1870s. Moreover the bold, dark blue silhouette of the boatman and the bright yellow of the boat also recall the example of Manet. Yet Cassatt once again used a high angle of vision, cutting off all but a slice of the blue Mediterranean sky (the picture was painted at Antibes) at the top of the canvas. The spectator is precipitated into the boat, pushed into the picture space by the *repoussoir* figure of the boatman and attracted towards the space between the two main figures who are linked by their exchanging glances. This device recalls the print *The Bonnet* (Plate 27), in which Cassatt fixed the look of the female figure on a reflecting object within the painting. Here the male figure throws back the look, redirecting the spectator into the space of the picture at the same time as his action threatens to propel him out of it. It is through the manipulation of these conflicting forces that Cassatt interrogated the nature of a painting and the spectator's relation to pictorial space and in doing so revealed a much more profound understanding of the significance of Manet's radical experiments than any simple stylistic or thematic comparison would suggest.

XXIX *Summertime*
LOS ANGELES, Armand Hammer Foundation. 1894. Oil on canvas 73·7 × 96·5 cm.

It would seem from this sunny picture, one of her rare landscapes with figures, that Cassatt was reconsidering both her earlier work and the concerns of the Impressionists on which, in her paintings of the early 1890s, she seemed to have turned her back. The loose and broken brushwork implies a certain spontaneity in its execution and on the left the canvas shows through the hastily executed brushmarks. Instead of the solid areas of colour, which characterize, for example, *The Bath* (Plate XXVII), the paint was applied in short strokes and the effect of the sunlight was represented by small bricks of pure white, for instance on the sunhat of the seated woman, in a manner reminiscent of the early procedures of Claude Monet in *The Beach at Trouville* of 1870 (London, National Gallery). Monet himself painted summer scenes of women in boats on the water, as did Morisot, and Cassatt used the motif in a number of paintings in 1894 and a print in 1895. These scenes could have been painted on the lake at the Château de Beaufresne and Bullard quotes a letter from the artist, 'I am now painting with my models in the boat and I sit on the edge of the water and in these warm still September days it is lovely . . . The whole beauty of the place is in the water.' Such a frank admission of admiration for atmosphere and landscape is rare in Cassatt's writings and in response to a scene which had so delighted the landscapists in the Impressionist group, Monet and Morisot, Cassatt chose their stylistic means to attempt to capture her own response on canvas. But in the sharp perspective and the dense blues and solid greens, with the white highlights of the ducks, her more recent concerns remain apparent.

XXX *Ellen Mary Cassatt in a White Coat*

CAMBRIDGE (MASSACHUSETTS), private collection. 1896.
Oil on canvas 81·3 × 61 cm.

In this portrait of her favourite niece, Cassatt returned to the monumental, structured and psychological qualities of the *Portrait of Mrs. Cassatt* of c. 1889 (Plate 26) and renewed her interest in young girls evinced in the *Girl in a Blue Armchair* of 1878 (Plate VI) and *Child in a Straw Hat of* c. 1886 (Plate 24). Such single figure studies became more frequent after this date (Plates 51–53). The background is almost non-existent, suggested only by a few rectangles of varying colour. The figure is thus pressed forward despite the solid framework of the large chair in which she is seated. Cassatt played with scale in this painting in the juxtaposition of the outsized chair and the miniature figure perched rather than seated on it, yet Ellen Mary Cassatt almost fills the entire surface, her hat cut off at the top, both arms meeting its confines at the side and her feet almost defining its foremost plane at the lower edge. The clothes are bulky, solidly painted and inevitably dominant through the large area of white in the centre of the painting. But it is the little features that are most significant, the tiny head, the hands and the feet. Through the relation of these oddities of scale, Cassatt drew out the portrait element and managed to distil a sense of her niece's personality, despite the almost overpowering impact of the accessories and the manner of the painting's composition and style. After emphasizing spatial and pictorial elements in the experiments of the early 1890s, Cassatt retrieved her psychological concerns and married the two in this quite stunning portrait.

XXXI *After the Bath*

CLEVELAND (OHIO), Cleveland Museum of Art (gift of J. H. Wade). c. 1901. Pastel on paper
65·4 × 99·7 cm.

The frontal composition of *The Oval Mirror* (Plate 49) became almost frieze-like in this large pastel executed in the same productive period. The placing of the three figures in a single plane across the paper establishes a certain rhythm, drawing the eye from one to the other. This is reinforced by the colours. The little girl on the left is dressed in a bright rich orange which sets off the very pale gold of her hair and the mother, although dressed in pale colours, has a rich purple-brown tone to her hair which breaks up the generally luminous colouring and echoes the dark vertical on the extreme right. The three figures are brought together by the meeting of the two children's hands across the mother. Achille Segard called this work *The Adoration*, which is typically composed of an adult woman and two children. But here the St. John figure is a little girl, signifying a considerable shift in intention despite the possible use of religious paintings as a compositional source. The painting harks back to the oil of c. 1886, *The Family* (Plate XIX), and in both Cassatt explored, in addition to the mother-and-child relationship, the interaction of siblings. The long horizontal format, atypical of an artist who commonly used an elongated vertical rectangular canvas, serves to emphasize the two children flanking the central and shared parent. The suppression of the background also concentrates the pictorial interest on the foreground plane. Rather than simply transposing a religious subject into a secular setting in the painting, Cassatt used traditional iconography that has been transformed to focus attention on the contemporary institution, the family; and, in the strange self-containment of each figure and the lack of psychological unity, despite the strong compositional tendencies linking the figures, that institution appears complex and problematic.

XXXII *Mother and Child*

WASHINGTON, National Gallery of Art (Chester Dale collection). c. 1905. Oil on canvas
92·1 × 73·7 cm.

Cassatt's later work elaborated the subjects and styles established by 1905 but increasingly showed the traces of her failing eyesight and less steady hand, and within ten years of *Mother and Child* she was obliged to abandon work almost completely. Thus in this painting one can appreciate one of her most mature statements. For the radical implications of Cassatt's entire undertaking as a woman painter and a painter of women lie in the way in which she questioned and then transformed the ideologically biased images of women, which are inscribed into the very language of art. Her involvement with contemporary innovations of style, modern subjects and independent organizations provided her with the means to rupture centuries of iconographic tradition. And significantly, despite the attempts of biographers and critics to reposition her works within the traditional bourgeois view of women as mothers or decorative additions to the domestic setting, they have remained outside this tradition and this is, ultimately, the sign of her quite remarkable and truly feminist achievement.

1 *Two Children at a Window*
NEW YORK, private collection. c. 1868. Pastel on paper 71 × 51 cm.

No work by Cassatt dated earlier than 1868 survives, although she must have made many student drawings and oil copies of Old Master paintings between 1861 and 1868. This study of two children is significant for it illustrates her early use of pastel, a medium associated with a lady's 'accomplishment', art, but one to which she turned later in life when the medium had regained respectability in the hands of Manet and Degas. Furthermore, the preoccupations with close, domestic settings, childhood aspirations and social rôles, which form a theme throughout her work, are adumbrated in this very early pastel.

2 *The Bacchante*
PHILADELPHIA, Pennsylvania Academy of the Fine Arts (gift of John F. Lewis). 1872. Oil on canvas
62 × 50·7 cm.

The inscription on the lower left of the canvas 'Mary Stevenson Cassatt/Parma 1872' firmly dates
and places the execution of this fanciful figure painting. Against a light background a woman in
a bright yellow blouse and a blue scarf, with vine leaves in her hair, plays the cymbals. The painting
has also been titled *The Bajadere* or *Hindu Dancing Girl*. The effects of Cassatt's study of the early
fresco paintings of Correggio in Parma are evident in the lively movement of the figure, the subtle
colouring of the face, the solidity of the forms and the averted gaze of the dancer. However by
removing the dancing girl from a decorative ensemble and concentrating on the single figure and
the expression of the head, the artist gave greater significance to the direction of the gaze away
from the viewer.

3 *Early Portrait*
DAYTON, Dayton Art Institute (gift of Robert Badenhop). 1872. Oil on canvas 58·4 × 50·7 cm.

This portrait, at one time mistakenly considered a self-portrait, was also painted in Parma as the dedication on the canvas, 'A mon ami C. Raimondi', confirms. Carlo Raimondi (1806–1883) was a teacher at the Accademia in Parma from whom the artist learned the basic techniques of etching. The treatment of the brushwork and subtle variations of tone show Cassatt already moving towards the style which attracted Degas to her work in 1874. The unity of the work is ensured by the use of a wine-red background and tones of pink in the drapery. The sitter gazes off left and her serious expression endows the whole painting with a weightiness reinforced by the monumentality of the placing of the figure.

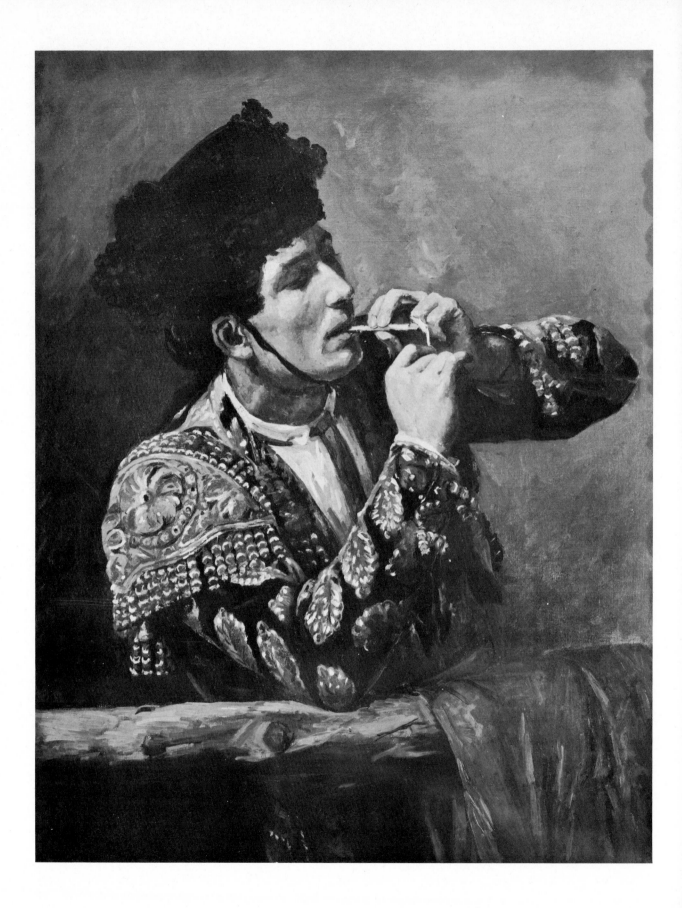

4 *Toreador*

CHICAGO, Art Institute of Chicago (bequest of Mrs. Sterling Morton). 1873. Oil on canvas 82 × 64 cm

The richly decorated costume of the Spanish matador provided an opportunity for a dazzling display of colour and virtuoso painting. However Cassatt began to shift her work from the picturesque subject composition through her study of the masters of Spanish art and Manet. The subject has a distinct flavour of modernity as the fighter pauses to light a cigarette.

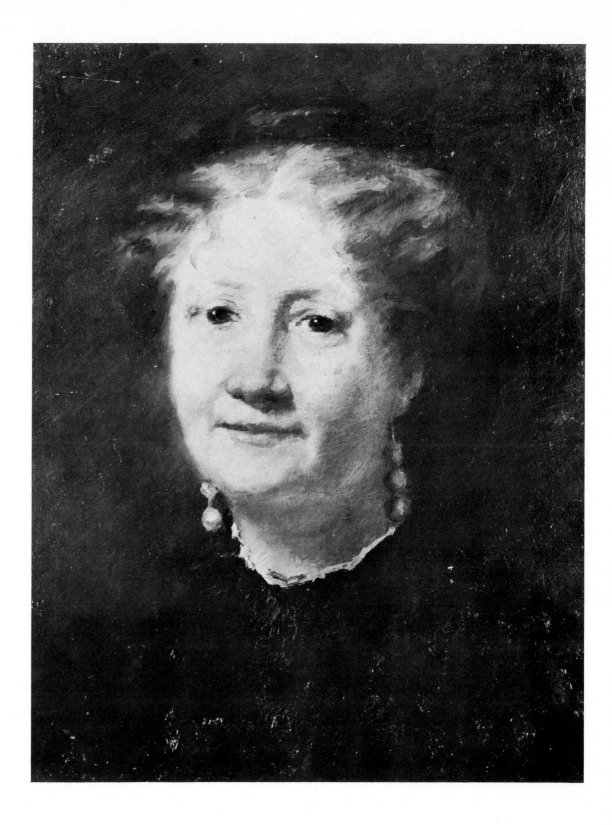

5 *Portrait of Mme. Cortier*
Private collection. 1874. Oil on wood panel 48·2 × 40 cm.

This was Cassatt's Salon exhibit for 1874. Its simplicity and frankness attracted the attention of Edgar Degas who is reported to have commented, 'C'est vrai. Voilà quelqu'un qui sent comme moi' ('It is real [true, genuine]. There is someone who feels as I do'). The warm-toned complexion, the attention to features and the characterful head that Cassatt so simply and convincingly portrayed introduced Degas to this young American painter and laid the foundation for the later fruitful friendship and working relationship based on shared concerns in modern art. The signature on the canvas, in the upper lefthand corner, reads M.S. Cassatt/Rome/1874. This provides evidence for a sojourn in Rome during this year.

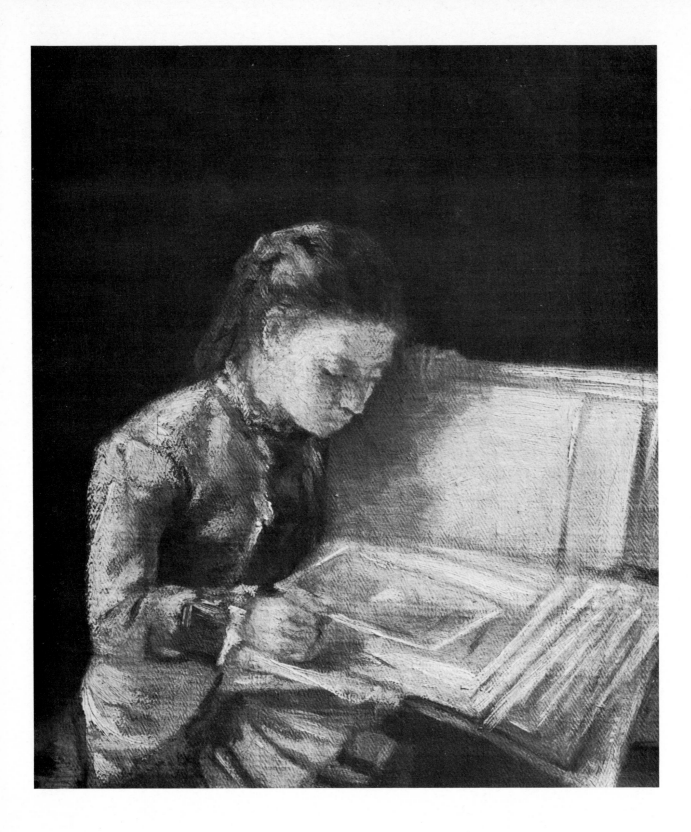

6 *Young Girl with a Portfolio of Pictures*
ATLANTA, High Museum of Art (J. J. Haverty collection). c. 1876. Oil on canvas mounted on
panel 22·6 × 20 cm.

Stylistically this work is close to *The Young Bride* (Plate IV), with a three-quarter-length seated figure
engaged in a quiet occupation. It also belongs with the rare but important representations of children
that are to be found in the first decade of Cassatt's documented work. It is tempting to read this
small painting autobiographically, for despite the awkwardness of the proportions of the figure
there is impressive dignity in the painting and the child's absorption in the large portfolio conveys
an authentic feeling, which springs probably from the artist's recollections of her own childhood
interests.

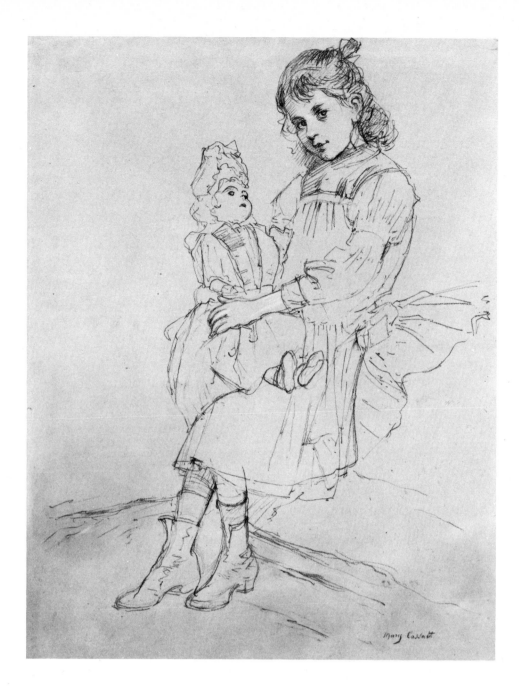

7 *Little Girl Holding a Doll*
NEW YORK, private collection. 1876. Black crayon on
paper 30·5 × 23 cm.

This lovely drawing shows a different and perhaps more
conventional view of childhood than *Young Girl with a
Portfolio of Pictures* (Plate 6), but the treatment of the
girl's expression and the rigidity of the doll belie any
sentimentality. The doll is awkward, stiff and constrained
and sits uncomfortably on the girl's knee. Its mask-like
face is caricatured by contrast with the gentle musing
expression of the girl, who almost disowns the doll by
proffering it to the spectator, while her whole mien seems
to question and quietly challenge the viewer. The
'naturalness' of a little girl holding a doll as a prefigure-
ment of her later maternal interests is thus subverted.
The little girl's conscious puzzlement is contrasted to the
overdressed, lifeless and miniature adult woman doll,
which can be taken as a symbol of the girl's likely future
as a woman.

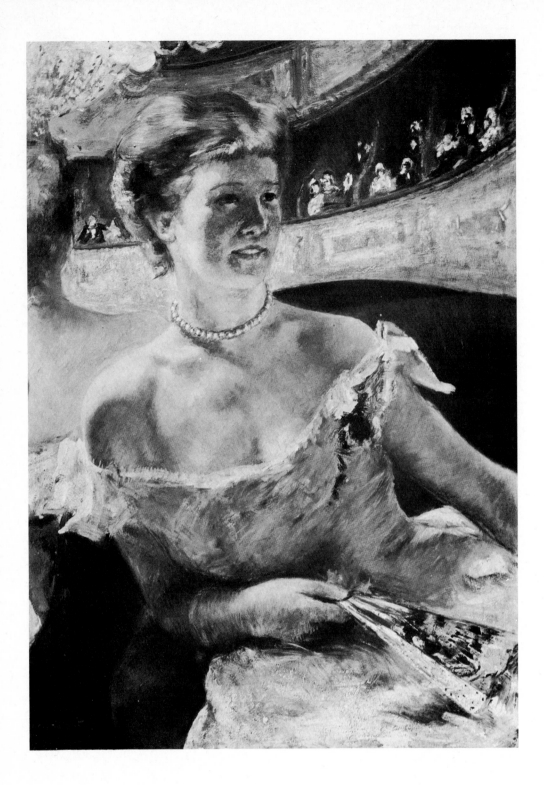

8 *Lydia in a Loge, Wearing a Pearl Necklace*
Present whereabouts unknown. 1879. Oil on canvas 80·2 × 58·2 cm.

Cassatt's family had come to Paris to settle with her in 1877 and her sister Lydia served, until her death from Bright's Disease in 1882, as a model for many of Cassatt's works. She seems to have been an excellent model for she appears in a variety of poses, places and guises with equal conviction, suggesting that, as a model, she had a sound understanding of the nature of Cassatt's work. In the canvas, the first Cassatt exhibited with the Independents in 1879, Lydia is a fashionable theatre-goer. This painting has been compared and contrasted (p. 10) with *The Loge* (fig. 4) by her fellow exhibitor, Auguste Renoir. Another comparison can be made between the rich colouration and more delicate brushwork of Cassatt's painting and that of Renoir, especially in the light hatching strokes describing Lydia's gloved hand. As the first Impressionist work exhibited by Cassatt, this painting caused quite a stir, which her father reported to his son Alexander in a letter of September 1879. 'I send you by this mail the number for August of *La Vie Moderne* containing a sketch by Gillot of Mame's Lady in a Loge at the Opera . . . The sketch does not do justice to the picture which was original in conception and very well executed, and was as well the subject of a good deal of controversy among the artists and undoubtedly made her generally known to the craft.'

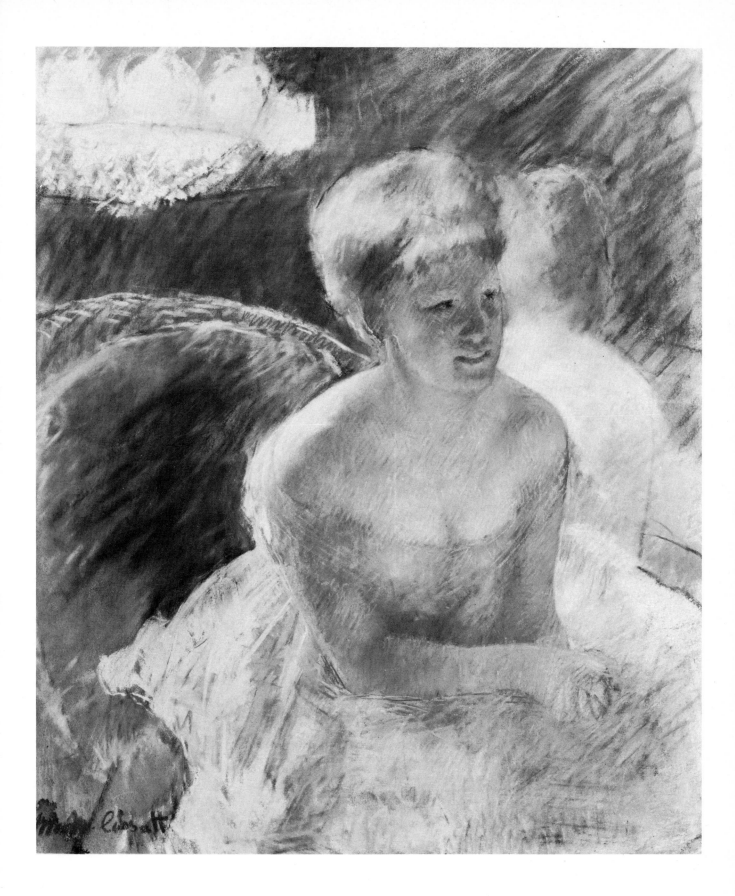

9 *Lydia Leaning on her Arms, Seated in a Loge*
KANSAS CITY (MISSOURI), Nelson Gallery-Atkins Museum. c. 1879. Pastel on paper 55 × 45 cm.

In 1879 Cassatt once again began to work in pastel, a medium of which she made brilliant use in the next twenty-five years until failing eyesight obliged her to abandon it. This pastel of Lydia at the theatre is a spirited work of brilliant colour. The red-headed Lydia wears a bright yellow dress and sits on a red plush velvet chair against a background composed of greens, blues and yellows over a warm beige-coloured paper.

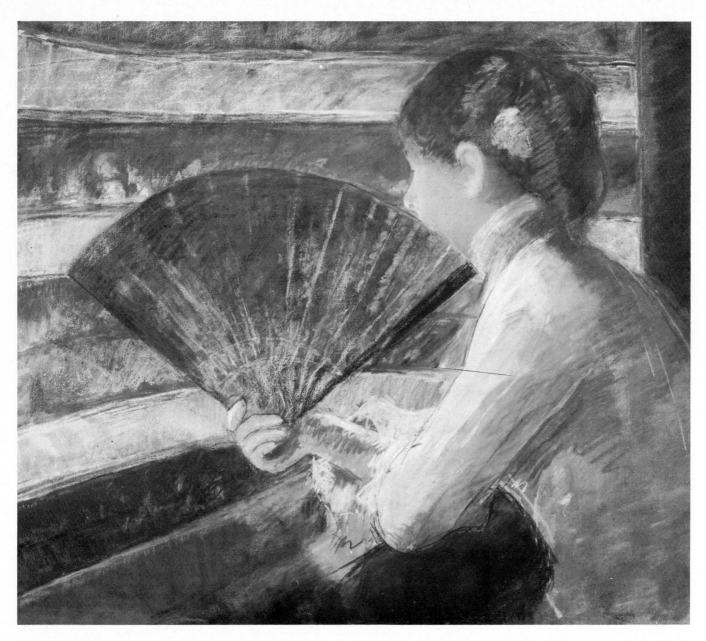

10 *Young Woman in a Loge Holding a Wide-open Fan*
BOSTON, Museum of Fine Arts (gift of Mrs. Margaret Sargent McKeon). 1879. Pastel on paper
66·5 × 82·4 cm.

This pastel, bold in colour, with auburn hair, lime-green fan, red and white flowers and a bright
yellow dress, is closely related in subject matter to *Lydia in a Loge* (Plate 8) and *Lydia Leaning on her
Arms* (Plate 9). But in contrast to both the oil and other pastel, the figure gazes into the auditorium
which is represented only as a reflection in the other two. However Cassatt created a tension
between the expanse of space beyond the figure and the surface of the pastel by placing the fan so
prominently across the foreground. 1879 had been one of the most productive years of her career
to date and in these works Cassatt's movement from close affinity with her fellow exhibitors to a
distinctive and individual treatment of subjects which they had introduced can be observed. With
these paintings and pastels she attracted many new buyers in both France and America and also
some commissions. Her work found favour with her colleagues in artistic circles and this pastel
was purchased by Degas. Another pastel of a *Woman in a Loge with a Fan* of 1880 (Fairhaven,
Massachusetts, private collection), was bought by Paul Gauguin, who compared Cassatt's
and Morisot's contributions to the Fifth Impressionist Exhibition in 1880: 'Miss Cassatt has as
much charm, but she has more power'.

11 *Profile Portrait of Lydia*
PARIS, Musée du Petit Palais. 1880. Oil on canvas 93 × 65 cm.

Late in her life Cassatt wished to donate one of her works to a public museum in France, where
she had lived most of her adult life. With the assistance of the critic and historian of the Impress-
ionists, Théodore Duret, this quiet and unpretentious study of Lydia entered the Musée du Petit
Palais in 1922. Her richly coloured coat is brushed in broadly with vigorous strokes that give texture
to the painted fabric. The woman's figure is painted in predominantly warm, red tones, set against
a green bench in front of a background of subtle green woodland.

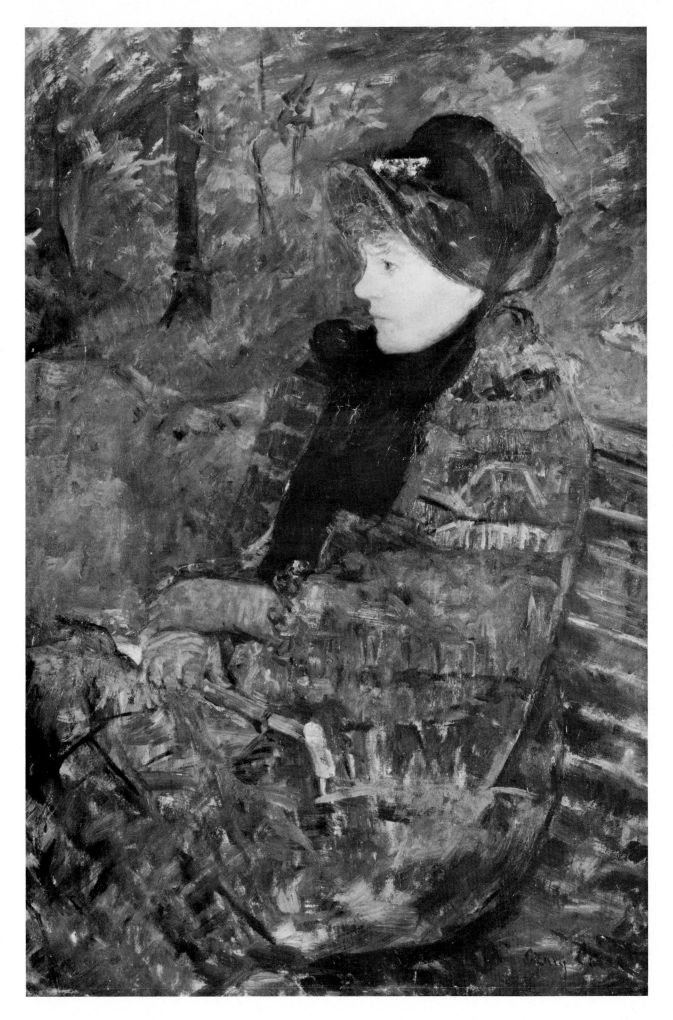

83

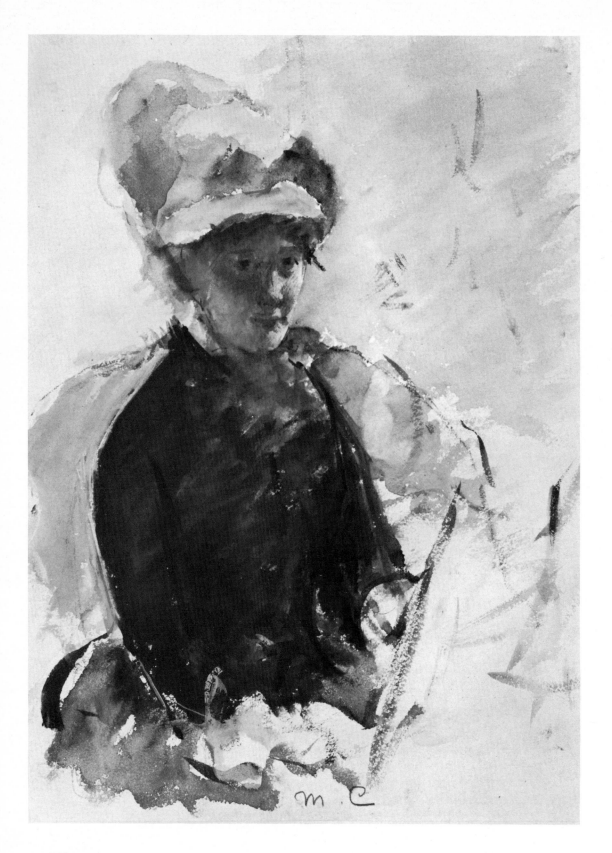

12 *Self-portrait*

WASHINGTON, National Portrait Gallery, Smithsonian Institution. c. 1880. Watercolour on paper 33 × 24 cm.

In disturbing contrast to the *Portrait of Miss Mary Ellison* (Plate XI), this small watercolour self-portrait is almost insubstantial, a quality heightened by the very medium used. The face is hidden in shadow and its features are undeveloped. A curious shyness emanates from the lightly painted eyes, and the few sketchy lines at the lower right are all that suggest the drawing board that indicates the profession of the sitter.

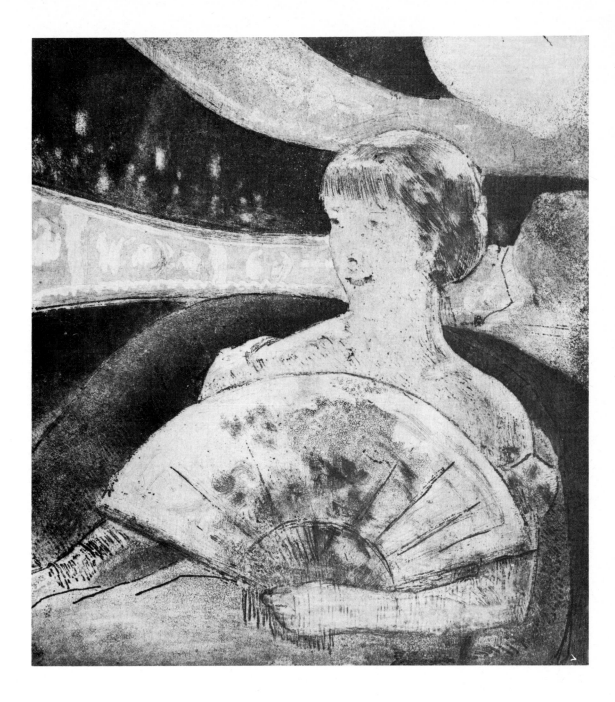

13　*In the Opera Box, No. 3*
NEW YORK, Metropolitan Museum of Art (gift of Mrs. Imrie de Vegh). 1880. Etching, softground and aquatint, third state 20 × 18·7 cm.

After her success with loge pictures in 1879–80, Cassatt worked on further variations of the theme in softground etching and aquatint in 1880–81, using devices similar to those of her paintings. For instance *Two Young Ladies in a Loge Facing Right* (Paris, Bibliothèque Nationale, second state) is a version of the subject illustrated in the Washington oil (Plate XIII). *In the Opera Box* was to have been Cassatt's contribution to the journal *Le Jour et La Nuit* which Degas was planning in 1879–80 and it illustrates her speedy mastery of this relatively novel medium. Three states of the print exist. Cassatt began in the first state with a textured ground of aquatint onto which the figure was lightly sketched. Then the figure's face, neck and shoulders were shaded with diagonal hatchings and minimal background details were added. In the final state, the linear shading was overlaid and the main effect results from a combination of large flat areas of dark and light with considerable textural variation both within and between these areas. Cassatt also set up a tension in the structure of the print between the dominant upright of the figure and the semi-circular curves of the balconies. Again the right-hand side of the print is filled with the figure, the reflection and strong light while the left-hand side spaciously opens up the auditorium into which the woman gazes so intently. Finally it is remarkable how slight the indications of the woman's features are, but how effective is the sense of her presence.

85

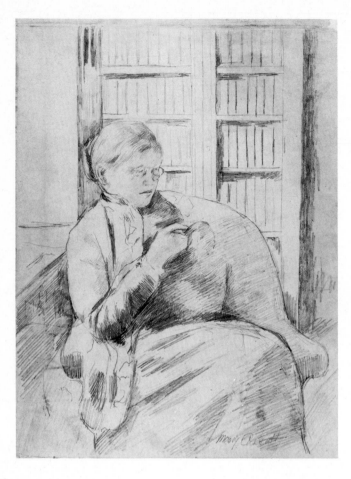 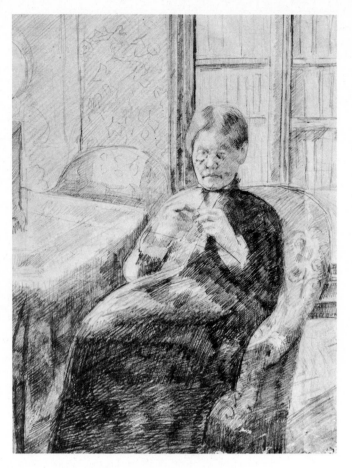

14 *Drawing for 'Knitting in the Library'*
CLEVELAND, Cleveland Museum of Art (bequest of Charles T. Brooks). c. 1881. Pencil on paper
28 × 22 cm.

This study in pencil, an earlier stage in the preparation of a finished plate, shows how Cassatt
blocked out the main areas of light and dark with strong diagonal shading. The freedom of line
seen here did not appear in Cassatt's etchings until she turned to drypoint. The drawings and their
variations in etchings are important documents of the sound draughtsmanship that underpins even
the most painterly of her canvases.

(above right)
15 *Drawing for 'Knitting in the Glow of a Lamp'*
NEW YORK, Metropolitan Museum of Art (gift of Mrs. Joseph du Vivier). c. 1881. Pencil on paper
29·2 × 22·2 cm.

This drawing of Cassatt's mother is a preparatory study for a softground etching. The soft glow of
the lamp, however, creates more acute contrasts than in *Drawing for 'Knitting in the Library'*
(Plate 14), while the dark expanse of Mrs. Cassatt's dress is thickly hatched in a style imitating the
marks of an etcher on the plate. In these drawings of women knitting Cassatt made use of the
setting to contrast the curving forms of the armchair and the figure to the verticals and horizontals
of the flanking bookcases, a device employed at times by both Degas and Cézanne.

(opposite)
16 *The Visitor*
NEW YORK, Metropolitan Museum of Art (Rogers fund). 1881. Softground etching, aquatint and
drypoint, fifth state 38·7 × 31·2 cm.

The subject of this print recalls the painting *Five O'Clock Tea* (Plate X), with its intimate interior
setting. *The Visitor* was included in Cassatt's 1893 exhibition at Durand-Ruel's gallery, where it could
have been seen by two young artists, Edouard Vuillard and Pierre Bonnard, who also concentrated on
the enclosed domestic world, exploring a rich variety of textures and patterns but with more satire
and wit. Cassatt's paintings and prints could well be considered sources for their later *intimiste* style.
The Visitor once again demonstrates Cassatt's mastery of mixed media. The early states of this
print are predominantly linear with strong diagonal hatching, but the final state incorporates a
bold use of aquatint graininess and softground patterning. The entire surface of the plate is covered
and the density of the texturing itself creates the sense of interior space, yet through this rich surface
pattern Cassatt still achieved a subtle sense of personality and conversation.

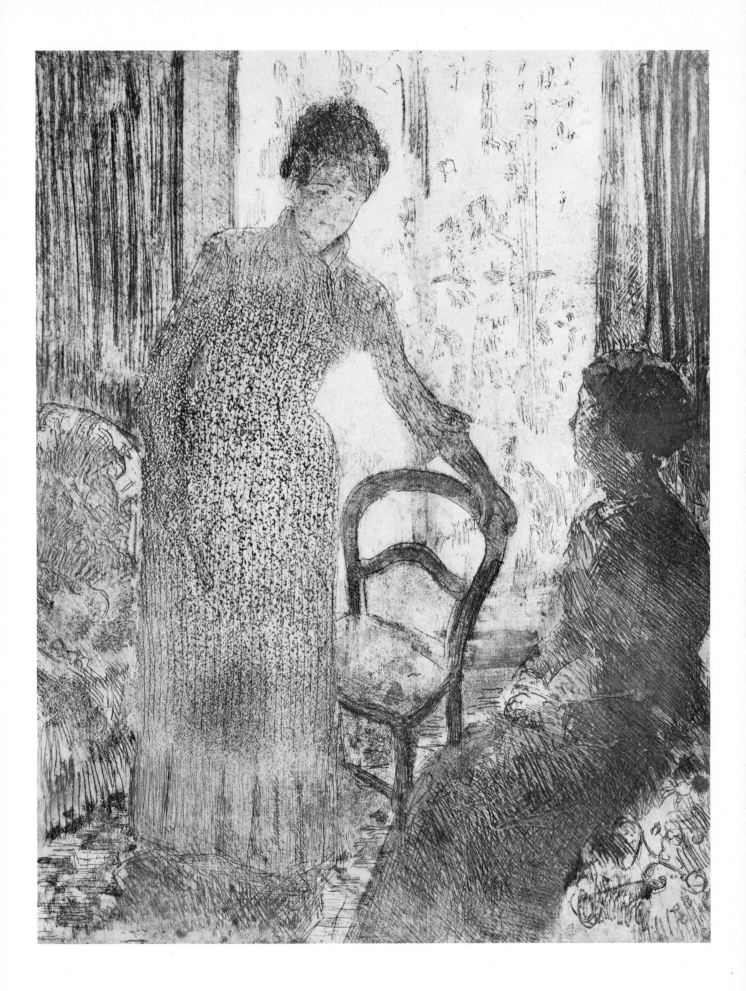

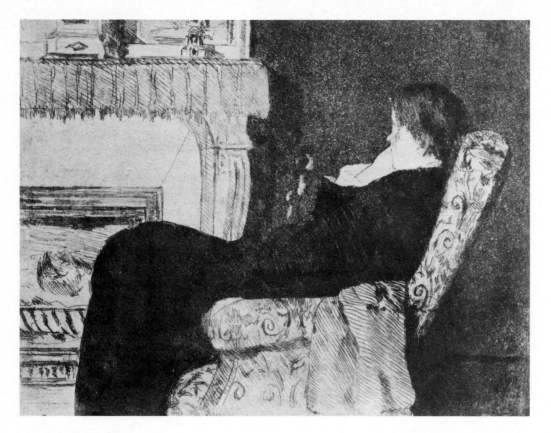

17 *Before the Fireplace*
NEW YORK, New York Public Library. c. 1883. Etching, softground and aquatint, third state
16·2 × 20 cm.

In this print Cassatt used texture to differentiate a surface that is divided into large well-defined areas, the wall, fireplace, chair and figure. The room is illuminated by the glowing fireplace creating around it the highest light, while the figure set ostensibly further forward recedes from the front plane of the pictorial space by virtue of the dark shadow on the side furthest from the source of light. In doing this, Cassatt compressed the planes and the space which were then orchestrated by the varied textures achieved through the medium. The sense of enclosure and interior warmth thus created echoes the mood of evening reverie suggested by the relaxed and solid pose of the seated figure, who rests her head on one hand and gazes towards the fire. Once again the psychological centre of the image is that which is treated most suggestively and only the slightest line, contour or detail plays over the face.

(*opposite top*)
18 *Interior with a French Screen*
BERWYN, private collection. c. 1881. Oil on canvas 43 × 57 cm.

This unfinished oil painting contains, in the seated woman reading, the expanse of white and the interior setting, features characteristic of Cassatt's *oeuvre* in the early 1880s, although the relation of the figure to the size of the canvas and the extended space is unusual. The pert silhouette with its chignon and the curving lines of the screen coupled with an overall airiness bring this painting closer to the studies of bourgeois elegance that the Goncourt brothers depicted in their novel *Chérie* (1884). The painting also resembles the boudoir and *toilette* scenes found in Berthe Morisot's *Young Woman Seen from behind at her 'Toilette'* of 1880 (Chicago, Art Institute of Chicago). Morisot and Cassatt were fellow exhibitors in the Independent and Impressionist group and, according to Louisine Havemeyer's *Memoirs*, were close friends. They were often compared to each other since, for many critics, they constituted 'feminine Impressionism' and it is not surprising to find mutual influences in their work.

(*opposite bottom*)
19 *Lydia Working at a Tapestry Frame*
FLINT, Flint Institute of Arts (gift of the Whiting Foundation). c. 1881. Oil on canvas 65·5 × 92 cm.

This is one of the last paintings for which Lydia modelled before her death, a fact which provides some clue to the date of the work. She is seated at her tapestry frame and her pink dress with red and dull green flower print sets the colour key for the painting which is warm in tone. The airiness of *Interior with a French Screen* (Plate 18) is also present in the filtered light from the chintz curtains to the left. The most remarkable feature of the painting is the placing of the solid wooden carved tapestry frame, which almost seems to project itself diagonally out of the paint into the viewer's space. The head is a marvellously sensitive study of quiet concentration that belies the poor health of the invalid model. Against this fine delicate painting of the head, the rest of the unfinished picture is boldly brushed, with large dashes of paint and defining contours.

89

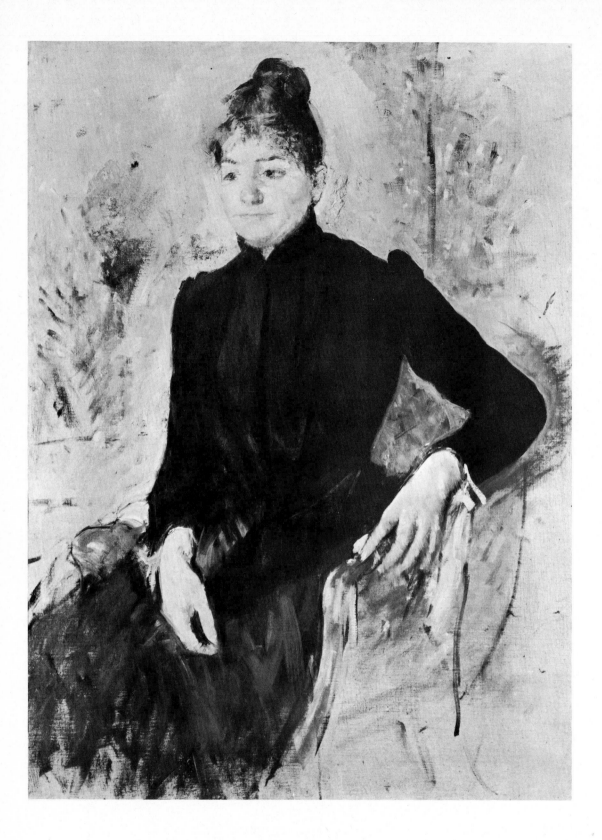

20 *Woman in Black*
BIRMINGHAM, Birmingham Museums and Art Gallery. c. 1882. Oil on canvas 100·6 × 74 cm.
A colourful, but only sketchily suggested, interior sets off the figure of an unknown woman, shaped and encased in a severe black dress. There are many details in the position of the figure in the chair and the placement of the hands that convey a sense of the character of this tense, upright woman, but the treatment of the face, softer and more delicate, belies this severity. It is probably a portrait study, but an ambiguous personality emerges from this canvas through the combination of personal features, the face and expression of the woman, and the setting and features of dress which pertain more to the social identity of this 'lady'.

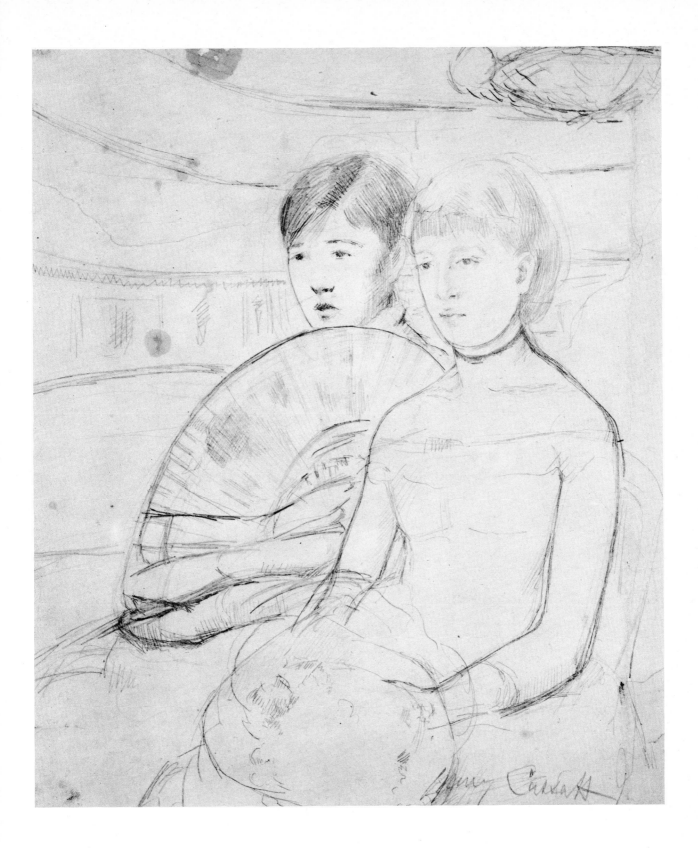

21 *In the Loge*

WASHINGTON, National Gallery of Art (gift of Chester Dale). 1882. Pencil with traces of colour on paper 28·2 × 22 cm.

While there are many drawings for Cassatt's prints, very few studies for her paintings have been catalogued. In this rare example one can see the importance for Cassatt's approach to form of both line and the pattern created by the clean contours. This tendency connects her both with what Novak (1969) calls the linear in the tradition of nineteenth-century American painting and also with Degas whose respect for masters of line was legendary.

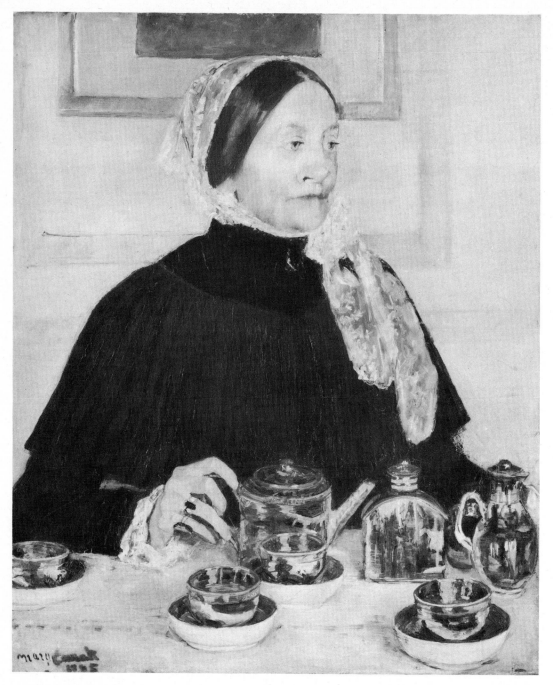

22 *Lady at a Tea Table*

NEW YORK, Metropolitan Museum of Art (gift of the artist). 1883–85. Oil on canvas 73·4 × 61 cm.

This monumental portrait of a Mrs. Riddle takes up the tendencies apparent in *Young Woman in Black* (Plate XV) with the use of a dark figure against a light ground and a play of the silhouette against the rectangles of the wall and picture frame behind. Yet the sharply receding plane of the table, with its painterly still-life of blue china, gives depth and solidity to the composition. The painting is unified by the use of blue, at its strongest in the dress of the sitter, but echoing throughout the painting in the china and in the whites of the cap, cuffs and wall behind, all of which are affected by reflections from the main colour. Both in the pose and the variations on one colour the picture can be compared to the paintings, particularly *Portrait of the Artist's Mother* of 1872 (Paris, Musée du Louvre), by Cassatt's fellow American James McNeill Whistler, with whom she was acquainted. However the similarities can also be attributed to the common sources the two artists shared in seventeenth-century Dutch portraiture. Although the tendency to integrate the figure into the overall design by means of simple shapes and static position can be observed in the work of both Cassatt and Whistler, the former retained her concern for the individual's likeness and presence, here captured in the fine painting of the head and the distinctive treatment of the delicate hand. The actual use of blue and blue-white, notably in the still-life details of the table, is closer to Manet's work, for instance one of his last paintings, *Bar at The Folies Bergère* of 1882 (London, Courtauld Institute Galleries). Cassatt produced an image of enormous dignity and insight, comparable to the great portraitists of the earlier American School (fig. 12), by marrying certain features of seventeenth-century art to those of Whistler and Manet, yet at the same time using the most modern of styles and the most recent tendencies in her own development.

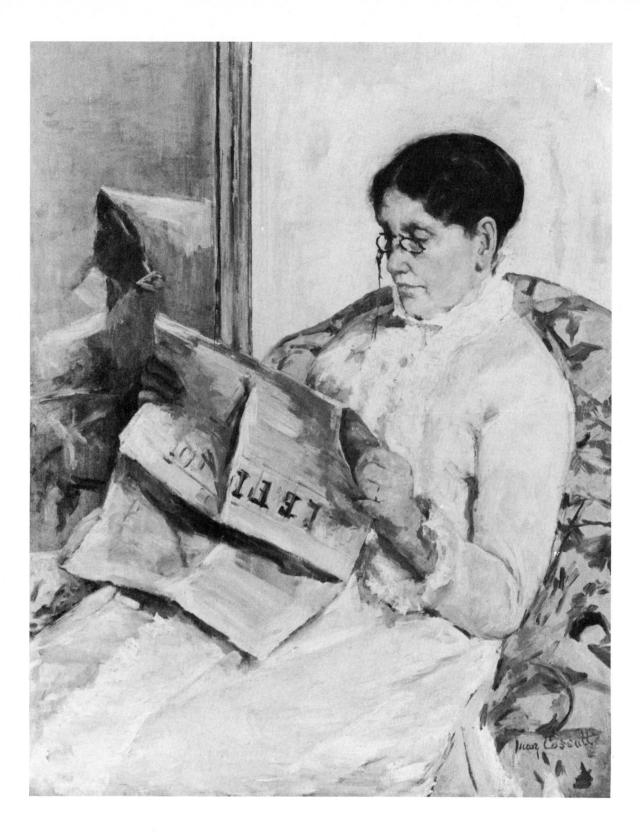

23 *Reading 'Le Figaro'*
HAVERFORD, private collection. 1883. Oil on canvas 104 × 83·7 cm.

Cassatt's exploration of the luminous effect of sunlight was taken a stage further than in *Susan on a Balcony* (Plate XIV) with this fine portrait of Mrs. Cassatt engaged in her daily activity of reading the newspaper. The whiteness of the dress and the luminous almost yellow-white of the plain wall behind are countered by the touches of colour in the patterned chair, the warm browns of the folded newspaper and the dulled and greyish reflection in the mirror to the left. This mirror functions not purely as an amplification of space or a means to incorporate the spectator, as in other paintings, but rather as part of the colour scheme, while its gilded frame is crucial in stabilizing and structuring the whole bright space. The portrait itself is intimate and unidealized. The pince-nez perched on Mrs. Cassatt's nose recalls the pastel self-portrait of Chardin then, as now, in the Louvre, in which the artist, wearing eyeglasses and eye shade, presented himself with unaffected simplicity.

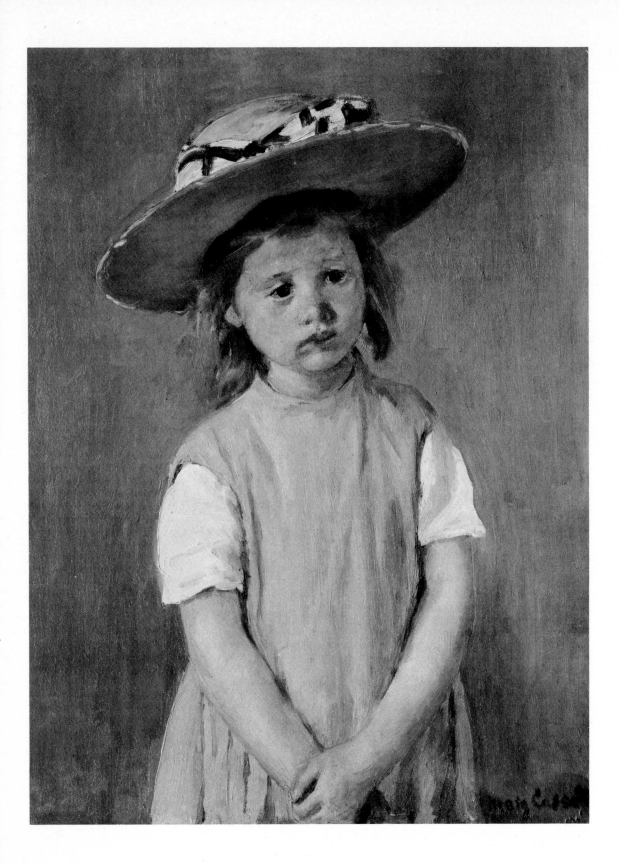

24 *Child in a Straw Hat*
UPPERVILLE, collection of Mr. and Mrs. Paul Mellon.
c. 1886. Oil on canvas 64·7 × 49 cm.

Against a plain, grey-tan background, a young girl stands in a white dress with a lilac pinafore and an over-large yellow straw hat on her fair hair. The model resembles one of the children in *The Little Sisters* (Plate XVI), although neither has been identified. The dress and general mien suggest the model was a country girl, for Cassatt often used local people as models when her family was not present. The simplicity and directness of this painting of a single figure against a plain background also shows Cassatt's growing interest in a strong, almost monumental image, such as that in *Lady at a Tea Table* (Plate 22), painted shortly before.

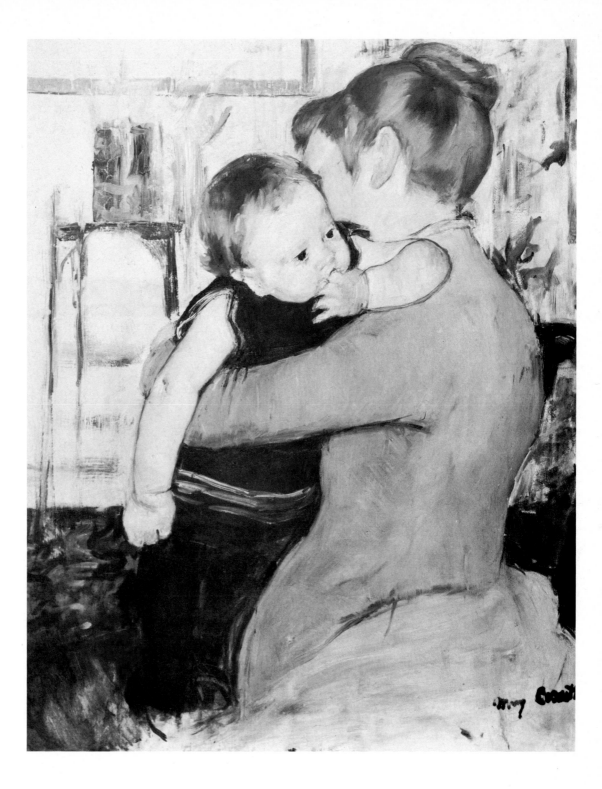

25 *Baby in a Dark Suit, Looking over his Mother's Shoulder*
CINCINNATI, Cincinnati Art Museum (John J. Emery endowment). 1889. Oil on canvas 73·7 × 59·8 cm.

In 1889 Cassatt took up the subject of mother and child in earnest and there are many examples in oil and pastel which explore the close relationship of adult and child. This painting is one of the early experiments and remained unfinished. The features of her earlier single figure paintings reappear, with the use of bold shapes set against a background of verticals and horizontals. However there is considerable tension in this work, for although the mother and child are bounded by one outline and fuse into a solid block against the lighter background, they face in different directions, creating a sense of space and substance. In both the sagging weight of the baby's body and the obscured face of the mother Cassatt achieved an honesty that is entirely free from any sentimentality.

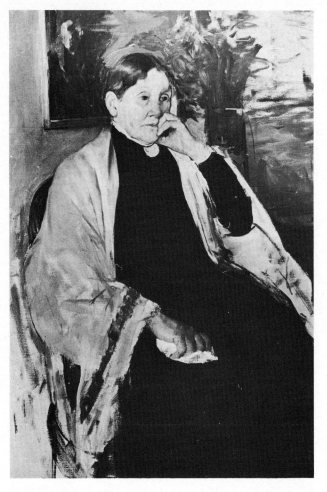

26 *Portrait of Mrs. Cassatt*

BRYN MAWR, collection of Mrs. Gardner Cassatt. c. 1889. Oil on canvas 96·5 × 68·6 cm.

Even in its unfinished condition this is as fine a portrait as Cassatt ever painted. In contrast to the earlier more robust and spirited portrayal of her mother (Plate 23), painted six years earlier, Cassatt here presented both the dignity of an old woman and the resignation. Its mood is far more intimate and gentle, despite the regal bearing of the large seated figure and the strong contrasts of her black dress on the paler shawl. The pose, the simple colouration and the use of the painting behind the head of Mrs. Cassatt recall above all the model of seventeenth-century Dutch portraits and one is tempted to compare this work to the late painting of Frans Hals, *The Regentesses of the Old Men's Almshouse* of 1664 in the Frans Hals Museum in Haarlem, which Cassatt had visited in her youth. Both the portrayal of old age and the painterly treatment of Hals's portraits were enormously admired by French artists in the 1880s when Hals's paintings enjoyed a considerable vogue. In painting her mother it is entirely appropriate that Cassatt should have recalled the great bourgeois portraitist of a school so often promoted in this period as a model for a contemporary realist school of painting.

(above right)
27 *The Bonnet*

NEW YORK, Metropolitan Museum of Art (gift of Mrs. Gustavus Wallace). 1891. Drypoint etching 18·1 × 13·7 cm.

This subject, comparable to *Woman Arranging her Veil* (Plate 28), was treated in a drypoint etching in the following year. It shows a seated woman holding up a small hand-mirror to her face while she draws tight the strings of her bonnet with her other hand, so that the hands cross each other both laterally and in depth. This alone creates the sense of the space between the flat circle of the mirror and her face. It is extraordinary to observe the way Cassatt managed to direct and then contain the steady, dark-eyed gaze of the woman by the placing of the mirror. She is looking at something we cannot see, yet what she sees in the mirror is what we see in the etching. The iconography of a woman and mirror associated with the Toilet of Venus (fig. 10) or with Vanity in traditional painting (fig. 9) is used to new effect not only by virtue of the contemporary clothing. The mirror also throws back to the woman her own image and at first suggests a narcissistic self-contemplation. However by the rigour of the medium and an absolute control over the psychological feeling of the print, Cassatt brought out instead the woman's sense of self-awareness and identity. This employment of the mirror to question and transform expected notions of Woman and of traditional iconography anticipates its later use in *Mother and Child* of 1905 (Plate XXXII).

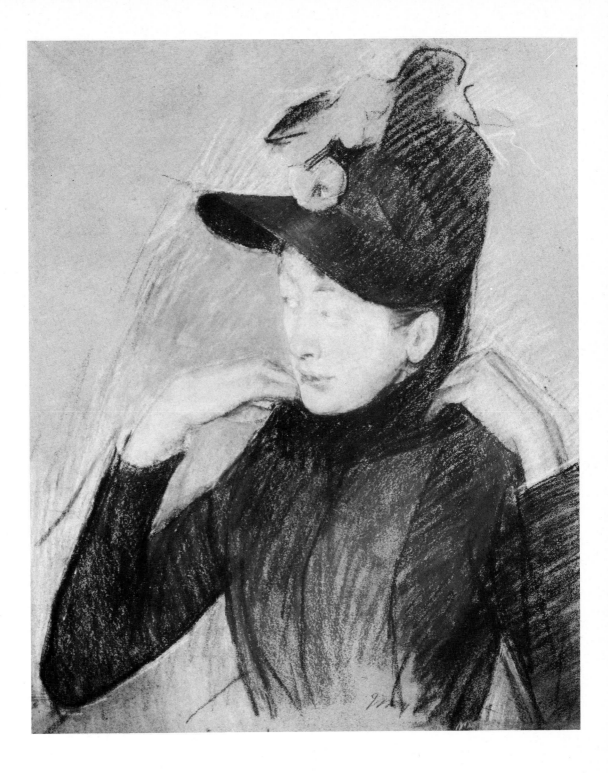

28 *Woman Arranging her Veil*
PHILADELPHIA, Philadelphia Museum of Art (bequest of Lisa Norris Elkins). c. 1890. Pastel on tan paper 64·8 × 54·6 cm.

The subject of visits to a milliner's shop had been frequently treated by Degas, and Cassatt reported to Louisine Havemeyer that on occasions she had assisted him by posing for positions which the professional model could not adopt with conviction. It is therefore not surprising to find a similar subject in her own *oeuvre*. In this pastel study, Cassatt depicted with considerable accuracy one of these casual poses, that of a woman trying on a black poke bonnet and arranging the veil, presumably while glancing in a mirror not shown in the painting but suggested by the momentary pause in activity and the considering expression on her face. The fleeting nature of the gesture is captured in the swift strokes of pastel.

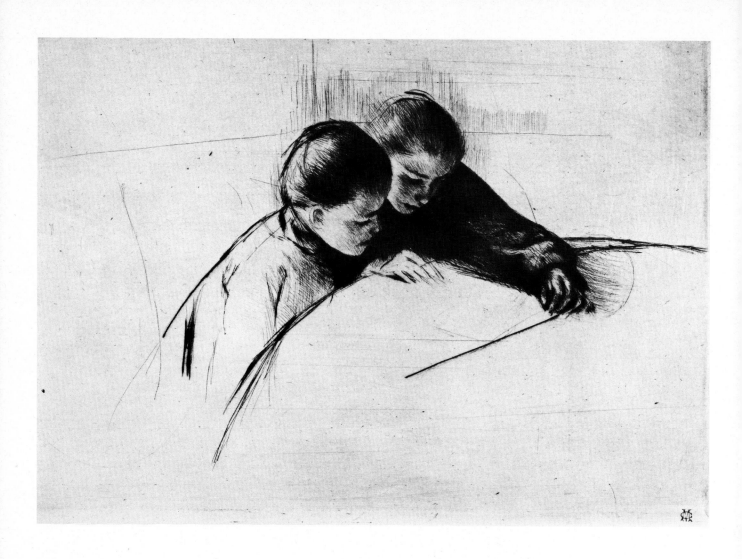

29 *The Map*

NEW YORK, New York Public Library (S.P. Avery collection). 1890. Drypoint etching, third state
15·6 × 23·6 cm.

Cassatt's ability to create form, mood and atmosphere is amply proven in her oils and pastels,
but it is more remarkable in the medium of drypoint etching, which requires absolute control since
one draws directly onto the plate with a needle, leaving little scope for error or correction. The
minimal indications of setting and the exclusion of patterned effects concentrate attention on the
two young women quietly absorbed in their study. The subject of the print harks back to the early
Young Girl with a Portfolio of Pictures (Plate 6) and is a continuation of the series of depictions of
women engaged in thought or study (Plates V and 22). Here, however, it is Cassatt's bold use of
the medium, its stark lines and the softer shaded effects of the burr that state with clarity the
women's complete absorption in their own activities and their desire for knowledge.

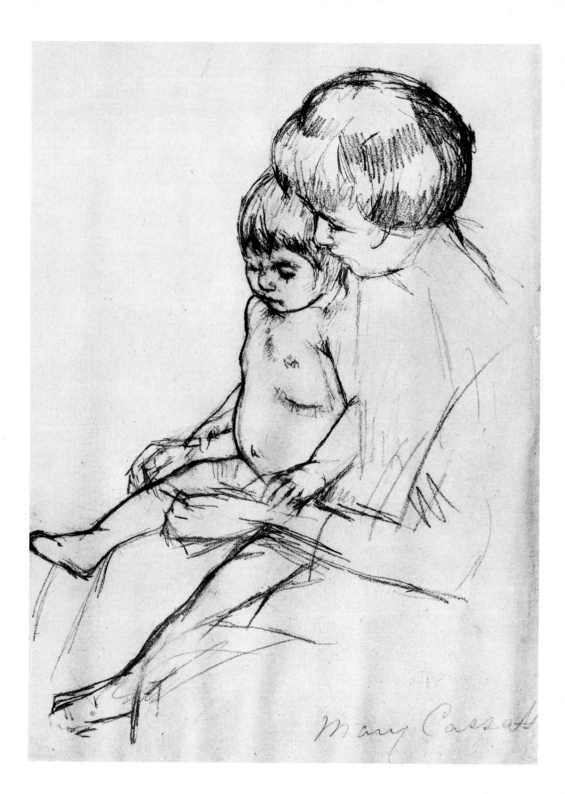

30 *Mother Pulling on a Baby's Stocking*
PROVIDENCE, Rhode Island School of Design, Museum of Art (gift of Mrs. Gustav Radeke). c. 1890.
Pencil on paper 26·7 × 20·2 cm.

This scene was also portrayed in a pastel of 1891 (present whereabouts unknown) and in a drypoint
etching and an earlier state of the drawing exists in a private collection in Paris. The Rhode Island
and Paris drawings demonstrate both Cassatt's swift use of line to grasp essential elements of the
composition and her experimentation with the mother and child in order to find the most expressive
relationship of figure and gesture. In the earlier drawing, the child's nude body received most
attention, the mother serving more as a frame for the child, while in this version the closeness of
the heads and the interconnections of hands and limbs bring out the mutual relationship. The
strong contours drawn over lighter, more exploratory marks anticipate the clean lines of later
drypoint treatment and, at the same time, provide the solid structure for the more suggestive and
delicate textures of pastel.

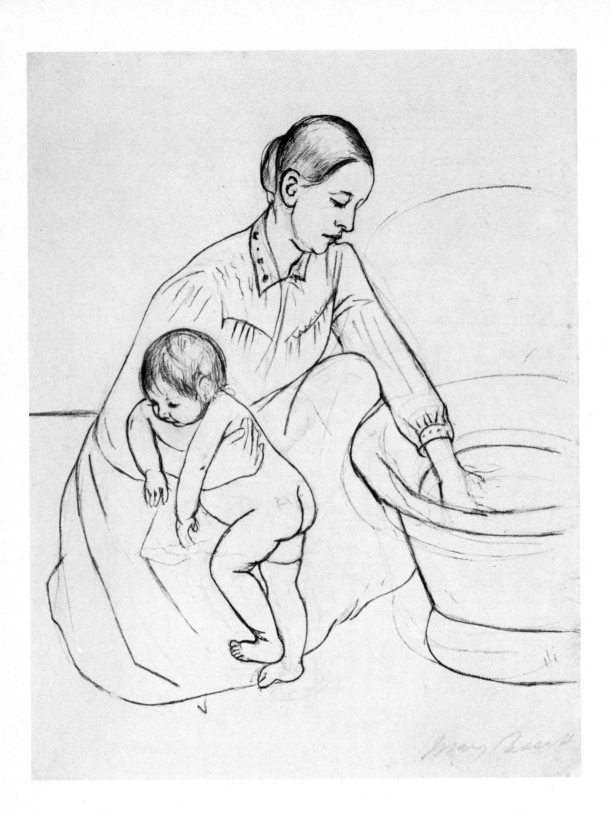

31 *Sketch for 'The Bath'*
WASHINGTON, National Gallery of Art (Rosenwald collection). 1891. Pencil and black crayon on paper 31·8 × 24·7 cm.

In 1890 Cassatt began the series of colour prints which constitute her most significant contribution to graphic art. The prints can be divided into pairs; simple versus dense composition, clear versus complex structure, light versus dark tone, figure versus interior. The first print, *The Bath*, went through eleven states before Cassatt was satisfied by her experiments with the novel possibilities of the combination of media and effects. It is a simple composition of mother, child and tub.
A mother washing her baby is a common motif in Japanese prints, but it also had precedents in Cassatt's *oeuvre*. The media of the colour prints and their incisive line, clear colour and clarity of design enabled Cassatt to treat this motif without the sentimental or religious readings to which Western audiences are so susceptible when faced with a mother and child. The combination of mundane activity and monumental dignity also avoided the sweetness, decorativeness and smiling domesticity of Japanese prints. This is a drawing for the first state.

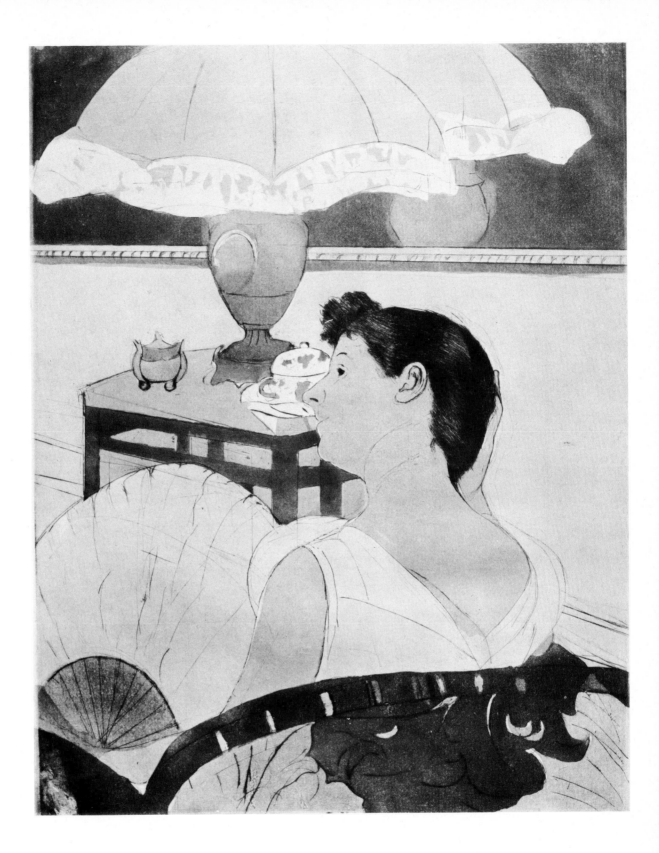

32 *The Lamp*
NEW YORK, Metropolitan Museum of Art (gift of Paul J. Sachs). 1891. Colour print with drypoint, softground and aquatint, third state 31·2 × 25 cm.

The second print in Cassatt's colour series of 1890–91, *The Lamp*, is an interior with an acute angle of vision into the room from behind the figure's head, which required a complicated articulation of space and reflections of objects within the compressed plane of the etching and the use of a variety of tones to organize the composition into flat areas of colour. There is considerable tension between the flat decorative effect of the colour and the organization of the space in depth and it is this tension that marks the originality of Cassatt's response to Japanese prints, while the structural elements reveal the continuing importance of her American background.

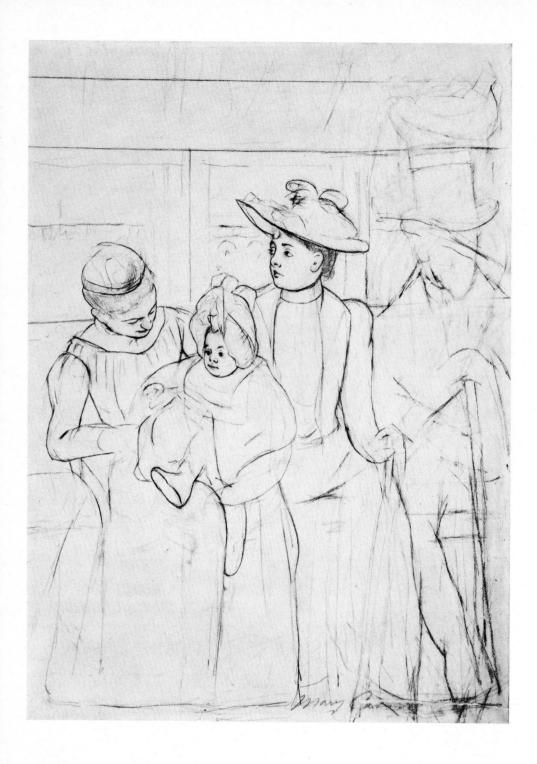

33 *Drawing for 'The Omnibus'*
WASHINGTON, National Gallery of Art (Rosenwald collection). c. 1891. Crayon and pencil on paper 36·5 × 27 cm.

34 *The Omnibus*
NEW YORK, New York Public Library (S. P. Avery collection). 1891. Colour print with drypoint, softground and aquatint, second state 35·6 × 26·2 cm.

These three illustrations document stages of the third print in Cassatt's 1890–91 series, which takes as its subject a typically modern scene of city life. The drawing (Plate 33) shows, summarily sketched, a figure of a man who was not included in the final print and also indicates the main outlines which were pressed hard for transference onto the softground of the plate. The second state of the print (Plate 34) has the main colour areas added in aquatint with shades of tan, rose, green and black ink, but it concentrates only on the scene inside the tram or bus. The fourth and final state includes the view out of the window and the shading of the interior of the vehicle. To achieve the clarity of colour that Pissarro so admired, enormous skill was needed in the printing, especially in areas where two tones intersect, for instance in the juxtaposition of the foreground figures and the view beyond.

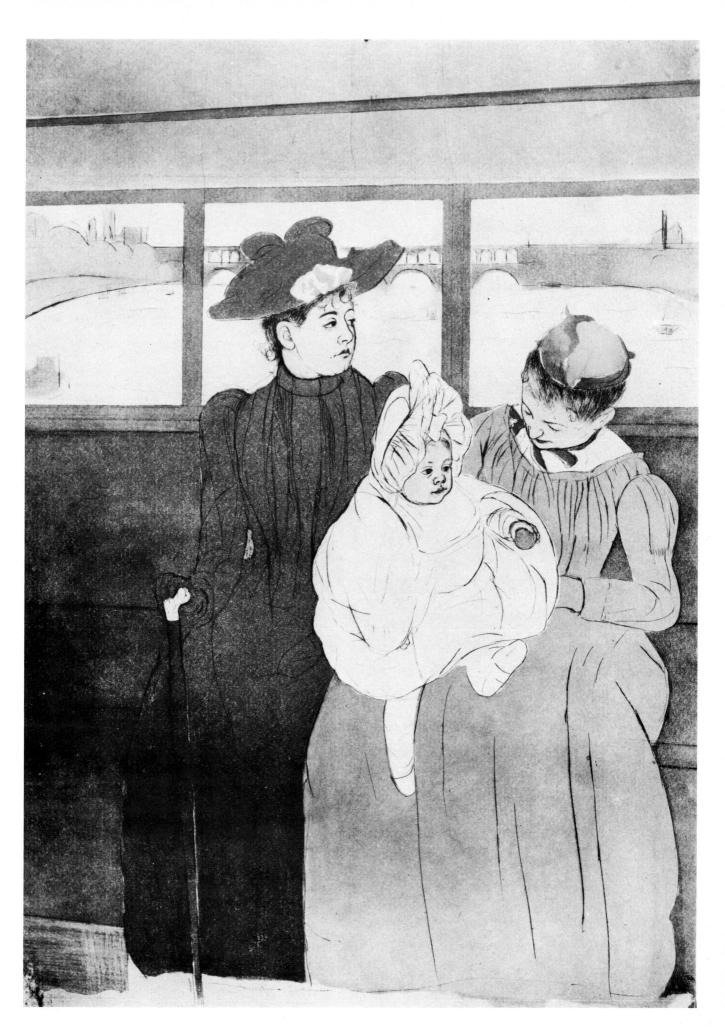

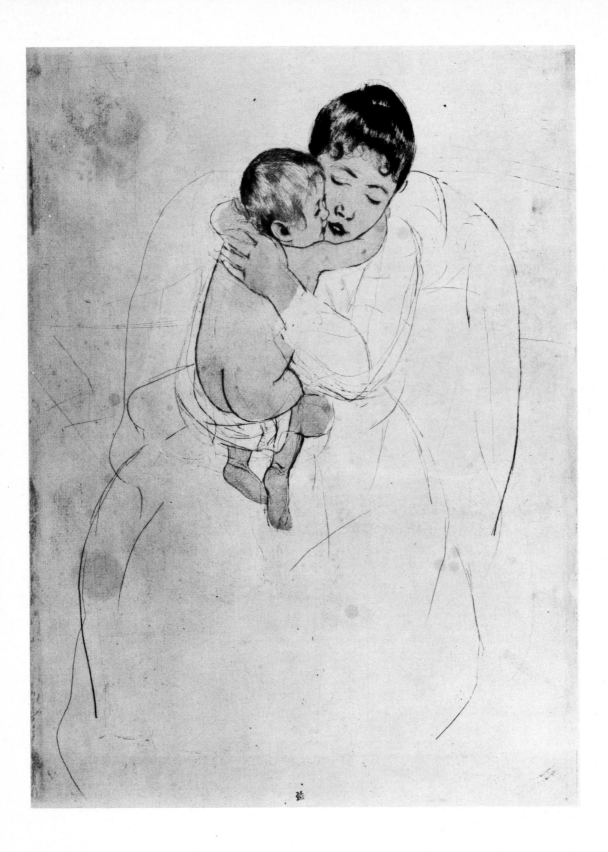

35 *Maternal Caress*
NEW YORK, New York Public Library. 1891. Colour print with drypoint, softground and aquatint, first state 36·2 × 26·2 cm.

36 *Maternal Caress*
NEW YORK, New York Public Library. 1891. Colour print with drypoint, softground and aquatint, third state 36·2 × 26·2 cm.

The seventh and eighth plates of the 1890–91 series returned to the subject of the first, the theme of mother and child, which, as Ives (1974) has shown, has striking parallels in Japanese woodcuts. Equally, all the ten prints rework in this original graphic medium the scenes from women's lives that had constituted Cassatt's own preoccupations in oil and pastel before 1891, underscoring Chesneau's

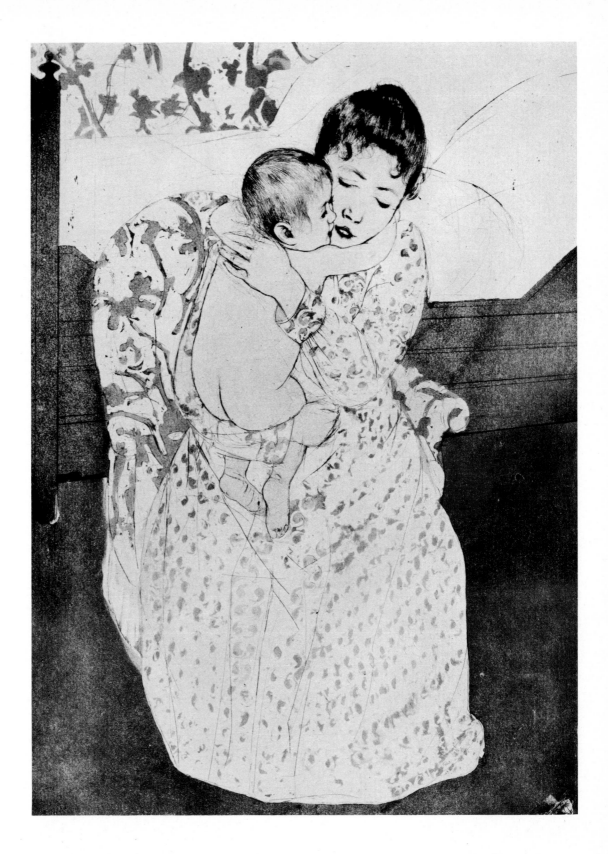

(1878) contention that ideological affinities between the French and Japanese Schools are more important than direct stylistic influences. This print illustrates further the alternations within Cassatt's series, for it reverts to a double figure composition and apricot and brown tonality, in contrast to the dominant blues of the single figure of *Woman Bathing* (Plate XXVI). Cassatt exploited to great effect the tension between the bold shapes and strong horizontals and verticals of the unpatterned floor and bed and the curving arabesques and lively textures of the mother and child in the armchair, who form a single block bounded by a single contour within the composition. But despite the emphasis on pattern, line and decorative flatness, Cassatt achieved emotional intensity with the distressed and tearful child pulling away from the mother's attempt to comfort and caress. This interaction, which provides the title for the print, gives to the mother the significant rôle, a fact which once again challenges Segard's (1913) argument that the mother has only a secondary and supportive function in Cassatt's *oeuvre*.

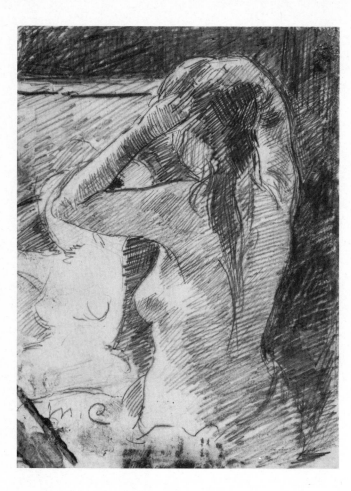 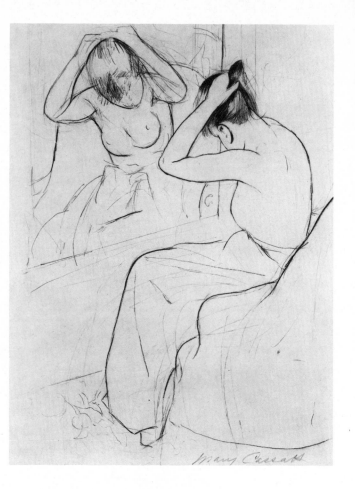

(above left)
37 *Drawing for 'The Coiffure'*
WASHINGTON, National Gallery of Art (Rosenwald collection). c. 1891. Pencil on laid paper
14·7 × 11·2 cm.

Many pencil studies for *The Coiffure* (Plate 39) exist, through which one can trace exactly the evolution of the final print. The style of this drawing recalls the earlier studies for softground and aquatint etching (Plates 14 and 15), with its close hatchings and chiaroscuro effects, and this may support Fuller's (1950) argument that Cassatt used softground more extensively in her colour prints than has hitherto been realized. The treatment of the nude in the drawing is far more sensuous than anything in the prints or paintings. This drawing lacks the depth and complexity of the final print and shares none of its linear clarity, but it is none the less interesting, for it reveals a certain intimacy in the treatment of the female figure, a softness in the forms and an atmosphere of private contemplation which often characterized such subjects in European art, but which Cassatt's work strove to eliminate from the representation of women through her formal inventiveness and her novel use of techniques and media.

(above right)
38 *Drawing for 'The Coiffure'*
WASHINGTON, National Gallery of Art (Rosenwald collection). 1891. Black crayon and pencil on paper 37·8 × 27·3 cm.

The basic composition of the previous pencil drawing has been radically transformed and clarified into the main outlines, in preparation for transfer to the etching plate. Although there are no traces of softground on this work, the main outlines are deeply impressed into the paper, indicating that this was the drawing Cassatt used for the transfer. The use of chiaroscuro to set off the mirror reflection in the earlier drawing has given way to an incisive linear design. This has changed the effect and meanings of the print, for not only is the sensuality excised but also the spectator no longer peers over the shoulder of the woman into the intimate space of her self-contemplation. Reminiscences of *The Rokeby Venus* (fig. 10) and traditional *toilette* scenes are replaced by a more modern, mundane scene. However this does not come close to Degas's studies of women at their *toilette* (fig. 7), but rather responds with positive proof to his challenge that women knew nothing about the rigours of drawing and could never achieve 'style'.

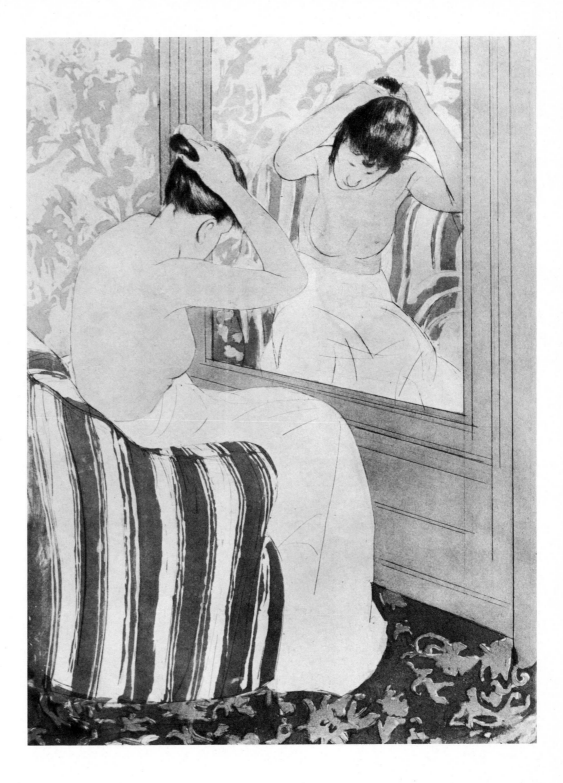

39 *The Coiffure*

NEW YORK, Metropolitan Museum of Art (gift of Paul J. Sachs). 1891. Colour print with drypoint, softground and aquatint, fourth state 36 × 26·2 cm.

This lovely plate is the final print of the 1890–91 series; its composition is perhaps the most complex and the orchestration of the pink tones the most subtle. The simple form of the body with its lightly-tinted flesh tone and white drapery is set off by the alternating light-on-dark and dark-on-light patterns of the walls and floor, both in the space of the room and within the framed reflection of that space. Japanese references are clearly made by the woman's features, however the pose, with the back view and the contrast of the figure's simple linear contours with the coloured and textured setting, invites a comparison rather with the work of Ingres, notably his *Valpinçon Bather* of 1808 (Paris, Musée du Louvre), a painting which Degas had once copied and to which he may well have drawn Cassatt's attention. In this final work of the series one can, therefore, appreciate the full marriage of the best of the European traditions of line with the decorative play on surface and pattern of the Japanese, presented in a completely original style and medium.

40 *Sketch of a Young Woman Picking Fruit*
DES MOINES, collection of Mr. and Mrs. Sigurd E. Anderson II. 1892. Oil on canvas 60 × 73 cm.

In 1891–92, when Cassatt was commissioned to paint a mural for the Woman's Building at the World's Columbian Exposition of 1893 in Chicago, the artist chose for the subject of the central panel (now lost) a scene of young women picking fruit in order to represent her idea of 'Young Women Plucking the Fruits of Knowledge and Science' in a symbolic Garden of Eden. This large sketch for a figure in the central panel provides some indication of the bright colour and offers some insights into Cassatt's working methods. The overall approach is painterly and high-toned, with pinks in the dress and an intense blue behind the woman's head. The most highly worked area is the solidly painted head, which is a study in perspective and of the fall of bright light on solid forms. Careful study of that section of the canvas shows considerable reworkings so that at times the paint stands out in relief. By careful modulation of colour, Cassatt worked to define and redefine the point at which the head meets the sky behind in a manner reminiscent of both the thoroughness and the intensity of Cézanne. The bold pose, with outflung arms and upturned head, is rhythmic and striking. However Cassatt modified the gestures and in the final painting this figure was more contained and less dramatic. The face in this sketch is determined and, despite the unfinished state of the canvas, it reflects more effectively what Cassatt wanted to convey in her programmatic statement of modern womans's ambition and dedication than poor photographs of the mural do.

(*opposite*)
41 *Women Picking Fruit*
PITTSBURG, Carnegie Institute, Museum of Art (Patrons Art Fund). 1891. Oil on canvas
132 × 91·5 cm.

Although there is no documentary evidence to link this painting to the Chicago mural, it has a similar theme. However the picture is significant for it reveals certain new tendencies in Cassatt's work, which were represented in the finished painting for Chicago. The figures are in contemporary dress and are definitely modern women. The paint is laid on thinly and the sharp contours define decorative areas of colour which are so evident in the colour prints of 1891 and are so appropriate for a large mural decoration. Large scale decorative work had not been a feature of the Impressionist group, but in the reaction of younger artists against Impressionism the large scale, monumental and decorative form took on a greater importance and artists looked back to examples of such schemes in Eastern, Egyptian and Italian art as well as to the contemporary work of Pierre Puvis de Chavannes (1824–1898). Cassatt's clear outlines and large areas of rich colour suggest certain affinities with these concerns of Post-Impressionist painters. Furthermore the Symbolist

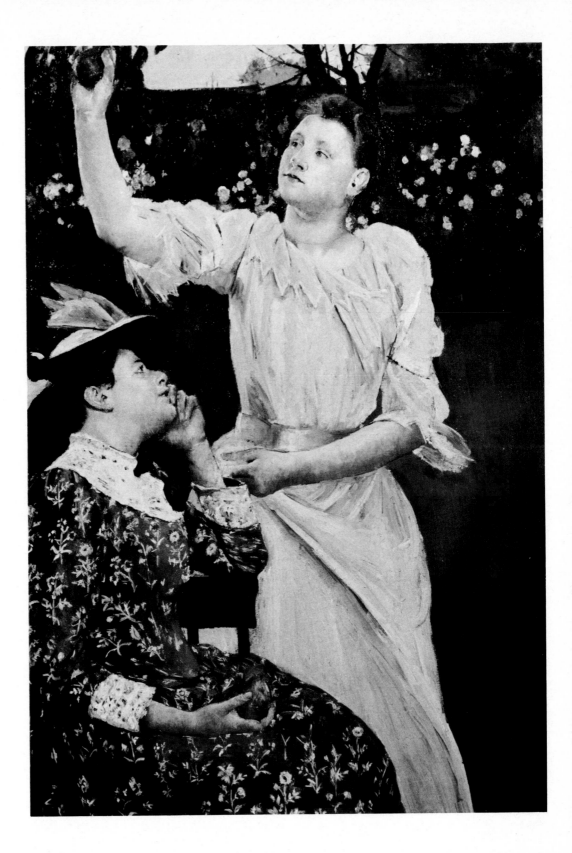

tendencies in the art of the late 1880s and early 1890s were encouraged by the work of the English Pre-Raphaelites and their followers. Millais has already been mentioned in connection with *The Family* (Plate XIX) and in *Women Picking Fruit* one can also observe similarities to those works of the English School which portray young women in natural settings engaged in seemingly mundane tasks, but which also contain a more contemplative and suggestive mood and underlying symbolism (fig. 13). Cassatt's painting of two young women, fashionably dressed, picking fruit in a garden, bridges the earlier phase of her interest in modernity with her later work where the more decorative and patterned style was used to create paintings that seem to carry larger meanings, more weighty concerns. The *Modern Woman* mural was thus anticipated in this painting, in which an everyday scene was so composed and depicted that the more Symbolist notions of a modern Garden of Eden are intimated. In the discovery of a style appropriate to those concerns, both the impact of the colour prints and the new directions in the work of her contemporaries were crucial.

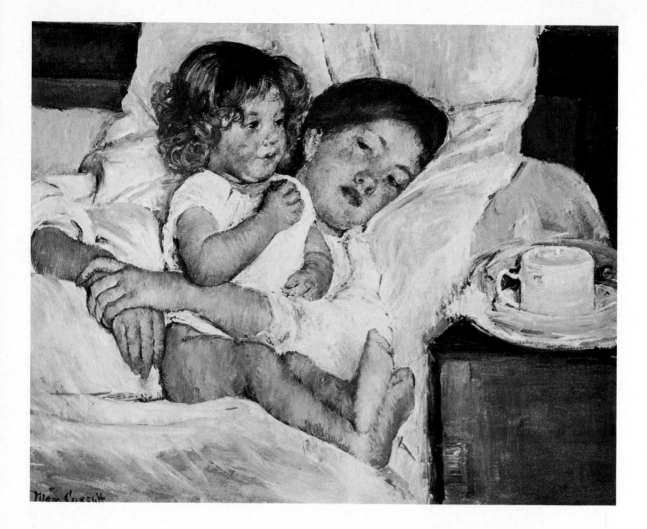

42 *Breakfast in Bed*
Present whereabouts unknown, formerly YOUNGSTOWN, private collection. 1897. Oil on canvas
65·1 × 73·7 cm.

Ellen Mary Cassatt posed for this painting one year later than her portrait (Plate XXX), when she
was about three years old. Yet in contrast to that portrait of the little lady or *The Little Infanta*, as it
has been called, she seems more of a baby in this later work with her soft round limbs and pert
expression. The relation of mother to child, so important in the late 1880s, reappears and the
figures are pictorially related by close physical contact and the interlocking hands of the adult.
The use of certain devices in the painting to set up pictorial oppositions which underline the
central opposition of youth and maturity have already been discussed extensively (p. 16). By
placing this painting in the context of the works of the 1890s one can observe the development of
the formal means which enabled Cassatt to transform the mother and child into an image that
could convey both a personal involvement in the concerns of the growing families around her and
the more general theme of the phases of women's lives. The manner in which the work was
painted is, however, more lively than that of *The Bath* (Plate XXVII) and, in certain passages on the
child's limbs and on the mother's arms, comes very close to the medium of pastel.

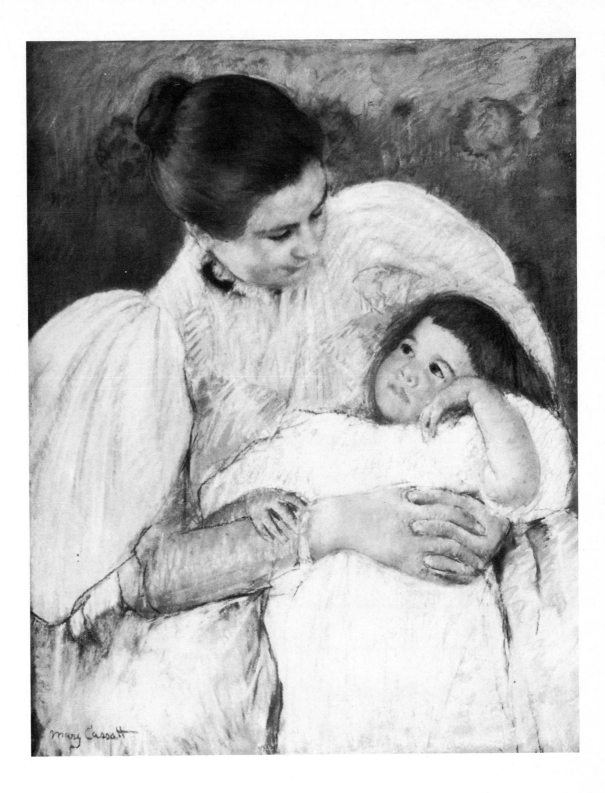

43 *Marie Looking up at her Mother*

NEW YORK, Metropolitan Museum of Art (gift of Mrs. Ralph J. Hines). 1897. Pastel on paper
80 × 66·7 cm.

Many studies of mothers and daughters in pastel are attributed to these years. They are often as
large in size as Cassatt's paintings and are quite thoroughly worked and complete. In this
pastel Cassatt used a virtually plain background with no distracting detail, but the huge puff
sleeves of the woman's dress create an interesting shape against the pink-green backdrop. The
child nestles in the mother's embrace, almost lost in the mass of material. They gaze at each other
from behind the barrier created by the mother's arms which are around the child and parallel to
the picture plane in such a way that the whole image conveys a sense of intimacy without
sweetness.

111

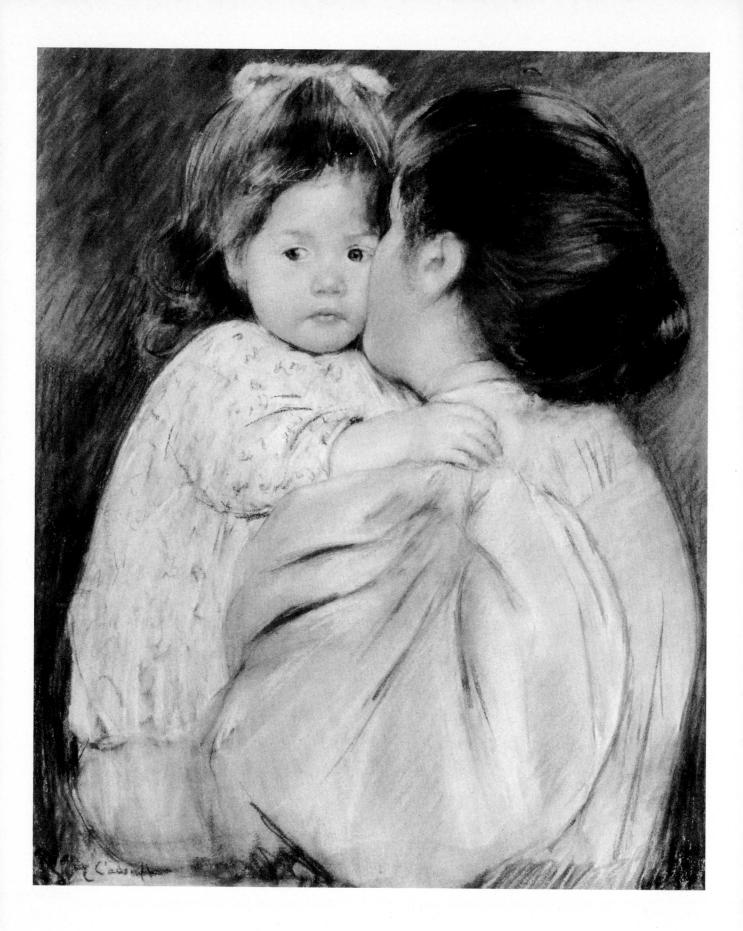

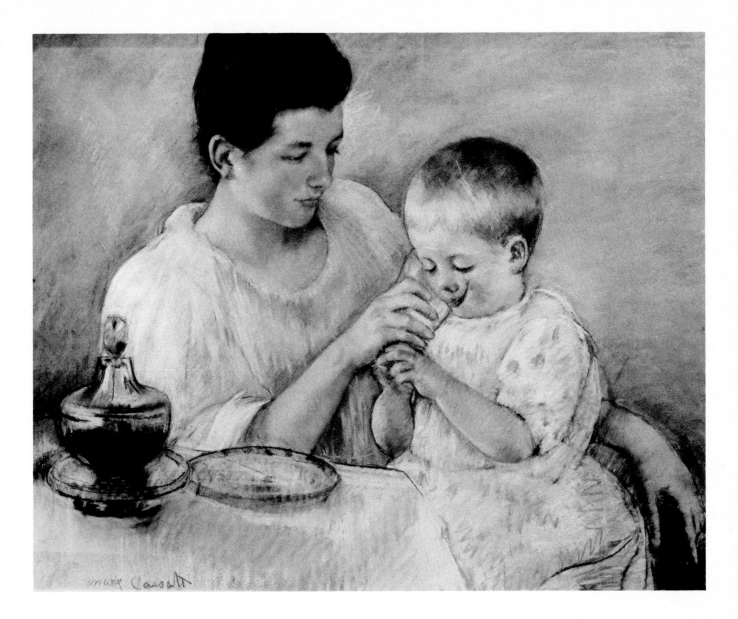

(*opposite*)
44 *Pensive Marie Kissed by her Mother*
PHILADELPHIA, Philadelphia Museum of Art (bequest of Anne Hinchman). 1897. Pastel on paper
56 × 43 cm.

Against a green background, the mother in yellow holds her child dressed in white with a grey
pattern. The child is red-haired and these colours recall the brilliance of Cassatt's essays in pastel
of 1879 (Plate 10). It is interesting to consider that using children as models necessitates
enormous powers of observation and memory, since the opportunity for prolonged sittings in the
same pose is remote. Cassatt conferred a permanence on these momentary expressions and chance
gestures, which have an absolute authenticity, obscuring the conditions of their production and
making transparent the profound studies and skills necessary to capture them so convincingly.

45 *Mother Giving her Child a Drink*
NEW YORK, Metropolitan Museum of Art (anonymous gift). 1898. Pastel on paper 65 × 81·3 cm.

The seriousness evident in the faces of the children in *Marie Looking up at her Mother* (Plate 43) and
Pensive Marie (Plate 44) was here conferred on the activity of a mother giving her child a drink.
It is a casual scene of daily domestic life, but was set up in the artist's studio. The painting of the
child's face through the glass is perhaps the most interesting pictorial exercise, but again one can
establish links with Cassatt's earlier work, especially in the concern in showing women absorbed
in their own activities, for the woman shows no other emotion than concentration on the task in
hand, and it is that sense of absorption that chiefly attracts attention.

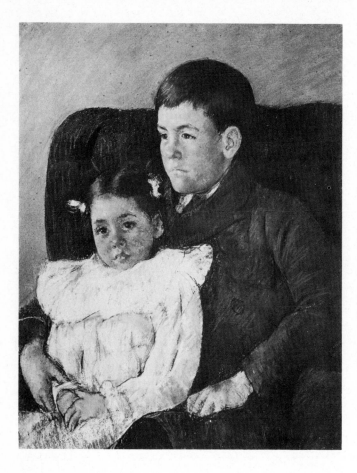

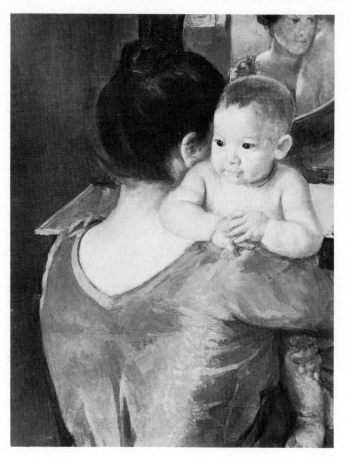

46 *Gardner and Ellen Mary Cassatt*
BRYN MAWR, collection of Mrs. Gardner Cassatt. 1899. Pastel on paper 63·5 × 47·6 cm.

In the autumn of 1898 Cassatt made her first visit to the United States since 1872, and during her stay she painted a number of portraits of the children of her friends and family. In this double portrait of Cassatt's young niece and nephew, all background details have bee suppressed and the focus of interest rests entirely on the two figures. The closeness of the brother and sister can be compared to the early *Two Children at a Window* of c. 1868 (Plate 1), suggesting a possible identification on the artist's part with this phase of childhood, represented by her brother's two children. The portrait of Gardner, one of the rare depictions of a male in Cassatt's work, is an image of great strength and dependability, but the expression emerging from the delicate pastel strokes on the face of his sister is more ambiguous and thoughtful.

47 *Baby Charles Looking over his Mother's Shoulder, No. 3*
NEW YORK, Brooklyn Museum (Carll H. De Silver fund), c. 1900. Oil on canvas 71 × 53 cm.

This equal balance of interest in both protagonists of the mother-and-child theme is shown in a reworking of the format used earlier in *Maternal Caress* (Plates 35 and 36), for the backview of the mother is complemented by the reflected face in the mirror. The introduction of the mirror indicates a return to a more elaborate composition and a more complex structure in her work.

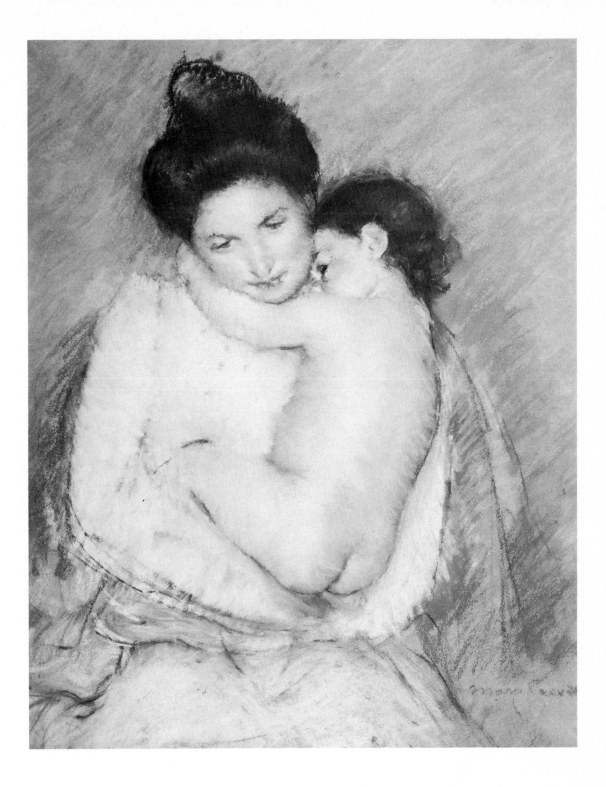

48 *Sleepy Nicolle*
CHICAGO, Art Institute of Chicago (bequest of John J. Ireland). c. 1900. Pastel on paper
48 × 53·5 cm.

This masterful pastel, with the glistening sheen of the child's nude body and the more matt effects of the mother's dress, continued Cassatt's interest in psychological states that is evident in the previous pastels, in which elimination of detail and simplified compositions point to her concern with the relationships between the figures or to the juxtaposition of two dispositions in the relationship. This pastel reverses the emphasis of many of the others, giving to the adult woman's face more significance and thus contradicting Segard's assertion that the mother has a purely supportive rôle in Cassatt's *oeuvre*. Too often the enormous changes wrought in a woman's life by childbirth and becoming a mother are overlooked. In her old age, Cassatt is reported to have commented to biographers that motherhood was an important vocation for a woman and she told Forbes Watson that a woman artist had to make many primary sacrifices. It is therefore not surprising that Cassatt should explore, through the craft of painting that demanded from her a primary sacrifice, the nature of the state of motherhood. This pastel documents a greater interest in the adult woman, suggested by its alternative title, *Mother Holding a Baby*.

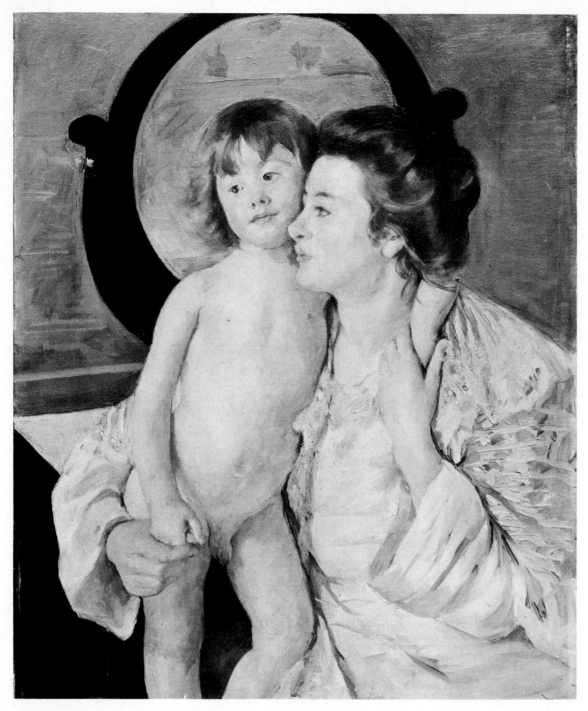

49 *The Oval Mirror*
NEW YORK, Metropolitan Museum of Art (H. O. Havemeyer collection). 1901. Oil on canvas
81·7 × 66 cm.

The frame of the mirror rather than the reflecting surface is used in this work as a decorative
shape to add interest to the background. Its position behind the head of the standing boy, however,
is reminiscent of a halo and it is not surprising to find that this painting attracted religious titles,
such as *The Florentine Madonna*, or that it inspired Degas's comment that it portrayed the infant
Jesus with his English nurse. In fact the figures are probably mother and son, for the little boy
can be identified as Jules who posed for a number of works in 1901. While living at the
Château de Beaufresne Cassatt used local people for her models, for instance Reine Lefebvre who
was the château's cook and the child Margot Lux. Despite Cassatt's involvement with the life of
the community through promoting secular education and providing opportunities for young women
to train for or move to better jobs elsewhere, the people of the village who came to pose for her
were not as well known by her as the models from her own family and class background. While a
painting such as this one reveals common concerns in the portrayal of the mother-and-child
relationship and the experiment with certain compositional features, there was nonetheless a greater
distance between the artist and the subject, suggested by the scale of the figures to the canvas,
while the frontal presentation of the models does not involve the spectator in the pictorial space.
The poses are more conventional and the standing child and its adoring mother do indeed come
close to the traditional Madonna and Child.

(*above*)
50 *Family Group Reading*
PHILADELPHIA, Philadelphia Museum of Art (gift of Mr.
and Mrs. J. Watson Webb). 1901–05. Oil on canvas
56 × 111·7 cm.

Once again Cassatt has used a horizontal format to give
dignity and scale to this family scene. The relatively rare
outdoor setting is, like that in the earlier painting *Woman
and Child Driving* of 1879 (Plate VII), merely a background
for the more important figures, who are here pressed close
to the frontal plane of the painting. The compositional
linking of the three women is underlined by their shared
and close attention to the activity portrayed, which con-
veys an atmosphere of complete quietness, absorption and
personal involvement. In contrast to the pastel *After the
Bath* (Plate VII), which has a similar compositional
format, this painting is unusual as a 'family' group; two
adult women instruct a small girl either in reading or, as
some have suggested, in looking at pictures. This echoes
the much earlier painting *Young Girl with a Portfolio of
Pictures* of c. 1876 (Plate 6), reinforcing the notion that
Cassatt's object was to examine the phases of women's
lives from childhood to adulthood. These later paintings of
mothers and daughters also deal with the education and
socialization of women by older women and these
different phases are pictorially signified here by placing
the small girl between two older women, with her small
childish hands placed over the larger hands that hold the
book. It is therefore the juxtaposition of the women rather
than the relationship between them that points to
Cassatt's consistent concerns in the painting of women.

(*right*)
51 *Drawing for 'Study of Margot in a Fluffy Hat'*
HARTFORD, Wadsworth Atheneum. 1902.
Pencil on paper 23 × 16·5 cm.

In the early years of the twentieth century Cassatt
produced an immensely popular series of pastels of young
girls, brightly dressed against plain backgrounds. For
many of these, preparatory studies in pencil were made.
This drawing, although catalogued by Breeskin (1970) as
a preparatory drawing for *Study of Margot in a Fluffy Hat*,
comes closer to *Margot in an Orange Dress* (Plate 52).

Many of the finished pastels have lost favour with modern
critics on account of the supposed saccharine prettiness of
the model, Margot Lux, dressed in big bonnets and fancy
frocks, but the number of preparatory studies enables us
to observe Cassatt's attentive search for the appropriate
pose and authentic expression. This drawing concentrates
on the wistful child seated awkwardly on a small sofa and
the overall effect is spontaneous and momentary.

52 *Margot in an Orange Dress*

NEW YORK, Metropolitan Museum of Art (anonymous gift). 1902. Pastel on paper 72·7 × 60 cm.

Although the pastel shares the same pose and mood as the drawing of Margot (Plate 51), the
subject underwent considerable transformation. The brilliant colours of the rich amber dress
against the green sofa and grey background and the bright whiteness of the bonnet dazzle the
viewer, while the accessories significantly almost dwarf or obscure the child. The pose seems more
assured, almost affected, in a theatrical posture far in advance of Margot's apparent age. However
the expression on her face immediately contradicts this sophistication and the wistfulness evident in
the drawing gives way to a more poignant sense of yearning. The pastel is a more serious study,
the twist of the figure is less rhythmic and the acute angle of the head helps create more
tension throughout the work. In the finished picture Cassatt once again used telling oppositions,
contrasting the prettiness of the dressed-up, doll-like figure to her unexpectedly mournful expression.
The little girl who looks out of the window in the pastel of c. 1868 (Plate 1) reappears in these late
works, but she is presented with the bold conviction of the artist's complete control of her art.

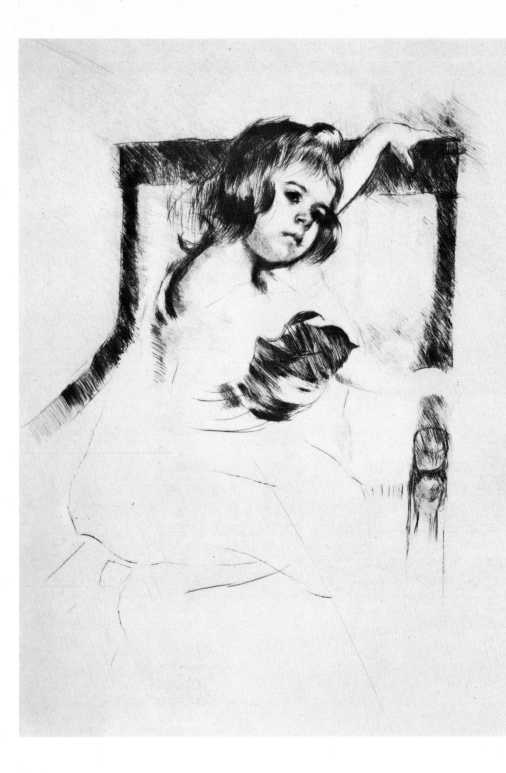

53 *Kneeling in an Armchair*
WASHINGTON, Library of Congress. 1904. Drypoint etching, only known state 28·8 × 23·7 cm.

The model once again is Margot, and the chair on which she kneels is the same as that used in *Ellen Mary Cassatt in a White Coat* (Plate XXX). But in contrast to previous works, this print is a superb example of the rigorous economy drypoint etching allows. The thickly inked chair-frame, the puffed sleeves of the child's dress and the face and head are treated in some detail, while only the most summary line indicates Margot's body and limbs. Cassatt made dramatic use of the contrast of the blank plate and very deep blacks which give the whole a decorative effect, yet the slightly indicated twist of the child's pose hints at volume and at the space she occupies on the chair. The fascination with young children and their awakening consciousness was never lost by Cassatt throughout her life and in this print she achieved a complete identity between subject and style. The stages of becoming and creation in the work itself reflect on those phases in the life of the female child.